To Jon -
Thanks for tuning in!
Enjoy these memories—

Bri-[signature]
KNBR

JON -
ENJOY THE PICTURES!

B [signature]

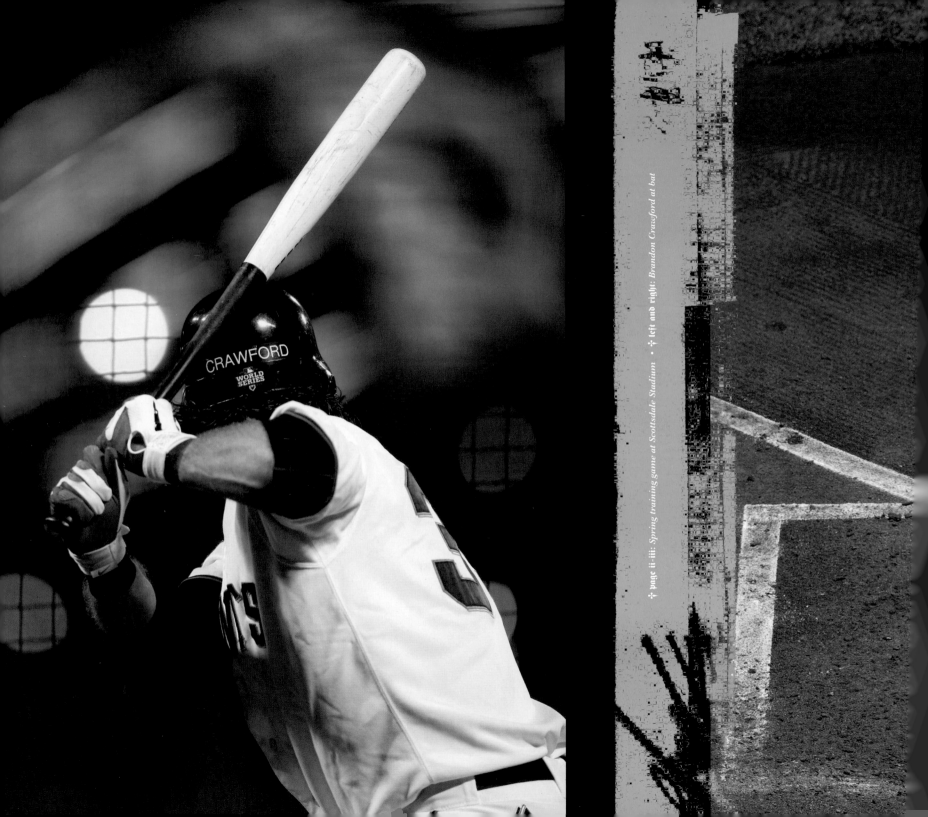

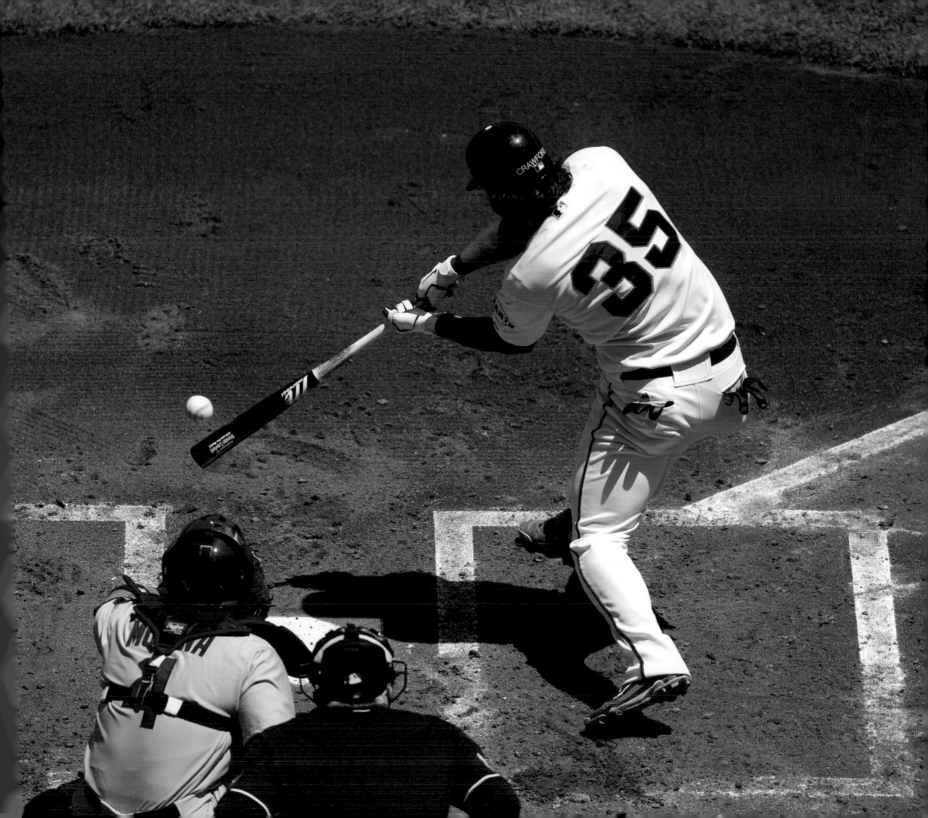

NEVER. SAY. DIE.

THE SAN FRANCISCO GIANTS — 2012 WORLD SERIES CHAMPIONS

All photographs by Brad Mangin.
Photographs ©2013 Brad Mangin, except iv, 20, 26, 32, 34, 39, 44, 52, 53, 55, 77, 79, 80, 94, 97, 98–120, which are ©2012 Major League Baseball Photos
Back cover images: ©2012 Major League Baseball Photos
Text ©2013 Brian Murphy
Foreword ©2013 Sergio Romo
Introduction ©2013 Brad Mangin & Brian Murphy

Library of Congress Control Number: 2012954802

ISBN: 978-1-937359-34-8

Printed and bound in China

10 9 8 7 6 5 4 3 2 1

CAMERON + COMPANY

6 Petaluma Blvd. North
Suite B6
Petaluma
CA 94952

(707) 769-1617
www.cameronbooks.com

† **right:** *Giants head groundskeeper Greg Elliott prepares the field*

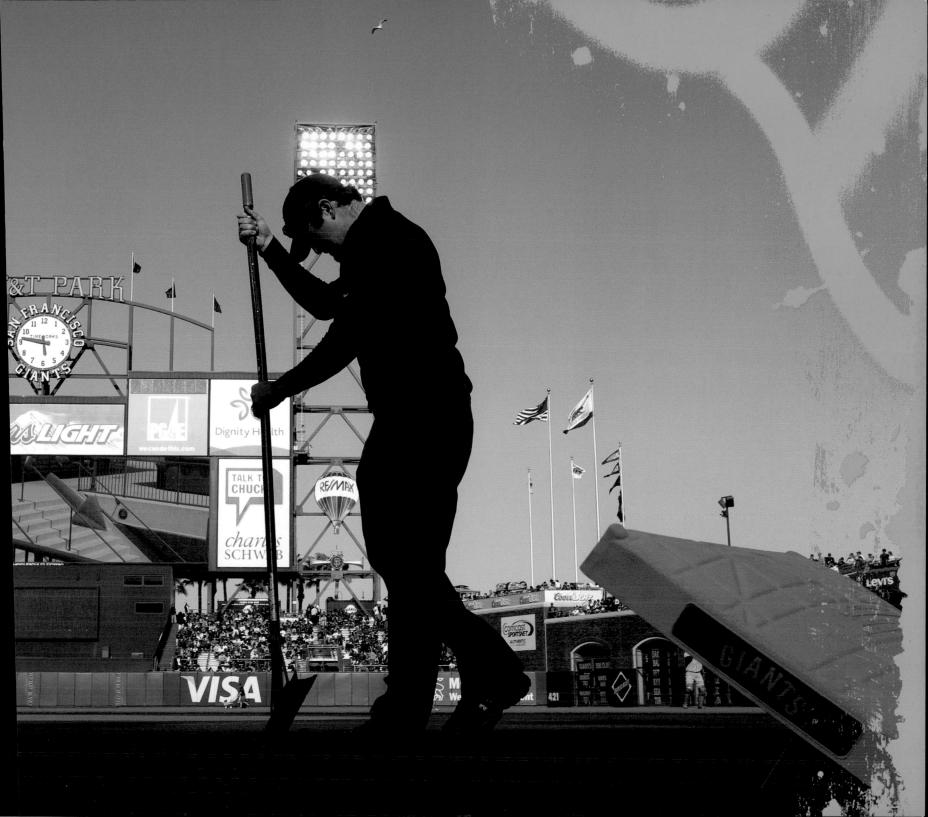

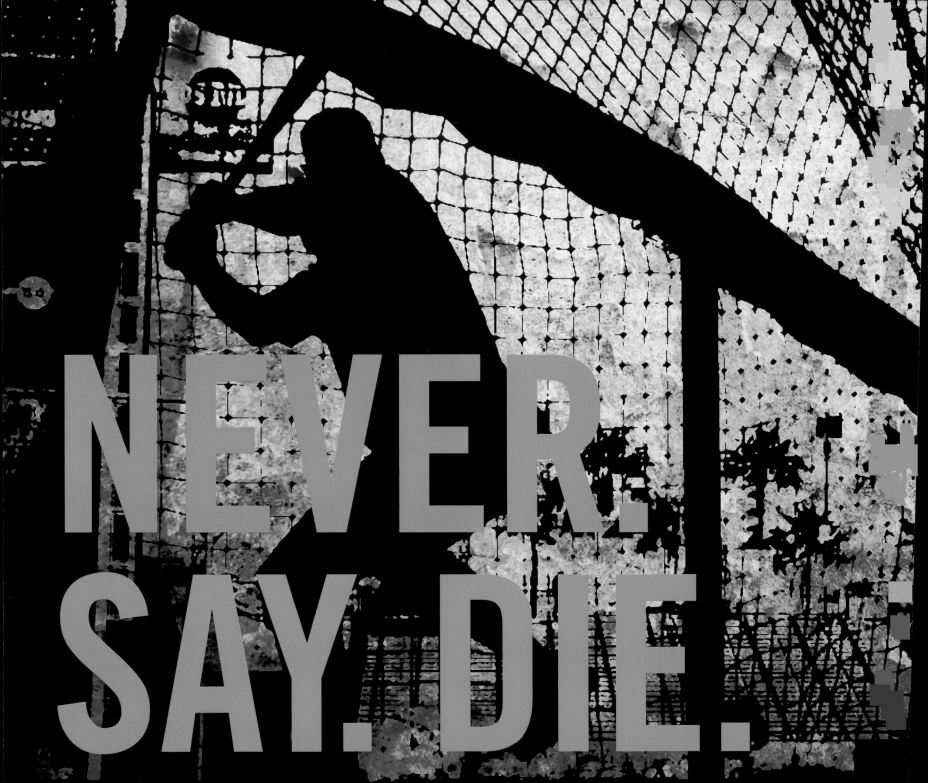

THE SAN FRANCISCO GIANTS — 2012 WORLD SERIES CHAMPIONS

PHOTOGRAPHY BY
BRAD MANGIN

•

WRITTEN BY
BRIAN MURPHY

•

FOREWORD BY
SERGIO ROMO

•

DESIGNED BY
IAIN R. MORRIS

CAMERON+COMPANY

CONTENTS.

love that this book is called *Never. Say. Die.*—because we never did.

I think back to Game 3 in Cincinnati, when we were down two games to none to the Reds, and facing elimination. In the clubhouse that day, there wasn't a feeling of nervousness; everybody understood we had our backs against the wall, but then again: When haven't our backs been against the wall?

Especially for the group that had been together since 2010, through the highs and lows of 2011, and then through the highs and lows of 2012. It seemed like a normal thing. Not much was said, and then here came this guy, Hunter Pence.

Pence got us all together, and he rallied the troops. He straight-up called us out. He said we were a good team, better than the position we were in. He also said he loved us.

do. Pence was the vocal one. Scutaro led by example, the true professional, getting those big knocks. Angel Pagan, he was vocal and passionate as well. So many different guys you can point to.

They all helped remind us to have that never-say-die mentality.

This book reminds me of it all. Its style is that of an art book, and through Brian Murphy's words and Brad Mangin's photos, the story of the season comes back. Look at the faces in the pictures. Look at the Giants playing baseball. You see a bunch of guys who love each other, who play for each other.

Like Buster Posey. He has so much on his shoulders every day. He's been in the limelight for so long, he's had the attention and pressures of living up to a reputation, or a projection of what he's capable of. And then, less than a year removed from his injury, he hit nearly .400 in the second half

FOREWORD.
SERGIO ROMO

I can honestly say that I love that man more than I love myself for what he helped us accomplish. Pence went to each of my teammates, and reminded us how important it was to have fun, to be kids, to play a game we truly cared about, that it was like playing baseball in the summer when we were young. He reminded us. He woke us up.

Marco Scutaro did, too. He and Pence reminded us why they were so happy to be traded to the Giants. They knew what they were getting themselves into on this team. It was like they saw something in us when they had played against us. They wanted to be in better situations, and the playoffs could be the exclamation point on what they were trying to

of the season. I mean, he had to call the shots behind the plate, be our cleanup hitter, and be the guy other teams prepare for, too. On our team, opponents think about Panda and Pence and Scutaro, but they think Buster first. It's easy for us to just let him be Buster, let him play the game. They're already going to remember him forever for, what, just two full seasons? I'm telling you now: They're also going to remember him for what he's going to do next, because he's going to do so much more.

Buster was one of the voices in the clubhouse who helped us move on from Melky Cabrera's suspension. You look at what Melky meant to the team. We were in playoff contention with him leading us—and then he's gone, just like that. It definitely hurt. It's hard not to be upset. You can't judge anybody for

their decisions unless you understand their reasons, but it did hurt to lose him. We'd already lost Brian Wilson and Guillermo Mota, too.

So it was a matter of looking at each other and saying: Who's going to pick up the slack? Gregor Blanco played more. We picked up Xavier Nady. Guys like that started picking up the slack. We understood Melky's absence had an effect on the team, but there's a reason we call it a "team." It's not built around one guy. Losing Melky wasn't the end of us. It was right around then when we'd gotten Pence, and he wanted to do so much for the team. You looked at the guys trying to fill Melky's gap, and you realized we had enough. You realized we'd be OK, because we never quit.

I think of guys like Tim Lincecum, too. Yeah, he didn't have the season he wanted. But what he always tried to do was be there for us. He tried to keep going out there, keep competing, keep being a guy who cared. And when we needed him most, he was there. He delivered. He was always ready. It was one of those cases where you can honestly say I've seen that before, because we have seen him be his best at the most important times.

A lot of our leadership came from our manager, Bruce Bochy. He always knew what he had in us. He always put us in positions where we could shine.

Bochy wasn't afraid to give us an opportunity to push ourselves to give it our all. He knew we'd all pull on the same rope at the same time for the same reasons. I can just hear his voice: "I'm not gonna lie to you . . . I think you guys are better than this . . . I believe in you guys." It makes me smile to think about it. Once this year, he told us the story of Gideon. He knows how to get his message across, because he's a pretty smart guy.

He certainly showed a lot of faith in me. And there I was, on the mound in Game 4 of the World Series, one pitch away from winning a championship for my teammates, the organization, and the city. At that moment, I was the least nervous I'd been all year. A calm came over me, because I knew my teammates knew how much I cared to get the job done. My teammates looked to me to do it when it mattered, they knew how much I cared to do it for them. I knew I wasn't getting it done alone.

I became the player I maybe once thought I never could be, because of them. It was all because of the belief and faith they had in my abilities. Not *my* faith in my abilities—*their* faith in my abilities. It sounds clichéd,

but now that I think about it, those guys made me become a bigger person, a bigger man. I played to win a World Series, and in the process realized that if I do my best for what's right for the team, there's a better chance to earn the respect I've always wanted. And now, when I get a pat on the back, I realize it's way cooler when you earn it this way, playing to make your teammates smile. It's way cooler.

I hope you fans enjoy this book. You can't replace what you guys bring every night to the park. When we Giants talk about how much the fans mean to us, it's real. The fans embrace us. They're what make AT&T Park one of the best places in baseball, maybe in all of sports. It's the real deal. The fans create the energy, the feeling, the passion. Jeez, you guys rock.

I loved seeing the fans in the parade. The 2010 parade hit us like a tornado. It was so much, it caught everybody off guard. This time we were able to understand it a little bit more. We're a little bit more grown up. We realize what we accomplished was not just for us individually, not just for our team and organization, but also for the city, and for everything that is the San Francisco Giants.

Go ahead, soak in the memories and images on these pages. I know I will.

December 2012

The cheers from the Giants' World Series Game 2 win still hung in the October night air, and the stadium lights from AT&T Park still reflected on McCovey Cove when we saw each other on the Lefty O'Doul Bridge.

Brad was laden with his photography equipment. The photos you will see on these pages were already encoded on his camera's digital memory, and he was headed home to get ready for a morning flight to Detroit for Game 3. His status as one of Major League Baseball's elite photographers for the World Series—his thirteenth consecutive year shooting the Fall Classic for MLB—ensured that he would capture the images of his boyhood-favorite baseball team playing for the game's ultimate prize once again.

Brian was laden only with a ticket stub from the game, a looming wakeup call for his five a.m. *Murph and Mac* show on KNBR the next day, and an

futile Candlestick Park–era Giants fandom, we collaborated on the book of a lifetime: *Worth the Wait*, the story of the Giants' 2010 World Series title, through Brad's pictures and Brian's words. We couldn't believe our good fortune. To be able to immortalize the season that brought San Francisco its first World Series title? For two Giants fans who thought seeing John Montefusco pitch or Jack Clark hit on the 'Stick's AstroTurf was the peak baseball experience of their youth, it was too good to be true.

Now, standing under the black riveted steel of a drawbridge named for an old San Francisco Seal, our lifetime dream was happening again.

Yes, the Giants won another World Series. Yes, we did another book.

Brad knew we had to do it from the moment Brian mentioned it to him. He called in to the *Murph and Mac* show from the airport before his flight to Detroit the next day, excited by the notion. Two days later at

INTRODUCTION.
BRAD MANGIN & BRIAN MURPHY

energized sense that *his* favorite team since boyhood, too, was two wins from an incredible second World Series victory in three years. We stopped mid-span, and laughed at the wonder of it all.

"Dude," Brian said. "Are we doing it again? Are we doing another book?"

Brad was tired, but felt a surge of adrenaline.

"Yes," Brad said. "Yes, we are."

Two years ago, as friends who shared sports journalism careers, Bay Area hometowns, season tickets at AT&T Park, and the wind-whipped scars of

Comerica Park, on a Sunday night where the first pitch was thrown at 44 degrees Fahrenheit with a 20-mph Michigan wind, Brad stood at what the photographers call "inside first," a "photo well" near the Giants' on-deck circle. Ryan Theriot slid across home plate with the Series-clinching run just feet in front of Brad, Theriot's exultant shout piercing his ears as he shot some of the photos you see in this book. Brad's trip to the packed, claustrophobic visitors clubhouse netted him some of the most memorable images of his career—among them, the normally stoic Buster Posey exploding in joy, covered in champagne—and a sweatshirt so soaking wet Brad peeled it off and tossed it in the trash before leaving Comerica Park at one a.m.

The photos you see here are all Brad's. This is the chance to see an entire season, from Scottsdale to the parade, through the eyes of one photographer, who also happens to be a lifelong fan.

With the creative design of Iain Morris, the images are given their proper due and flow. Iain's idea was to take Brad's photos and make sure they are enhanced with a gritty edge, to personify a team that refused to let its season end, time after time.

The idea of making this book an "art book," if you will, freed up Brian to write the season as he saw fit. A chronological recap of the 2012 team wouldn't do. Instead, Brian decided the Giants' low point against the Reds

a championship in them—especially after August 15, when Melky Cabrera was suspended for 50 games.

On KNBR, Brian called the Melky suspension "damn near a death blow" and said the Giants' season was "on life support." Brad wrote in his blog that the Giants "do not seem to have a big run left in them. They have no closer, no power, and no Melky."

And the truth was, neither of us could expect serendipity to visit our ball club again so soon. We were still sustained by the 2010 championship. After a lifetime of waiting, that glow still warmed us. We rationalized that maybe we'd only get one World Series victory for our team in our lifetime,

and maybe that would be enough. Heck, we even did a book to say so.

Seventy days had passed from the Melky suspension to our meeting on the Lefty O'Doul Bridge. Happy fans were streaming out of the park. Memories of 2010 were thick. It turned out the Melky suspension wasn't a death blow. The Giants did have a big run left in them. Maybe the Giants themselves were the only ones who knew it, and they were the ones who had the passion and the magic and the guts to make it a reality.

in the NLDS, followed by the six elimination games the team faced and won in October, provided the window into the essence of the 2012 team. Through each win, in Cincinnati, St. Louis, and San Francisco, the season's story unfolded. The Series sweep only punctuated it.

And that's the thing: *They swept the World Series!* To be entirely honest with you all, there were many times neither of us thought the Giants had

This book is our salute to them.

December 2012

LET'S.
PLAY.
BALL.

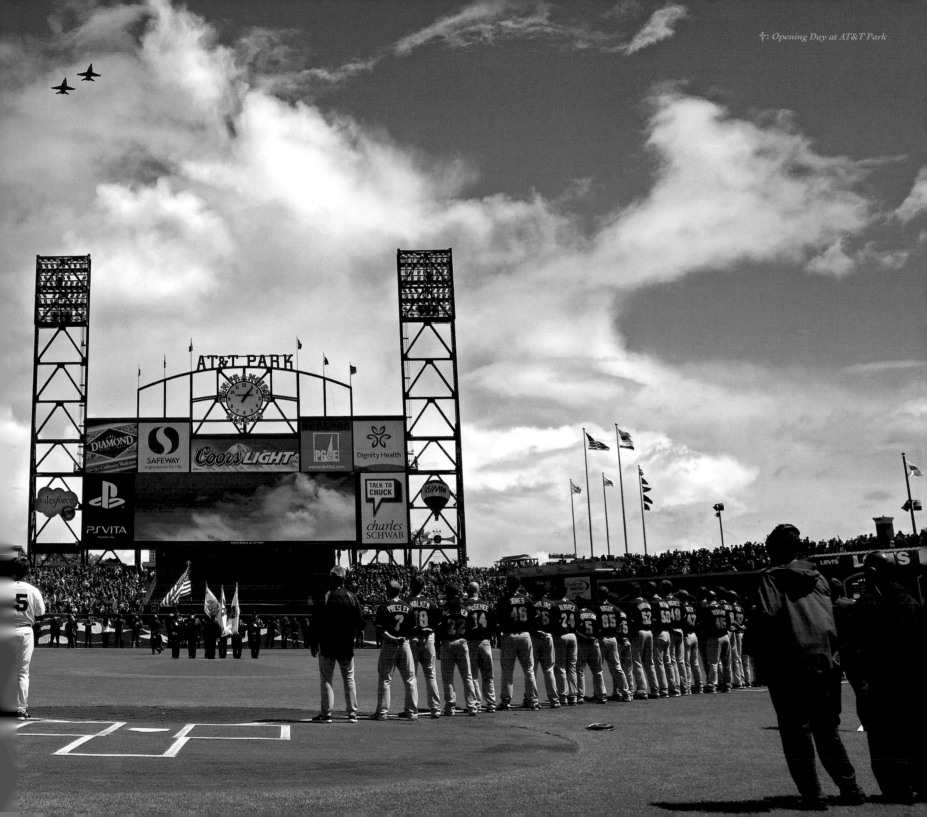

If you're looking for another chronological, spring-to-summer-to-fall summary to somehow capture the essence of the 2012 World Series champion San Francisco Giants, don't.

What the Giants did in the month of October 2012 so defied expectation, momentum, and history that it defined them, and their magical season, in total. An assortment of disparate baseball narratives collided to form something larger than could have been conceived, except that in some way, the players on the 2012 Giants had conceived it all along.

The best way to remember this band of happy competitors, this now immortal collection of players in black and orange, is to begin at their lowest point, and trace them to the peak. The six elimination games faced by the team brought out something that will live for many years, even as each game carried with it the threat of extinction. Those six games, then, and the dark ebb of the day before, added to the World Series sweep that followed are the essence of the 2012 Giants. The ballplayers who crafted those plays and indelible memories to play again for One More Day—

HONOR. THE. GAME.
BRIAN MURPHY

that phrase they all heard from Hunter Pence—each had their stories written in the scorecards of our minds forever.

Every game featured a star or key Giant whose season-long narrative was illuminated, or salvaged, or exalted by the October sorcery. That is what follows here: a look back at history, and the stories of the players who made it.

National League Division Series, Game 2, Sunday, October 7, San Francisco
Reds 9, Giants 0

Sometime around 8:30 p.m. on a quiet Sunday night in China Basin, the seagulls seemed to outnumber the fans.

AT&T Park emptied as if a late-inning fire drill had sounded, but the truer alarm was for a Giants season that appeared to be over. A second consecutive flat home loss sucked the life out of the packed yard, the same ballpark that drew 3.37 million rollicking fans in a 94-win, National League West championship regular season. Memories kindled of a championship October just two years earlier seemed gone, just like that.

Now, as the Cincinnati Reds, a swaggering 97-win NL Central champion skippered by longtime Giants manager Dusty Baker, plated run after run in a five-run 8th inning, each fan who left the yard seemed to take with him or her a piece of the Giants' waning hopes to make magic happen in October 2012.

Mid-9th inning, the Giants' scoreboard operator channeled gallows humor. He blasted the Bee Gees' "Stayin' Alive" on the sound system, accompanied by video footage of John Travolta lighting up the disco floor in *Saturday Night Fever*. Maybe it was an attempt to resuscitate the diehards who stayed all nine. Punch-drunk fans around the yard stood out of their seats and mimicked Travolta's moves, swaying and pointing up and down in an almost pagan ritual to the baseball gods—please, don't let this summer end.

When Hunter Pence grounded out to end the shutout, it was over. Down on the field, Reds pitcher Bronson Arroyo spoke on national TV. He'd authored the Game 2 masterpiece, twirling seven innings of one-hit ball.

But he talked cautiously, as if not to wake the sleeping Giants. "We know we're in the driver's seat," Arroyo said, "but this game is very funny and there's nothing guaranteed. . . . We hope to keep them quiet, because if they get some momentum, anything can happen."

The words seemed overly safe, judging by the faces of two young female fans sitting in the stands, their Panda hats draped over their heads as they sat, watching the park empty. One fan, passing them on the steps, took stock of their glum countenances. "Remember," he said, almost whistling through the graveyard, "it's the first team to three wins, not two." One of them looked up, and offered a wan smile in return, totally unaware that the greatest three weeks in the 130-year history of the Giants franchise were about to unfold.

What happened next veered from the inspirational to the almost inexplicable. Six consecutive elimination game wins, followed by a World Series sweep, vaulted the 2012 Giants from playoff afterthought to baseball legend.

NLDS Game 3, Tuesday, October 9, 2012, Cincinnati, Elimination Game 1
Giants 2, Reds 1 (10 innings)

No team in the history of baseball had ever won three straight elimination games on the road in a best-of-five series, but that little piece of seemingly insurmountable history didn't bother Hunter Pence when he gathered the team in the visitor's clubhouse at Great American Ballpark.

Beat writers would afterward say they could only hear crazed shouts and cheers from behind the thick clubhouse walls. Longtime team broadcasters and former Giants players Mike Krukow and Duane Kuiper said they were in the coaches' room when they heard an explosion of noise. They looked at each other, quizzically: *Is that a motivational speech, or a religious revival?* Nobody was sure what was happening. Only later would they learn.

Meanwhile, the Game 3 starting pitcher, Ryan Vogelsong, came to the park imbued with a quiet strength. A text he had received from longtime big league pitcher Jamie Moyer had filled him with resolve. It had arrived on his phone the night before, and it detailed the story many Giants fans had come to love about Vogelsong: how his career was a study in resilience, a path forged by a love of the game and a refusal to accept the end.

At age 35, Vogelsong had seen it all: traded in 2001 by the Giants, the team that had drafted him; granted free agency by the Pittsburgh Pirates in 2006. With no takers in Major League Baseball, Vogelsong and his wife, Nicole, headed for Japan. Pitched two seasons for the Hanshin Tigers, and one for the Orix Buffaloes. In 2010, his hometown Philadelphia Phillies signed him, and released him in July. The Los Angeles Angels of Anaheim signed him in 2010. Then they, too, released him.

When Vogelsong signed a minor-league contract with the Giants in the winter of 2011, it seemed a last shot at a dream. At least the dream would end with the team that had drafted him out of Kutztown (Pa.) University in the fifth round of the 1998 MLB Draft. The dream was realized: Vogelsong became an All-Star in 2011, won the team's coveted Willie Mac Award (for spirit and leadership), too, and backed it up with a stellar year (14-9, 3.37 ERA) in 2012.

But he'd still never pitched in the playoffs.

In contrast, Jamie Moyer was a baseball lifer. He'd won a game at age 49 in the year 2012, and knew that moments like these need to be crystallized. He said as much to Vogelsong. "I know you've been waiting for this moment a long time," Moyer wrote. Yes, Vogelsong would say later, he had.

Except, when the Reds strung together a walk and two singles in the first, including an RBI hit from Jay Bruce to score Zack Cozart, the Giants trailed, 1-0, in a road elimination game. If ever there was a time Vogelsong needed to dip into the resolve reservoir, it was now—and he did it on a full count pitch, fanning Scott Rolen looking, to snuff the rally.

In the bottom of the 2nd, the two protagonists of the evening joined forces. Reds catcher Ryan Hanigan lofted a sinking fly ball down the right field line, laden with potential trouble. But Pence, the right fielder, maniacally kept his eyes locked on the ball. Despite the looming presence of a wall down the right field line, he folded into a slide at the foul line. He speared the ball just before it touched ground, a magnificent display of athleticism and focus as his slide carried him into the wall. It would have been a foul ball, but it didn't matter. It was the kind of energy play Giants general manager Brian Sabean envisioned when he had traded longtime Giant Nate Schierholtz and top catching prospect Tommy Joseph (along with minor league pitcher Seth Rosin) to the Phillies for Pence on July 31.

For Pence, the trade from Philadelphia had to rock him. The team that had drafted him, the Houston Astros, traded the native Texan to Philadelphia

in the summer of 2011 for a bushel of prospects. When the Phillies saw their 2012 season disintegrating, they, too, moved Pence, who at age 29 was now on his third team—despite being a two-time All-Star and a career .290 hitter.

Pence remained unfazed. He showed up in San Francisco with his trademark high black socks, awkward on-deck practice swings, and unorthodox fielding style, more herky-jerky than "Say Hey." He rode an electric scooter up and down the Embarcadero to the ballpark. He told reporters when he played they'd see things they don't usually see, and also said the trade was "like being born again . . . a new life." Sabean echoed the mutual affection, saying, "We like the way he approaches the game."

And despite a wicked batting slump in the final two months of the season —he only hit .219 in August and September—he found ways to drive in 45 runs in that stretch, the highest on the team.

Now, in Game 3 of the NLDS, he trotted back to right field after retiring Hanigan on the foul ball, his pants stained with Ohio dirt. After the top of the 2nd, Vogelsong grabbed Pence by the shoulders in the dugout. "You don't know," he said, "how much that play did for me."

The Giants tied the score with some classic National League ball. Gregor Blanco was hit by a pitch. Brandon Crawford walked. Vogelsong sacrificed them over, and Angel Pagan hit a sacrifice fly. A game-tying run, all without a hit against Homer Bailey, who was mesmerizing the Giants.

But Dusty Baker removed Bailey for a pinch-hitter after seven innings of one-hit ball, much to the Giants' relief. Baker would also, curiously, burn his top two relievers, Sean Marshall and the fireballing Aroldis Chapman, in the 8th and 9th, leaving Jonathan Broxton to pitch the 10th. As well as Broxton pitched in 2012, the Giants knew him from his days as a Dodger, when he was less than ironclad.

And here came the Giants. Buster Posey, ever the key, singled. A wicked leg cramp seized Pence in his at-bat, but there would be no sympathy from the Reds. Broxton went after Pence, and Pence somehow, with little leg base to support his swing, grounded a ball into left field for a single, limp-walking his way to first. He refused to leave the game.

A passed ball put the runners at second and third, and with two outs, Joaquin Arias, a utility infielder, stood in.

Arias entered the game as a pinch-hitter for Crawford in the 8th, a move by manager Bruce Bochy to take advantage of Arias' .303 batting average vs. left-handed pitchers in 2012. But now Arias faced a righthander, Broxton, and Arias had only hit .240 against righties.

Still, Arias was a player Giants teammates and fans had come to enjoy for his underrated knack. Often overlooked because of his peripatetic career —signed by the Yankees in 2001, brief big-league stints with the Texas Rangers and New York Mets (only 257 career at-bats before the Giants invited him to spring training)—Arias had shined many times for Bochy. Perhaps he was never better than this August, when he filled in for an injured Pablo Sandoval and hit .417, with an OPS (On-base Plus Slugging percentage) even higher than Buster Posey's in a month where the Giants surged to an 18–1 record.

Broxton threw a 95-mph, 1-2 sinker to Arias, and Arias did the best thing possible: He put it in play.

Some could call it a weak ground ball, but its second hop carried with it the fates of the San Francisco Giants. The baseball toyed with eight-time Gold Glove winner Scott Rolen, top-spinning into his chest. He fumbled with it, and an adrenaline-charged Arias sprinted down the line. Rolen's throw was just late. First-base umpire Dan Iassogna would signal safe, but he didn't need to. Giants first base coach Roberto Kelly, surging with energy, made the "safe" sign himself, not once, not twice, but three exulting times, as Arias crossed first, his fist raised in triumph, as Posey scored from third.

The Giants won, 2–1.

Asked afterwards if he'd felt nervous at the moment, Arias smiled. "Nervous? Why? It's baseball," he said.

Vogelsong, whose five innings of one-run ball required maximum effort, heard his voice catch when he told reporters about his first playoff start: "I've been waiting for this moment a long time." As for the pregame noise? Krukow had described it as "Jimmy Swaggart would have been proud . . . except for all the cursing." Only after the game, in a relieved and alive clubhouse, did the story emerge. The pregame war whoops were the product of a Pence speech, a passionate plea to his teammates of just two-plus months that their baseball together not be over. The history of baseball shows that it is a sport not played with an adrenalized energy, but rather a controlled skill, and a quiet concentration that must last nine innings, daily, weekly, monthly. Pence eschewed that tradition. Nobody in the clubhouse

would say exactly what Pence said, but third base coach Tim Flannery, a singer and songwriter and man in touch with emotion in words, took to the social media platform Facebook and posted the following later that night :

get in here, everyone get in here . . . look into each others' eyes . . . now! look into each other's eyes, I want one more day with you, it's the most fun, the best team I have ever been on," said the Reverend Hunter Pence. *"And no matter what happens we must not give in, we owe it to each other, play for each other, I need one more day with you guys, I need to see what Theriot . . . will wear tomorrow, I want to play defense behind Vogelsong because he's never been to the playoffs . . . play for each other not yourself, win each moment, win each inning, it's all we have left.*

Flannery added underneath the script that Pence's words moved him like he has never been moved before. He centered on a phrase: "Honor the game, and the game honors you."

That night, 3,448 Giants fans clicked the "Like" button on Flannery's post.

NLDS Game 4, Wednesday, October 10, 2012, Cincinnati, Elimination Game 2
Giants 8, Reds 3

A year in which the Giants and 49ers showed mutual admiration —Bruce Bochy wearing a 49ers cap to a pregame dugout media session, Alex Smith throwing out the first pitch in NLDS Game 1—continued when 49ers president Jed York tweeted out his support of the Giants, the night of Oct. 9: *How do you win three games on the road? One at a time!*

Or, as Angel Pagan said after Game 1: "We didn't come here to win one game. We came here to win three."

Game 4 caused angst in Cincinnati's clubhouse even before the first pitch, as they searched for a starting pitcher. All-Star pitcher Johnny Cueto had strained his oblique muscle in Game 1 in San Francisco after just eight pitches. Baker removed Cueto from the post-season roster, and went with Mike Leake in Game 4. Leake's 2012 season wasn't good enough to make Cincinnati's 25-man roster, but here he was, assigned the task of preventing a Game 5. It would not go well for the 25-year-old righthander.

His second pitch of the game was an 89-mph cutter that sat over the plate.

Pagan crushed it, a line drive into the red-clad fans in right field, and the Giants dugout, recipients of another Pence pregame speech, applauded mightily. The Giants had won Game 3 without any extra-base hits, and had never led a game in the NLDS. Pagan's swing cured both those ills.

More pop came in the 2nd, when Gregor Blanco took a fastball and squared it. The baseball didn't stop until it landed in the right-center-field bleachers, a two-run home run that scored Hector Sanchez, too. As Blanco rounded the bases with his third hit of the NLDS, Giants fans marveled at the production they saw from a position—left field—owned by another Giant for most of 2012.

That Giant left fielder would be Melky Cabrera, and he was no longer on the team.

Of all Brian Sabean's many moves in shaping the 2012 Giants—trading 2010 World Series cog and Willie Mac Award winner Andres Torres to the Mets for Pagan, inviting Arias and Blanco to spring training, signing Ryan Theriot for an injured Freddy Sanchez—none was as heralded through the spring and summer as the startling piece of burglary that was trading enigmatic lefthander Jonathan Sanchez to Kansas City for Melky Cabrera. Cabrera was nothing short of a team-changer.

His checkered career included huge promise as a Yankee prospect, even hitting .274 with the 2009 World Series champions; then a flame-out 2010 season in Atlanta, where he was considered out of shape; then a resurrection of sorts (201 hits) on the 2011 Royals, well below the sports radar.

Sabean sensed Sanchez's productive days were dwindling, and traded him for Cabrera, whose switch-hitting lash provided the perfect No. 3 hitter in front of Posey.

Cabrera's month of May was the stuff of legends. His 51 hits tied Randy Winn's club record for hits in a month, and he spent most of the summer leading all of MLB in hits. Sergio Romo wondered on his weekly KNBR radio show if it was as easy for Melky as playing a video game, and Matt Cain told reporters, "If he doesn't get a hit, we think something's wrong."

In a park where Brian Wilson–inspired beards and Pablo Sandoval–inspired panda hats dotted the stands, some enterprising fans came to the yard dressed in white slacks, white pressed shirts, white caps, and orange bowties. They looked like early-twentieth-century milkmen, and that was their intent: to honor Melky as the "Melk Men." "Melk Maids" could also be seen.

Melky Cabrera had officially become a fan favorite.

The love affair continued when the Giants fans voted him into the starting outfield in the All-Star Game with 7.5 million votes, topped only by Posey's MLB-best 7.6 million. And when Melky ripped two hits and two RBIs to go along with Sandoval's three-run triple, Melky didn't just win All-Star Game MVP (the first Giant since Bobby Bonds in 1973), he also caused rival Matt Kemp of the Dodgers to be caught on microphone saying: "It's the San Francisco Giants' show." For ecstatic Giants fans, it was music to their Melky-loving ears.

And then came August 15.

As the Giants prepared for a home day game, the rubber game of a three-game set against the NL-East-leading Washington Nationals, word rippled throughout the park: *Melky got popped for performance-enhancing drugs. Fifty-game suspension.*

What? Just the night before, in a 6-1 win behind Bumgarner, Cabrera notched his MLB-best 156th hit and scored a run. He was hitting .346, second only to Pittsburgh's Andrew McCutchen. The Giants were tied with the Dodgers atop the NL West in a classic August pennant race. Could this really be happening?

It was true. Cabrera had tested positive for testosterone, issued a statement saying he was "deeply sorry," and apologized to the team and fans for "letting them down." Only he never said anything to his teammates in person. He simply vanished from the park, and nobody saw him from that morning on.

As fans scrambled to check their smart phones for the news that was buzzing among the corridors and seats of AT&T Park, the team got silenced by Stephen Strasburg and saw Tim Lincecum's record fall to 6–13. The Giants fell out of first place by a game. The whole thing felt like a death blow to the season.

Except in the clubhouse.

Pence, only two weeks a Giant, stood firm: "It happened, and now we move on. We play with what we've got." Said Pagan: "We believe in what we have in here." Added Sabean: "We've got a survival instinct."

Posey, in the midst of a torrid second-half surge, was even more succinct.

"Ultimately, it was a bad decision. And that's all I'm really going to say about that."

Posey's words seemed to pack an extra punch of defiance, given he chooses his words carefully in media settings. Almost rebellious in a way, Posey's words seemed to say his Giants team would cede little ground to the Melky-sown seeds of adversity.

How correct that would prove in the coming weeks is still stunning, even in retrospect. The Giants went a staggering 25–9 in the next 34 games without Melky, clinching the NL West on September 22. Though the team signed veteran Xavier Nady to play some left field, and though the Giants went 6–1 in Nady starts in left field en route to the clinch, the bulk of the starts went to Blanco, the "White Shark" who some felt was one of the best defensive outfielders in the National League.

Wooed by Roberto Kelly after he coached Blanco in the Venezuelan Winter League, Blanco started 20 games in left field between Cabrera's suspension and the NL West clinch, and the Giants went 14–6 in those starts. For a guy who had spent two and a half mostly unmemorable years with the Braves, a half-season with Kansas City in 2010, and was out of MLB in 2011, it was sweet stuff, indeed.

So, as Blanco trotted around the bags after his NLDS Game 3 home run, and the Giants had a 3–1 lead against wobbly emergency starter Leake, things seemed positive. After all, Barry Zito was on the mound, and he was an elixir. The team had, incredibly, won eleven consecutive games in Zito starts.

But Game 4 in Cincinnati wouldn't be won because of Zito. When he walked in a run in the first inning, he seemed unsure. And when he gave up a Ryan Ludwick home run in the 3rd, then gave up two hits in the 4th, Bochy made his move. Zito was gone. It would be up to the Giants' bullpen to get seventeen outs.

The Giant who got thirteen of those seventeen outs was maybe the biggest story of October.

When TV cameras showed Tim Lincecum watching the 4th inning from behind a fence in the bullpen, the sight was odd, even unsettling for Giants fans. Here was Timmy the Kid, their two-time Cy Young and World Series champion hero, relegated to the bullpen after an historically awful 2012 season. It felt like a disconnect between a fan base and a favorite, almost an exile.

In fact, the whole 2012 season felt like a disconnect between Lincecum and his career. Whether because of diminished velocity, or malfunctioning mechanics, or lost confidence, or a combination of all three, Lincecum's season was a disaster: a career-worst 10–15 record, the most losses of any pitcher in the league; a career-worst 107 earned runs allowed, the most in the league; an unthinkable 5.18 ERA for a pitcher with a career 2.97 ERA entering the year; and a league-worst 17 wild pitches.

Come October, Bochy had no choice. He removed Lincecum from the postseason rotation, and asked him to become a reliever. The move risked losing Lincecum mentally for all of October, but in one of the most critical moments in the team's drive for a championship, Lincecum signed on. It took a lengthy heart-to-heart from pitching coach Dave Righetti, but Lincecum's public stance was clear. "I'm not going to be the one to throw a tantrum," he said. "I understand it more than you expect. It's about earning it."

And when he jogged in to face Reds slugger Ludwick with two outs and two on in the 4th in a 3–2 ballgame, he began the earnest task of earning. In one of October's finest moments, he fanned Ludwick on a 2–2 changeup, the sort of string-pull he'd engineered so many times since his Giants debut in 2007, one year after he was the tenth overall selection in the MLB draft, out of the University of Washington.

What transpired over the next four innings was breathtaking for Lincecum fans. He rediscovered his changeup and used it at a rate higher than at any point all year, spinning 4⅓ innings of one-hit, one-run ball. The Giants poured it on. Pablo Sandoval hit a two-run home run, and the team continued its scintillating road offense, bats that had scored 102 more runs on the road than at home. When the 8–3 score was final, the Giants hadn't just forced a decisive Game 5, they'd also seen the "Win" go next to the name "Lincecum" in the box score, a development that felt like home to so many Giants fans. The Giants still alive, and Timmy the Kid dealing?

Bring on Game 5 was the sentiment.

Lincecum, meanwhile, smiled after the game about those Hunter Pence speeches. "They are extremely inspiring," he said. "They raise us up and bring us together. He's a tough cookie."

So was the guy talking.

NLDS Game 5, Thursday, October 11, 2012, Cincinnati, Elimination Game 3
Giants 6, Reds 4

By now, Hunter Pence had morphed into the Ray Lewis of the Giants. Like the NFL's fire-and-brimstone pregame energy ball, Pence led the team before Game 5 in yet another ritual. Now the team was gathering in the dugout before first pitch, and doing what Pence would later call the "Slow Clap," a rhythmic clap by players gathered in a circle, while Pence exploded in a burst of inspirational energy and words. This day his speech ended in a flurry of high-fives and hugs, with many wide smiles on Giants' faces.

For a major league baseball team of professional athletes with agents and combined annual contracts totaling over $100 million, the entire scene was unusual, refreshing in a childlike way.

The Reds, no doubt feeling the constricting pressure of trying to avoid getting swept at home and to avoid being on the losing end of history, did no "Slow Clap" dance in their dugout. Instead, they turned to a teammate who was intent on ending the black-and-orange party: Mat Latos, the scowling, tattooed, towheaded six-foot-six righthander who had a history with the San Francisco Giants.

Latos played the role of villain for Giants fans beautifully. In 2010, as a San Diego Padre, Latos first incurred their wrath by beating the team in dominant fashion, including a one-hit complete-game shutout in May of 2010 as the Padres built an NL West lead on the Giants. But when Sabean made key moves in the summer of 2010, adding Pat Burrell, Cody Ross, Javier Lopez, and Ramon Ramirez, among others, Latos insinuated to reporters the Giants were less of a team than the Padres, more a collection of transactions with "San Francisco Giants" across their chests. This was met with predictable scorn in the Giants' clubhouse.

And then, like most villains, Latos got his comeuppance. He lost a key game to the Giants in September of 2010, when Buster Posey hit a first-inning home run at Petco Park that won the series for the Giants. Then, in 2010's final game of the season, Latos took the loss in the Giants' NL West–clinching win at AT&T. Vengeance was San Francisco's.

And when the Padres traded him to Cincinnati in 2012, Latos was out of the NL West, and seemingly out of the Giants' hair.

Until October 2012.

Latos's four innings of sterling relief had helped the Reds win Game 1, and now, in a Thursday matinee with everything at stake, Latos would start Game 5. Nothing would please Latos more than to end the Giants' dugout pre-parties right then and there.

Opposite him was Matt Cain, the very definition of Giants mettle, an expression-free veteran who was the team's longest tenured member, and the starter with the best 2012 resume: At 16–5 with a 2.79 ERA, Cain finished sixth in the NL Cy Young race. Moreover, he was Bochy's choice to go Game 1—and now, Game 5.

Cain's excellent season rewarded Giants management for their big move on Opening Day. With Cain set to be a free agent after the 2012 season, and the rival Los Angeles Dodgers under new, huge-money ownership, the pressure was on to see if the Giants and Cain could find common ground before the season began. If not, talks would be tabled until after the season, a perilous thought for Giants fans.

But at the team's Opening Day luncheon at the San Francisco Hilton, team president Larry Baer broke the news: Cain had signed a five-year, $112.5 million contract that keeps him a Giant through 2017, and the $22.5 million per year average set an MLB record for righthanders, previously held by Lincecum at $20.2 million per year.

Just to make things even better between Cain and the Giants, he made history on June 13 when, against the Houston Astros, he threw the first perfect game in a franchise history that dates to 1883, only the 22nd perfect game ever in the major leagues. His fourteen strikeouts in a perfect game were matched only by Sandy Koufax, and the game also featured another bit of sterling Giants' defense when Gregor Blanco made a remarkable diving catch deep in right-center field on a ball hit by Jordan Schafer. For a team built around pitching and defense, it was what one might call a defining moment of how the Giants win.

But now Cain needed to beat Latos in Cincinnati. He was up to the task through four tense, scoreless innings. He and Latos matched zeroes in a stressful bit of "Dueling Banjos." Who would crack first?

The answer came in the top of the 5th.

Blanco singled to left field to give the Giants their first leadoff runner. Latos seemed upset at home plate umpire Tom Hallion's strike zone, and lost his concentration on a 2–0 pitch—a mistake Brandon Crawford lined into the right field corner for an RBI triple. The Giants' No. 7 and 8 hitters had cut Latos. When Pagan hit a slow ground ball to shortstop, and when Cincinnati's Zack Cozart muffed it on an error, Crawford scored. The Giants led, 2–0, and sweet memories of 2010 opposition mistakes—primarily Atlanta's Brooks Conrad making key errors in the NLDS—flashed through happy Giants fans' minds.

Now, it was time for the kill. Marco Scutaro drew a walk from a rattled Latos, and Sandoval singled to left. Pagan stopped at third. The bases were loaded.

And up stepped Buster Posey.

That it would be Posey at the bat in such a critical situation was baseball poetry. After all, at age 25, the kid from Leesburg, Georgia, the Golden Spikes winner from Florida State, the first-round draft pick from 2008 played baseball in its purest form: with a gorgeous, inside-out right-handed swing; with catching fundamentals that, while imperfect, produced the kind of steadying influence and game-calling that equaled wins; with a graceful stoicism, an everyday steadiness and poise, and a maturity that called to mind Derek Jeter's winning ways with the Yankees.

His dismissal of Melky Cabrera's drug bust backed it up. His performance on the field in 2012 did so even more.

The Buster Posey who dug in against Latos finished the regular season as most everyone's consensus NL MVP. Declared the NL batting title winner with a .336 mark after a new rule disqualified Cabrera's .346, Posey had added team-leading 24 home runs and 103 RBIs to the Giants' totals. Most important, Posey played his best as the season wore on. His second half numbers—.385 batting average after the All-Star break, a remarkable .456 on-base percentage—spoke to a player who smelled the playoffs, and who willed his team to post-Melky wins. Weeks after his at-bat with Latos, he would win the awards: NL MVP, the Silver Slugger, the Hank Aaron, and one other award, too—Comeback Player of the Year.

The Posey who batted against Latos with the bases loaded that day in Cincinnati was only a little over sixteen months removed from a home plate collision that had threatened his career. The image of Florida's Scott Cousins bowling over Posey in the 11th inning of a May 25 game at AT&T Park is a nightmare in franchise history. Three torn ligaments and a fractured bone in his ankle didn't just mean Posey would miss all of 2011; it meant 2012 was in question, too. Even if he did play, how much could

he play? How effective could he be? How much of his potential would or would not be realized?

As the hits and the runs and the RBIs piled up throughout 2012, and as the wins piled up, too, and as Posey played better and better and more and more, he said, "We've all got a certain number of years to play. Last year, I saw how quickly it can be gone. You've got to take advantage of each moment you have."

While Bochy liked to get Posey off his surgically repaired ankle and give him starts at first base throughout the year, the Giants saw a nine-game stretch in August where Posey caught every game. "It's time," Posey said, "to push it more."

On September 9, in the rubber game of a three-game series with the Dodgers, and with a chance to push the Dodgers 5½ games back in the West, Posey engaged in an at-bat with Dodgers pitcher Joe Blanton, fouling off six consecutive pitches before hitting his twentieth home run. The Giants won, 4–0. "That's one of the best at-bats anybody's ever had against me," said Blanton.

And when the Giants clinched the West on September 22, Posey spoke for the team. "We had the Melky incident," he said. "But everyone kept pushing."

The awards parade for Posey actually started in September, when Posey was voted the Willie Mac Award winner for 2012, further proof of his indispensable presence in the clubhouse. Even Stretch joined the fan club. "I don't usually tell who I voted for," Willie McCovey said in a pregame ceremony, "but I voted for this year's winner."

The accumulation of Posey's arduous road back perhaps caused his lull at the plate in the first four NLDS games. He was only 3 for 17 when he came up in the 5th with the bases loaded. He did have one home run, though. He'd hit it off Latos in Game 1, just as he had in September 2010.

And now here they were again: Posey vs. Latos.

As Latos looked in for Ryan Hanigan's 2–2 sign, he saw the catcher call for a fastball inside. Instead, he left a 94-mph heater over the plate. Posey's perfect swing got all of it. Its trajectory was majestic, so much so that the normally head-down Posey took four paces to watch it before beginning his trot. Posey's gaze at the baseball's arc was more than Reds catcher Hanigan could bear. Hanigan's body instinctively jerked away from home plate as he

walked disgustedly and immediately away, disconsolate.

Latos never turned around. He didn't have to. Four hundred and thirty four feet the baseball traveled, incredibly bouncing off the facing of the second deck, where the name "LATOS" burned on the scoreboard.

Or, as Jon Miller called it on KNBR:

> *Now the crowd tries to insinuate itself into the game . . . Pagan at third, Scutaro at second, Sandoval at first . . . the pitch . . . there's a swing! . . . a long high fly ball deep to left field! . . . and . . . UPPER DECK! GOODBYE! A grand slam for Buster Posey! . . . the Giants have scored 6 in the 5th inning of this elimination game, this winner take all . . . and Buster Posey, whose bat had been slumbering for a couple of days, hits the big fly! . . . and perhaps driving a stake through the heart of the Reds . . .*

Posey was as uncomplicated as ever in explaining it. "I told myself to see the ball," he said. "I got the barrel on it, and when you do that, good things happen."

For older Giants fans, its drama recalled Will Clark's grand slam off of Greg Maddux in Game 2 of the 1989 NLCS, the last postseason grand slam by a Giant. Except that wasn't an elimination game. For much older Giants fans, its drama recalled Chuck Hiller's grand slam at Yankee Stadium in Game 3 of the 1962 World Series, the only other Giants postseason grand slam. Except that wasn't an elimination game, either.

This was an elimination game, and a game that, if the Giants won, would enter the history books.

As such, the Reds fought to avoid ignominy. They finally got to Cain for three runs and had two runners on in the bottom of the 6th, with nobody out, after a Jay Bruce walk and Rolen single. While Giants fans pulled their hair out wondering why Bochy was sticking with a wobbling Cain, Baker tried a daring gambit. He sent the runners going on a full-count pitch to Hanigan. It would not work out.

Hanigan took a fastball on the outside corner for strike three, and Posey had so much time to throw out Bruce, he even hitched once before throwing a strike to Sandoval, who applied the tag. Baker had outfoxed himself, and the Giants were delighted.

But it was not over, not by a long shot. Though Cain stood to get the win

after 5⅔, it took George Kontos to get an out, Jeremy Affeldt to get three, Javier Lopez to get one, and Santiago Casilla to get one before Bochy asked Sergio Romo to come get the last four.

In the bottom of the 8th, the bearded closer faced pinch hitter Dioner Navarro with a 6–3 lead, and two runners on. Navarro hit a sinking liner to center field, full of portent.

Angel Pagan stared at the ball, charged, and made his dive.

When the Giants traded for Pagan on Dec. 7, 2011, sending Torres and reliever Ramon Ramirez to the Mets, they banked on a leadoff hitter and center fielder who could make the team better. They viewed Pagan as an upgrade offensively, defensively, and on the base paths, even though Torres performed beautifully in all three phases during the 2010 championship run. Some wondered if Pagan's nickname, "Crazy Horse," was a bit too literal—that the sometimes wayward Pagan missed cutoffs, or threw to the wrong base, or took the wrong angle. By October, Giants fans concurred that none of Pagan's ills trumped his 154 starts, .288 batting average, 29 steals, and franchise-record 15 triples.

It took until August for Bochy to settle on Pagan as his leadoff man for good. In 62 games, Bochy batted Pagan either fifth or sixth, but by August, he settled on the bearded 31-year-old with the intense eyes as his switch-hitting leadoff presence.

Pagan, perhaps motivated by a free agent contract in the winter, soared. In August alone, his 32 runs topped the National League, and Giants fans began to relish his military salutes to the dugout after reaching base.

Now he bore down on Navarro's sinking liner. If it fell and got past Pagan, two runs would score. If he caught it? Well . . .

Pagan dove and held his left hand, his glove hand, to the grass. As his glove's leather brushed the grass and as he slid to the turf, the baseball nestled into the pocket. A diving catch. A heroic out.

Pagan knew it. While his body was still spinning forward out of the catch, he threw a clenched right fist into the air as he spun upwards and to his feet. He had caught it, and sprinted to the dugout for a hero's welcome of high-fives and hugs. The Giants were three outs from history. Later, after the game, Pagan said: "I was going to block that ball with my teeth if I had to."

That the Reds scored in the ninth and brought the potential go-ahead run to the plate, that it took Romo to retire Jay Bruce in an epic twelve-pitch battle, then to strike out Scott Rolen on a hanging slider that Rolen simply missed, for the Giants to finish off their three-game slice of history was perfect. The team that had more guts than the other team was required to show as much until the end.

Romo was part of the "closer by committee" hierarchy Bochy installed in August, as the team searched for its bullpen identity without Brian Wilson. Romo now graduated to Bochy's closer. Six of his fourteen saves came in the final month, with more to come.

"The guy's got some stones," said George Kontos, of Romo staring down the Reds in the ninth. Posey went so far as to call the dozen-pitch encounter with Bruce "one of the best battles I've ever been a part of in my life."

The team sprayed champagne and laughed and danced, unaware how they did it, and yet aware how they did it, all at the same time. They were only a little over 48 hours removed from Hunter Pence—the "Reverend"—and his out-of-nowhere speech to the troops, imploring them to play for one more day. On the grease board in the visitor's clubhouse, Pence's words were inscribed: "Play for the man next to you."

Buster Posey smiled when asked about Pence. "Without his want and willpower," the guy who hit the grand slam said, "I'm not sure we would have done this."

National League Championship Series Game 5, Friday, October 19, 2012, St. Louis
Elimination Game 4
Giants 5, Cardinals 0

A week and a day had passed between that glorious afternoon in Cincinnati and a 51-degree night in Missouri, and so, too, seemingly, had passed the Giants' chances of another World Series run.

Though the wild-card St. Louis Cardinals came to San Francisco boasting only 88 wins and surrendering home field to the higher-seeded Giants, they also came with the idea of defending their 2011 World Series title, and with a cast-iron will that had fueled their recent triumph over the NL East champion Washington Nationals, including overcoming a 6–0

deficit in Washington, D.C., in the decisive Game 5.

History linked the Giants and Cardinals, too, both past and present. Cards manager Mike Matheny was a Willie Mac Award winner as a Giant, and Cards outfielder Carlos Beltran was Sabean's Giants' trade acquisition in 2011—a move that failed to net the Giants a playoff spot in defense of their 2010 Series title and cost them top pitching prospect Zack Wheeler, made more painful when the Giants and Beltran never found common ground in free agency. He landed in St. Louis and produced a 32 HR, 97 RBI season.

A deeper past bound these teams, too. Three times now in the last quarter century the Giants and Cardinals had tangled for the NL pennant. In 1987, Giants fans felt the sting of a blown 3-games-to-2 lead, losing Games 6 and 7 on the pale AstroTurf of Busch Stadium. In 2002, however, the Giants dealt the pain, knocking out Tony LaRussa's Cardinals in five quick but charged games.

Now the 2012 characters played out the drama, and unfortunately for the Giants, the color red dominated the script. The Cardinals cuffed around Madison Bumgarner in a 6–4 Game 1 win, leaving Bumgarner's October future in doubt. Though the Giants won Game 2 behind another epic performance from Ryan Vogelsong, the game was marked by Matt Holliday's late slide into Giants second baseman Marco Scutaro, an incident that loomed larger as the series wore on. In St. Louis for Game 3, amid 3 hours and 28 minutes of rain delays, the Giants stranded 11 runners and went 0-for-7 with runners in scoring position in a frustrating 3–1 loss. And when Bochy made the bold move to go with his new bullpen toy, Tim Lincecum, as the starter for Game 4, most Giants fans were thrilled with the prospect of a dominant Timmy guaranteeing a return trip to San Francisco. Instead, the Giants got "Bad Timmy." He didn't make it out of the 5th inning. Adam Wainwright proved the far better pitcher, and an 8–3 Cardinals win brought the Giants to a familiar place—on the brink of extinction, down 3 games to 1.

In the postgame meeting with the media, Bochy stuck with the theme. The Giants team that lost Brian Wilson and Freddy Sanchez to injury, that endured the seemingly crippling blow of losing Melky Cabrera to drug suspension, was a tough group. "The guys, they'll be out there fighting tomorrow," he said, almost wagging a finger. "That's not going to change. We've been through a lot this year. We've just got to come out and try to win the game tomorrow."

Giants broadcaster Kuiper used dark humor. In a postgame interview,

he shrugged at the odds, as if acknowledging the severity of the task somehow lessened it. "These guys play their best in elimination games," he said with a wry grin. "Bring 'em on, baby."

On the one hand, the idea of somehow eking out a Game 5 win and getting it back to San Francisco for Games 6 and 7, with Vogelsong and Cain starting, was enticing. On the other hand, the Cardinals owned momentum, and the Giants handed the ball to one of their most embattled, enigmatic figures:

Barry William Zito.

That Zito got the Game 5 start was entirely Bochy's call. The rotation called for Bumgarner to start, but the young lefty's two sketchy October starts had rattled the manager's confidence in him. He wanted Zito, a man who'd once been at the top of his profession, albeit years ago.

Many moons had passed since December 29, 2006, the day a 28-year-old Zito signed an eye-popping seven-year, $126 million contract to become the new "face of the franchise" in San Francisco. The signing signaled so much. The Giants' cross-Bay rival for fan and media attention, the Oakland A's, had lost their 2002 Cy Young Award winner and the man who out-pitched Twins' ace Johan Santana in Game 1 of the 2006 ALDS. Zito had gone 102–63 for the A's, made seven playoff starts in four different years and the All-Star roster thrice, and once, as a 22-year-old rookie, outpitched Roger Clemens at Yankee Stadium in October.

A Southern Californian for most of his life, Zito's laid-back ways were a perfect fit for the Bay Area, with light media scrutiny and surfable waves nearby. But somehow it all went wrong.

Whether because his fastball lost fuel as the years went by, or because he abandoned his trademark curve ball, or because his release point affected his accuracy or, more likely, because the yoke of the contract and attendant expectations wore down the psyche of a sensitive athlete, Zito came to represent the face of "free agent bust" signings. Despite his publicly even keel and his consistent health (he didn't miss a start until 2011), the numbers were stark entering the 2012 season. As a Giant, Zito was 43–61, with a 4.54 ERA. As an Athletic, in only one season did his ERA even top 3.86.

What could Giants management do, except trot Zito out every fifth day? They couldn't trade him. No team wanted that contract. He became, in the

plainest of terms, an $18 million-per-year No. 5 starter. Every time Giants fans looked at Zito, they saw an imaginary calendar over his head, counting down the days until his contract expired after the 2013 season.

Truthfully, the contract couldn't be considered crippling to the franchise, since the team won its first World Series title in San Francisco history in 2010 with Zito on the payroll. But a defining moment of that playoff run was Bochy's announcement that Zito would be left off the playoff roster. It was a massive embarrassment for the man. True to form, he handled it with calm grace. He even traveled with the team throughout October, and joined in on the celebration that legendary night, November 1, 2010, in Texas, when Tim Lincecum pitched the San Francisco Giants to their first World Series title.

Even the franchise winning an historic title didn't relieve the pressure on Zito. In spring training of 2012, his search for mechanics proved so arduous it lasted until the last day the Giants were in Scottsdale. Alex Pavlovic of the Bay Area News Group reported the sight of pitching coach Dave Righetti, in slacks, dress shirt, and shoes, ready to board the plane home, still studying Zito's delivery on the mound even as the Giants broke camp.

And then came April 9, 2012.

The Giants opened their 162-game schedule the victims of a sloppy, dis-appointing sweep at the hands of the host Arizona Diamondbacks. They made six errors, saw Lincecum have a lousy opener, and blew a 6–0 lead in the finale. They arrived in Colorado for the Rockies home opener, and gave the ball to Zito.

He responded with a work of art: a 114-pitch, complete-game shutout, allowing just four hits, walking none, and whiffing four. The Giants won, 7–0. It was Zito's first complete game shutout since 2003. Giants fans were stunned and delighted, the first real blast of positivity in the young season. Zito carried it through April with a 1.67 ERA, and while he eventually saw his ERA finish up at 4.15—same as it was in 2010—a combination of better run support and more consistent pitching saw Zito notch his first winning record as a Giant, a remarkable 15–8.

More important, as opposed to 2010 when his failed attempt to clinch the NL West in Game 161 sealed his post-season fate, Zito came up big late in the year. He beat the playoff-bound Cardinals and Braves in August, and won the critical rubber game from the Dodgers, 4–0, in the Sunday night, September 9 game that extended the Giants' NL West lead to 5½ games. That night, he pitched into the 7th inning and left to raucous chants not

heard in years down in McCovey Cove: "BAR-RY! BAR-RY!"

The Giants won the last eleven games Zito started. Giants fans wanted to love Barry Zito. Now, he was giving them the chance.

And here he was in St. Louis, in Game 5 of the NLCS, with the ultimate opportunity.

Truthfully, most Giants fans knew the situation was dire. Despite the idea that a fan should never give up on his or her team, Zito's career ERA of 8.20 in Busch Stadium loomed over the scene like a zeppelin. Perhaps it was because of that very notion—that the Giants had no chance, none at all—that the movement started on social media that Friday morning took hold. After all, if you're going to go down, Giants fans seemed to be saying, you might as well go down guns blazing.

So, on Twitter, where so many Giants fans interacted throughout the season in a sort of virtual sports bar, the hashtag #RallyZito began to circulate.

Giants fans changed their avatars to images of Zito: Zito in throwing motion, Zito playing guitar, Zito's wedding photos, Zito on a unicorn, Zito posing for designer jeans near the Golden Gate Bridge. There was a devil-may-care humor to the movement, but at the core, an organic energy, almost a crazed belief, took hold. People checked their timelines to see the latest. People kept posting the hashtag.

#RallyZito.

It started to trend . . . worldwide. True story.

Who knows what sort of particles gather to create such unlikely sports stories? Surely, Zito's performance that night had nothing to do with energy created by the fans. Or, are we so sure?

When Pablo Sandoval sprinted, dived, and speared Allen Craig's foul liner to end the first inning scoreless, Zito had his first defensive gem behind him. What happened after that, though, was pure Zito.

In the bottom of the 2nd, Yadier Molina singled, and David Freese doubled to right field. The Cardinals had runners at second and third, with nobody out. The Giants' season began to teeter. Zito faced Cards second baseman Daniel Descalso.

In what could easily be interpreted as one of the most important at-bats of Zito's career, he worked the count to 2–2 with sliders and curves, then

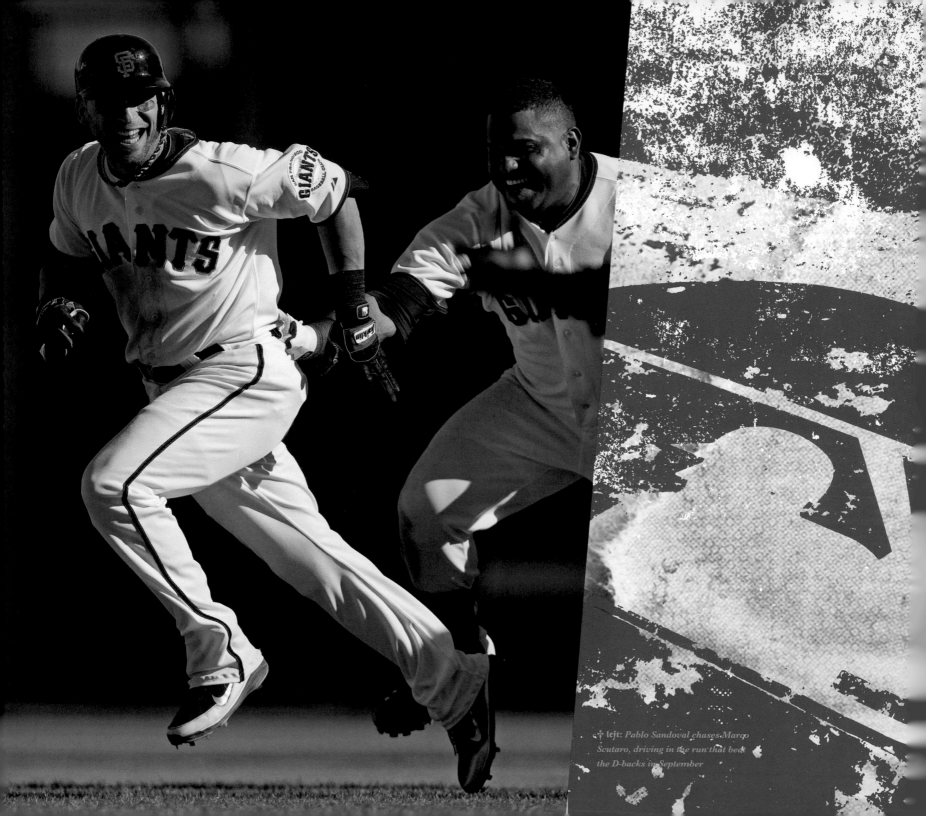

✦ left: *Pablo Sandoval chases Marco Scutaro, driving in the run that beat the D-backs in September*

stunned Descalso with a shoulder-high, 84-mph fastball that looked too good to lay off. Descalso was tied up in guessing what Zito would throw. He wasn't ready for it. He swung and missed, and Zito had a gigantic out.

It was a no-brainer to intentionally walk shortstop Pete Kozma to load the bases for pitcher Lance Lynn, a career .056 hitter. The scene played out beautifully. Lynn hit a broken-bat ground ball directly to the shortstop Crawford, who relayed it to Scutaro at second, and over to Brandon Belt at first base. Double play.

Incredibly, Zito escaped the jam without being scored on.

#RallyZito, indeed.

That Zito later contributed an RBI bunt single—his own decision, and his first ever bunt hit, his first ever post-season hit and RBI—made it even richer. He joked that Brian Wilson told him he showed off his "Arabian horse gallop" in legging out the bunt.

He pitched and he pitched and he pitched—fanning Matt Holliday on a full-count fastball in the 3rd; inducing a weak tapper to third on a breaking ball to John Jay to end the 5th; striking out Beltran himself with an 84-mph fastball in the 6th; then deploying that snappy curve ball to induce a swinging strikeout from Skip Schumaker to start the 8th—until he coaxed Beltran to fly out in the 8th with a man on. That made for 7⅔ shutout innings, and 115 pitches, and Bochy decided that was a fine evening's work. He came out to remove Zito.

As Bochy headed to the mound, Zito's teammates gathered around him. Individually, each reached out to touch him, affirm their appreciation. FOX cameras caught Posey taking his bare hand and tapping Zito twice on the chest, near the heart.

The Giants won, 4–0, and saved their season. Zito saved the season.

His effort had Giants fans agog. Some gave standing ovations in their living rooms. If Zito's six-year odyssey as a Giant led to that moment, well, then, many fans thought, it's all been worth it. The NLCS was headed back to San Francisco for Game 6.

How Zito channeled that Cy Young–era precision at the most important time is the stuff that makes sports so delicious. Who could have predicted Zito mesmerizing the Cardinals, who ached to win their second consecutive pennant right there in front of their red-clad fans?

"He was pitching," Matheny marveled. "He was raising the eye level . . . he was moving in and out, back and forth. He was taking speeds off his breaking balls and changeups. That's what pitching is."

Bochy, Zito's only manager in San Francisco, knew the history.

"He's been through a lot," Bochy said. "But this guy, he's some kind of tough. He put on a show."

Zito added to the memory of the evening by appearing in front of the media wearing a stylish fedora, something either former New York Knick Walt (Clyde) Frazier or fictional boxer Rocky (The Italian Stallion) Balboa would have worn in the 1970s. He acknowledged it was a "huge blow personally" to be left off the 2010 playoff roster, but said: "You've got to be professional. You can't pout."

He added: "This is definitely it for me . . . coming here, doing it in a Giants uniform."

They'd now won thirteen consecutive games in which Barry Zito started, and four consecutive elimination games on the road. It was time to play one at home.

NLCS Game 6, Sunday, October 21, 2012, San Francisco, Elimination Game 5
Giants 6, Cardinals 1

Playing a fifth elimination game in ten days? Shoot, old hat for these Giants. On a lovely Sunday 62-degree late afternoon in San Francisco, the Cardinals had no chance in this one.

They were walking into a Vogelsong start, and if his seething energy wasn't enough to control the game, 43,070 Giants fans who wanted, needed, had to unleash vocal affection for their heroes who'd refused to expire made sure they'd count, too. Metallica's James Hetfield, a Giants fan, who'd asked to start the game with a ceremonial, celebrity announcement of "Play ball!"—set the tone early.

Hetfield channeled heavy-metal energy on the crowd. "Are you ready," he shouted, "TO KICK SOME CARDINALS ASS??"

The crowd, suffused with the passion of those who have nothing left to lose, roared. The Cardinals watched from the visitor's dugout. One wondered if

some headed to the clubhouse to delete Metallica from their iPods.

Completely amped, Vogelsong pumped 94-mph fastball after 94-mph fastball to start the game. Posey saw no reason to call anything else. Vogelsong struck out the side in the top of the 1st. The stands nearly shook from the noise. "Vo-gey! Vo-gey!" they chanted, and Vogelsong, famous for his game-day recalcitrance, never changed expression.

The Cardinals thought veteran righthander Chris Carpenter could be their rock, but the Giants had already beaten Carpenter. That was in Game 2, the game in which Holliday took out Scutaro in a slide that, as the series wore on, only seemed to inject more and more tenacity and resistance in the second baseman, who was having a monster series. Scutaro had seven hits in sixteen at-bats since Holliday's slide, and, more important, hadn't missed an inning when the original contact suggested he might be out for some time.

The slide had forced both fan bases to take sides. To Cardinals fans, Holliday was playing hardball—honoring an age-old tradition of trying to break up a double play when he dove at Scutaro's knee in the first inning of Game 2. To Giants fans, the sight of the six-foot-four, 235-pound player once recruited to play football at Oklahoma State hurtling his body at Scutaro's lower extremities was, at best, a gray area of baseball ethics, and at worst, a deliberate attempt to injure a star player. Krukow had a word for it. "Bush," he spat on his KNBR radio appearance.

Besides, when it came to Scutaro, protective instincts came easy. Giants fans were two months into an intense love affair. The 36-year-old Venezuelan was a big trade pickup by Sabean on July 27, when he shipped prospect Charlie Culberson to the Colorado Rockies. The well-traveled Scutaro—the Giants were his sixth team, including four productive years with the Oakland A's from 2004 to 2007—in the short term could play third base while Sandoval sat out his second significant injury of the season. When Sandoval returned, Scutaro could, in the eyes of Sabean and Bochy, nudge out the effective but less talented Ryan Theriot at second base.

Sabean knew Scutaro's style. He cited Scutaro's versatility, and the depth he'd add to the team. "Look at the Dodgers bench," Sabean said, "and look at our bench."

Sabean dropped the magic "D-word" in his answer purposefully. The Dodgers were the Giants' primary adversary in the 2012 chase for the West.

Though they'd the missed the playoffs in 2010 (80 wins) and 2011 (82 wins), the Dodgers returned to the scene. It wasn't a huge surprise. Clayton Kershaw, the 2011 Cy Young Award winner, owned one of the best arms in baseball, and many observers felt their center fielder, Matt Kemp, might be the best all-around player in the game. And as of May, the Dodgers were under new ownership. Mark Walter of Chicago-based Guggenheim Financial, with L.A. Lakers legend Magic Johnson as part of his investment group, paid a record $2.1 billion for the team, and immediately sent a signal that the deep-pocketed Dodgers were intent on building a huge-money franchise, the Yankees West as it were. The Dodgers, under penurious owner Frank McCourt, only spent $95 million on payroll in 2012, compared to the Giants' $117 million.

That number would soon go north in L.A. The first punch landed when the Dodgers traded for the Miami Marlins' mercurial but talented infielder Hanley Ramirez on July 25. Giants fans grew uneasy. Known to be a player who turned his talents on and off at his pleasure, Ramirez looked to be the kind of force energized by the bright lights of Hollywood. Joined with Kemp and Andre Ethier in the middle of the Dodgers order, L.A.'s lineup looked fierce. Three games behind the Giants on Friday night, July 27, the Dodgers rejoiced when Ramirez swung at a Sergio Romo tenth-inning slider. He parked it, a dramatic home run in the Giants' own yard for a 5–3 win. Adding to the pain, Ramirez made a flashy hand gesture of goggles over his eyes rounding second base—something he called "Lo Viste" (Spanish for "Did you see that?")—to celebrate the move. Giants fans saw it, and seethed. And worried.

That night, the Giants announced the trade for Scutaro. The next day, the Giants lost again, 10–0. The Dodgers were one game back. On KNBR, Giants' weekend radio voice Marty Lurie fielded calls from irate fans unsatisfied by the Giants' answer to the Ramirez trade. One howled in discontent: "They have Murderer's Row, and we have Scutaro!"

As was often the case in his GM tenure since 1997, Sabean knew time and experience were on his side, even against his many critics he once dubbed "The Lunatic Fringe." Even though the Dodgers finished the sweep of the Giants and caught San Francisco in a tie on July 29, Sabean placed faith in his pitching staff, his bullpen, the acquisition of Pence two days later, and Scutaro's indispensable professionalism.

Scutaro made 27 starts in the Giants' 18–11 August, and hit .314 with 18 RBIs. If Giants fans thought that too good to be true, he made 25 starts in

their 19–8 September and hit a remarkable .401, with 21 RBIs.

The Dodgers threw even more ammunition at the Giants, acquiring a whopping $260 million of payroll in a huge trade with the Boston Red Sox on August 25. Coming to Los Angeles were three-time All-Star and two-time World Series champion pitcher Josh Beckett, and four-time All-Star first baseman Adrian Gonzalez, among others. Outrageous in its boldness, audacious in its cost, the trade was damn near just short of an act of war against the Giants, and defined the old baseball term "blockbuster."

The Giants shrugged, took two of three from L.A. September 7th and 9th, and clinched the West on Sept. 22. Inside the Giants clubhouse, Scutaro took on a new nickname from gleeful teammates: "Blockbuster."

Scutaro's response to the Holliday slide exemplified what the Giants loved about him: an enduring toughness backed up by fundamentally sound baseball. And, of course, the recurring ability to stay calm at critical moments, to shorten his swing and stay up the middle or go to the right side in key at-bats. Scutaro's hand-eye coordination, combined with his acumen, produced a jaw-dropping statistic: He'd swung and missed at only 5.6 percent of pitches in 2012, the best contact rate in the big leagues.

His reaction to the Holliday slide was wary. Despite absorbing the blow in Game 2, he refused to leave the game and wound up going 2-for-3 with two RBIs in the 7–1 win. The teams traveled to St. Louis, and Scutaro's availability was in question until the day of Game 3. Asked about the play, Scutaro called the slide "kind of late" and described it as "all of a sudden, I saw this train coming." He joked with reporters who asked what he'd do if he saw Holliday at Busch Stadium: "I might kick his ass."

Perhaps the most stark statement of Scutaro's toughness was that he was still playing when Game 6 came back to San Francisco, while Holliday asked out of Matheny's Game 6 lineup with a stiff back.

Scutaro drew a first inning walk off Carpenter, moved to third on a Sandoval double, and scored the game's first run on a Posey ground out. The crowd made thunderous noise for what it perceived as an inevitable win, and by the second inning, the Giants made sure of it.

Ahead 2–0 after Brandon Belt tripled and scored, the Giants had two runners on—including Vogelsong, who'd reached on a fake-bunt-full-swing infield single. And here came Scutaro, in the late October shadows.

Carpenter's 1–1 pitch came in on the inside part of the plate, and Scutaro,

with that compact swing, laid the barrel on it. The baseball rocketed into left field's open grass between the foul line and left fielder Allen Craig. It rolled all the way to the wall as both runners scored. The park turned orange with the sight of rally towels waving exultantly. Scutaro pulled into second base and, uncharacteristically for a player of few emotions, went into a deep knee bend and pointed both fists out, toward his teammates in the dugout. He clenched his right fist and pounded it into his left, three times. In the KNBR radio booth, Jon Miller marveled.

"Scutaro is uncanny," Miller said. "He does it again and again and again and again . . ."

The Giants led, 4–0. Vogelsong wasn't about to let that lead evaporate. The energy in the ballpark washed over him, and after seven innings of nine-strikeout ball, he said: "I didn't want to let these guys down. I didn't want to let this city down."

The Giants won their fifth consecutive elimination game. Only the 1985 Kansas City Royals had ever won six consecutive elimination games, en route to their World Series title. But the Royals didn't win three straight on the road. The Giants did. Their chance at six consecutive was waiting Monday night, back at AT&T Park, with Matt Cain taking on Kyle Lohse. The fans who poured out into the streets around King Street on Sunday night seemed ready to camp out, if need be, for Game 7.

Inside the clubhouse, Scutaro pondered the doorstep of his first World Series. Asked how it felt to be one win away, the trade pickup who wasn't named Hanley Ramirez or Josh Beckett or Adrian Gonzalez took it all in.

"For me," he said, "that's priceless."

NLCS Game 7, Monday, October 22, 2012, San Francisco, Elimination Game 6
Giants 9, Cardinals 0

One hundred and thirty years of Giants baseball, dating back to the days when Ulysses S. Grant saw them at the Polo Grounds, through the days of Mel Ott's 22 years and 511 home runs as a Giant, through Willie Mays' 1954 World Series championship, through Willie McCovey's 1969 NL MVP campaign, through Barry Bonds' five MVPs in black and orange, through a 2010 season that brought the first World Series to the City by the Bay . . . and the Giants had never won a playoff Game 7.

Ever.

You didn't have to tell fans who remembered the pain of McCovey's line-out to Bobby Richardson in Game 7 of the 1962 World Series, or the fans who remembered the pain of Jose Oquéndo taking Atlee Hammaker deep in Game 7 of the 1987 NLCS, or the thunderous sound of inflated Rally Stix and the sight of a jumping "rally monkey" in Orange County in Game 7 of the 2002 World Series.

When Cain struck out Cardinals' leadoff man, Jon Jay, to start Game 7 of the 2012 NLCS, the Giants' sixth consecutive dance with death had begun, and the franchise took aim at history.

Not to suggest that the 1962 team, laden with Hall of Famers Mays, McCovey, Juan Marichal, and Orlando Cepeda, lacked wherewithal. Not to suggest that the 1987 team, fueled by all-time fan favorite Will Clark, lacked it, either. And not to suggest that the 2002 team, with MVPs Bonds and Jeff Kent, didn't have what it takes.

But if any team was going to become the first Game 7 winner in Giants history, perhaps it had to be the bunch who began each elimination game with a pagan ritual to the baseball gods. Pence led the team in the "Slow Clap" again before Game 7, and by now, dugout cut-up Theriot added props to the shenanigans. While Pence bounced in the middle of the dugout circle, Theriot showered the group with bubblegum and sunflower seeds, tossing them so high they spilled over to the dugout roof.

It became a shower of seeds, and when Pence put his hands in the air to dance under the sprinkling, it seemed a religious ceremony, an appeasement to the baseball gods.

Plus, it was working.

All the evidence needed came in the bottom of the 3rd, when the Giants looked to add to a 2–0 lead with the bases loaded and Pence at the plate. To the naked eye, Cardinals reliever Joe Kelly threw and Pence swung, hitting a knuckleball toward shortstop. Pete Kozma read the ball hooking to his right, and stepped right. Incredibly, almost impossibly, the ball then sliced away from Kozma, past him, into left field. When Jay overran the squirrelly baseball, the bases were clear. Three runs had scored, it was 5–0 Giants, and AT&T rattled with the sound of history.

Only when FOX's super-slow-motion camera broke it down frame-by-frame did the evidence present itself: Pence's bat had shattered upon contact with the 94-mph inside fastball, and the baseball had bounced off the breaking bat not once, not twice, but three times, producing its crazy spin.

"Very unusual," is how Matheny termed it.

"You know baseball," Pence said. "You can't explain it even if you play."

The heavenly work of baseball gods was one thing. Great baseball was another.

Pence's heroism only put the game on ice because one inning earlier, a rookie shortstop had made the play of the game. With runners at second and third in the top of the 2nd inning, Lohse came to bat against Cain, trailing 1–0. A career .153 hitter, Lohse was a decent hitter for a pitcher, and showed as much when he made contact with a Cain pitch and sent it toward left field. At shortstop, Brandon Crawford eyed it, and leaped.

Of all the 2012 Giants, none had a hometown tale like the 25-year-old, shaggy-haired shortstop. Crawford grew up in the Bay Area, a Giants fan since childhood. His parents owned season tickets at Candlestick Park. A brick outside of AT&T Park, laid in the ground in 2000 when Crawford was a 13-year-old kid in Pleasanton, has each Crawford family member's name, including Brandon's. His Giants roots stretched back so far he names 1990s shortstop Royce Clayton as his playing idol.

And on top of that, the San Francisco Chronicle unearthed a classic photo to run with a column on Monday, October 8, showing a five-year-old Crawford at the Giants' final home game of the 1992 season. That wasn't just any home finale. It was, at the time, believed to be the team's last game in San Francisco, pending a sale of the club to Tampa. Crawford is pictured with a backward Giants cap and an innocent expression, hanging over the metal bars that marked the front row at Candlestick Park. His father has a sign, on orange construction paper, addressing then NL President Bill White: "Mr. White. Do What's Right. Keep Giants in SF."

If you wanted Giants street cred, Crawford's life story epitomized it.

The Giants loved his glove coming out of UCLA, and used the 117th pick in the 2008 draft to make Crawford a fourth-round pick. When he took the field for Game 7 of the NLCS, he was one of two Giants from that draft. A kid named Posey was the fifth overall pick of the first round that year.

Called up to the big club for fourteen games in 2011, Crawford finally won over team brass in the spring of 2012. The club named him the Giants' starting shortstop, even though his bat was believed to be less than steady. Bochy took pressure off Crawford by saying he'd be happy if the kid hit .240, in exchange for that magical glove, the one that was featured in YouTube videos of fielding excellence. Bochy went so far as to call Crawford the best defensive shortstop he'd managed as a Giant.

Crawford promptly went out—and flopped. He made three errors in the Giants' year-opening sweep at the hands of the Diamondbacks. He made 12 errors in his first 60 games. Fans howled for Arias to play more. If Crawford couldn't field, they wondered, what good was he—especially as his batting average fell to .219 at the end of May.

Bochy owned a well-earned reputation as a manager who favored veterans over young players through the years, but in this case, he stood by Crawford. In a show of faith, the Giants never demoted Crawford, nor did they trade for a veteran shortstop. Instead, Crawford's game steadied. He flourished at shortstop as the summer wore on, and the team began to rally around his defense, particularly a batch of grateful pitchers. Crawford only made six errors in the Giants' next 102 games.

He surged at the plate, too, hitting .288 in August, .281 in September. In short, he became, at age 25, the reliable everyday shortstop for his childhood team, with a growing fan base in his hometown.

But now, as Lohse swung and blooped a ball that appeared to be over his head, Crawford had to make good. Using the innate athleticism Giants fans had come to enjoy, Crawford timed his leap, and at its apex, secured Lohse's line drive in the webbing of his glove, even as Cardinals broadcaster Mike Shannon on KMOX shouted, "Base hit!" then "No!"

Cards catcher Yadier Molina, running toward home plate from third base, jumped in frustration twice, turning his head away in anger. Cain walked off the mound with his right fist clenched. Giants fans embraced in the stands, and cheered Crawford as he walked back to the dugout. The kid was having a hell of an October, including his clutch two-run single in Zito's Game 5 win in St. Louis. Crawford later said he knew he needed to make that catch, so he did.

"Growing up a Giants fan," he said, "this is a dream come true."

As darkness fell, and as the Giants extended their lead to 9–0, the party among the 43,056 took on cathartic tones. The bleachers used the final few innings to serenade the villain Holliday with the sing-song "Hollllidaaaaaay, Holllllidaaaay . . ." Cain even hit Holliday with a pitch, possibly as an act of revenge for Scutaro. The fans danced to Otis Day and the Knights' "Shout," popping their orange rally towels in the air at the chorus. They swayed and sang the Giants' 8th-inning victory song, "Lights" by Journey, belting out the lines: "When the lights / Go down in the cityyyyy . . ." And, of course, they danced "Gangnam Style" to the hit-of-the-moment song by the Korean rapper Psy.

By the ninth inning, things veered toward the surreal. An unusual October rain front moved into China Basin, and began to pour buckets. By continuing play amid the heavy rain, the umpiring crew acknowledged that only three outs remained in a game all but decided. Problem was, the rain wouldn't let up. Puddles formed on the infield, a sign to stop play. But the umpires knew the rain front was in for the night, and if they stopped play in the ninth, it likely would not resume. They couldn't call the game, because postseason baseball is played until the 27th out.

The fans took the rain as a sign. It was a cleansing wash, a liberating wash. Gone were the demons of any Games 7 past. The harder it rained, in fact, the louder the fans cheered. The decibels grew as the skies opened, an unforgettable moment in the park's history.

At second base, Scutaro, a week shy of his 37th birthday, realized he was headed to his first World Series. FOX cameras caught him tilting his head back in the rain, letting it smack him in the face. He spread his arms wide and opened his mouth to catch some rain in an act of baseball communion. Movie fans likened it to Tim Robbins' character in *Shawshank Redemption* tasting nature as a free man after a prison escape.

Finally, in impossible conditions, Sergio Romo induced a pop up off the soaked bat of Holliday. As if directed by the deities served by Pence's dugout dance, it headed to Scutaro. Through the raindrops, the man who tied an LCS record with 14 hits, the player who would be named NLCS MVP, the man thought badly injured by Holliday's slide, gloved the last out.

The Giants won their record-tying sixth consecutive elimination game, and were National League champions for the fifth time since moving to San Francisco in 1958.

Almost every fan, soaked to the bone in dripping-wet Giants hats, stayed to cheer and cheer and cheer. The team took off on a victory lap around the

park, slapping hands with fans leaning over railings. Pagan carried a Giants flag in military style, befitting the man who saluted after every key hit.

The 2010 Giants had clinched each of its series—the NLDS in Atlanta, the NLCS in Philadelphia, the World Series in Texas—away from home. The 2012 Giants wove their Game 5 NLDS magic in Cincinnati. So this, in the downpour, was the first chance the team, in this newfound era of success, this Bruce Bochy/Buster Posey era, had to celebrate with the fans at home. And celebrate they did, refusing to leave the field, which now looked like a swamp under the bright stadium lights.

"We did what they would say is the impossible," said reliever Jeremy Affeldt. "And to have these fans behind us . . . this city is an awesome city, and I'm so glad we got to do it in front of them."

As Bochy and Sabean accepted the National League trophy on a podium behind second base, Romo spoke nearby.

"This is a never-say-die team," he said as the rain continued to fall. "We don't want to go home yet. We're not done yet."

World Series Game 1, Wednesday, October 24, 2012, San Francisco
Giants 8, Tigers 3

Giants fans were still drying their clothes from Monday's spiritual gully washer when the World Series began two days later. By this point, adrenaline was the fans' and the team's only fuel. Only thirteen days had passed since Posey's grand slam in Cincinnati lifted them both; less than a week had passed since Zito saved the season in unlikely, heroic fashion. If winning a second World Series in three years meant reaching deep for something, so be it. Some 42,855 fans, once again armed with the autumn colors of orange rally towels, poured into AT&T Park, ready for anything.

So much seemed familiar from two years ago. The Giants, again by virtue of the National League winning the All-Star Game—which boasted four Giants on the starting roster, including winning pitcher Matt Cain—owned home field advantage in the Series. In 2010, the Giants had hosted the Texas Rangers because the NL had won on a Brian McCann All-Star Game RBI, and it was sometimes joked the Braves' catcher deserved a World Series share from the Giants. Now, in 2012, home field was the Giants' because

Melky Cabrera dominated the All-Star Game as MVP. If that formed an awkward bit of explaining, the Giants and fans didn't care. They just wanted Games 1 and 2 at home, and a possible Game 6 or 7 at home, too.

Also familiar was the public perception of the matchup. Two years ago, the AL champ Texas Rangers arrived in San Francisco with a band of sluggers and perhaps October's finest pitcher, Cliff Lee. Odds makers in Las Vegas immediately installed Texas as favorites. The Giants beat Cliff Lee twice, silenced Texas' big bats, and won the Series.

In 2012, the Tigers arrived in town with a band of sluggers—headlined by baseball's first Triple Crown winner since 1967, the great Miguel Cabrera—and arguably the game's finest pitcher, the reigning AL MVP and Cy Young winner, Justin Verlander. Though Detroit only won 88 games in squeaking out the AL Central over the rival Chicago White Sox, they beat back the force of energy that was the AL West champion Oakland A's in five games in the ALDS, then obliterated the big-money New York Yankees in an ALCS sweep. Vegas installed the Tigers as favorites to win the World Series.

One fact lingered in the Giants' favor. Three times in the last 25 years had a team played a seven-game League Championship Series, then faced a team in the World Series that had swept its LCS and had to wait a week. Each time—the 1988 Dodgers, the 2006 Cardinals, and the 2007 Red Sox—the team that played the seven-game LCS beat the overly rested opponent.

Still, the Vegas money went Detroit's way. Accentuating the Giants' status as Game 1 underdogs, Bochy announced he'd go with Barry Zito in the opener. Giants fans were still ecstatic over Zito's work in Game 5 of the NLCS in St. Louis. And, of course, the team had won thirteen consecutive games started by Zito. Still, the idea of Zito, whose top-end fastball usually hit 85 mph and whose career in San Francisco was checkered with disappointment, versus Verlander, a superstar who often hit 100 mph in his later innings, looked a mismatch at best. But third base coach Tim Flannery and Sabean adopted the mantra that the Giants were "cockroaches" who couldn't be killed. If it meant using slingshots and rocks, said Flannery, the Giants would still come at you.

Pablo Sandoval dug into the batter's box in the bottom of the first, armed with more than a slingshot and a rock. He dug in, about to make history.

At age 26, the portly Venezuelan had already compiled a career's worth of ups and downs as a Giant. Sandoval had raced through the Giants farm

REDS
CARDS &
TIGERS
OH MY!!!

501

No Smoking
No Alcohol

system after signing at age 17, and by 2008 took his first big-league at-bats at age 21. In 2009, when the Giants sowed the seeds of the homegrown talent that launched this multi-Series run, Sandoval arrived in full force. He displayed crazy good hand-eye coordination, hit baseballs pitched anywhere in and out of the strike zone, and hit .330 with 25 home runs. Perhaps just as important for his image, he landed the nickname "Kung Fu Panda," bestowed upon him by Zito, who thought the upbeat, almost goofy manner in which the heavyset Sandoval approached life mirrored a physical and behavioral similarity to the cartoon movie character.

As nicknames go, it was about as big a hit as any in Giants history since Will (The Thrill) Clark. Clark's name proved key in any discussions of Sandoval as well. Fans had to go as far back as Clark and his teammate Matt Williams to find a time the Giants developed a homegrown bat this good. Panda hats soon dotted AT&T Park, and became a symbol of Giants fandom.

But in 2010, weight issues plagued Sandoval. Management scowled as Sandoval gained pounds and dropped points in his batting average—62, to be precise, hitting just .268 with only 13 home runs in the 2010 season. While 2010 would take its place next to the 1981 49ers as one of the most joyous and historic sports seasons in the history of The City, Sandoval's story was the black sheep. He lost his third base job to Juan Uribe, and took only three hitless at-bats in the Series win over Texas.

A public weight-loss program dominated Sandoval's off-season, with TV cameras following his runs up Camelback Mountain in Scottsdale, Arizona. Things got better in 2011, when a noticeably thinner Sandoval hit .315 and earned enough respect back from Bochy that the manager named him a National League All-Star with one of his manager's picks. Bochy made the selection despite Sandoval suffering a broken hamate bone in his right wrist that caused him to miss the entire month of May, and play in only 117 games.

When the 2012 season arrived, fans grumbled that the Panda appeared to have put his weight back on. Though he was hitting .316 on May 2, more bad news came—Sandoval broke a hamate bone again, in his left wrist this time, and would miss another five weeks. That wasn't all. Playing first base in a July 24 game against the Padres, Sandoval had stretched to complete a double play, and strained his hamstring. Back to the disabled list went the Panda, and fans wondered if he and his then .299 batting average were doomed to a career of fits and starts, injuries, and battles with physical

conditioning. The injury proved a blessing in disguise in one respect: Sandoval's absence hastened Sabean's move for Scutaro, who played third base until the Panda returned.

And return he did, though not at the level the team wanted. A .211 August caused Bochy to tell reporters he'd sit Sandoval for a couple of games in September, to try to get him right. The Panda finished his year with a disappointing .283 batting average, only 12 home runs, and just 63 RBIs. A large bright spot, however, dominated Sandoval's season: Fans voted him to start the All-Star Game in July, though he'd only played 45 first-half games. While it proved a joyous occasion for Giants fans who exulted in their ballot-box power, some around the country questioned the wisdom of voting him into the third base spot ahead of New York Mets third baseman David Wright, who owned superior statistics. Mets GM Sandy Alderson, never one to shy from an opinion, sent out a snarky tweet tweaking Giants fans: *ASG election of "Kung Fu Panda" shows value of a cute nickname. Surprised Giants fans didn't elect a "ball dude" to start at 3B.* Ouch!

Baseball is an unpredictable sport, however. So when Sandoval took his first at-bat on July 10 in the All-Star Game at Kansas City, he did so against the AL starter, Detroit Tigers fireballer Justin Verlander. He did so with the bases loaded, too. And on a 1–1 pitch, Verlander offered a curve ball, a nicely breaking one. But Sandoval kept his head on it and hammered the baseball. It soared down the right field line and bounced high off the wall, bounding toward open grass. The bases cleared, Sandoval pulled into third, clapping his hands, with a three-run triple off the mighty Verlander.

Now, three months and two weeks later, in Game 1 of the World Series, the same matchup loomed: Verlander vs. the Panda.

With two outs and nobody on, Verlander got ahead, 0–2. He was one pitch away from a 1-2-3 first inning, and a marking of territory. Verlander and his catcher, Alex Avila, agreed on Verlander's calling card: high heat. He unleashed a 95-mph fastball. Sandoval took stock of the chest-high offering, and unleashed the virtues that sustained his career through weight issues and injury issues: his natural and incomparable hand-eye coordination and bat speed.

The force with which Sandoval made contact sent the ball on a line drive toward the deepest part of AT&T Park, right-center field. Thousands of well-struck pitches had died as outs in that part of the cavernous yard over the years, but not this one. This one was special. It didn't stop until it had sped into the front row of the bleachers, and the World Series had changed.

The Panda had gone yard, off Verlander, off the fastball. The Giants led, 1–0. AT&T Park went bananas.

The trajectory and force of the home run called to mind the home runs hit by Barry Bonds in his prime, and the best part was that Sandoval was only starting his historic day. In the third inning, the Giants led, 2–0, with Scutaro on first and Sandoval in the batter's box. The park rocked with noise after Scutaro had knocked in Pagan, who'd reached base on a ground ball that kicked off the third base bag for a magical double. Now, with the Panda working a 2–0 count on Verlander, something happened that even further changed the nature of the Series: Tigers pitching coach Jeff Jones popped out of the dugout and scampered to the mound.

Giants fans, hopped up on adrenaline after Sunday night's Game 6 win and Monday night's rain-soaked Game 7 catharsis, roared louder and louder as Jones approached the mound. They knew what it meant, that the struggles of the Tigers' impenetrable ace had caused worry in Detroit's first-base dugout. The noise that accompanied Jones's trot to the mound called to mind a crowd at a boxing match sensing a knockout, raising its decibel level. And it spoke to the savvy and passion of the Giants' home crowd, a theme consistently raised by out-of-town observers, that something different happened on the shores of McCovey Cove: Fans connected to the baseball team on a primal level. Dodgers manager Don Mattingly noticed it during the year, calling Giants crowds "the rowdiest ballpark on the West Coast . . . just different."

Cameras caught Verlander shaking his head at Jones, as if suggesting his talents were so supreme a coaching visit was pure folly. Whatever transpired between Verlander and Jones didn't work. The pitcher's next offering was a 95-mph fastball that painted the outside corner of the plate. Sandoval swung, and laid the barrel of the bat on the baseball.

It flew to left field—and kept flying. The opposite-field home run landed in the front row of the left field bleachers and the park rattled with noise as Scutaro and Sandoval scored to make it 4–0, Giants, on the Panda's second home run in as many at-bats. Verlander stood off the mound and mouthed one word: "Wow."

In the KNBR broadcast booth, Duane Kuiper, assessing Sandoval's All-Star-game triple and two home runs off of Verlander in only three career at-bats, said: "I think we know who has 'ownage' on Verlander." Added Krukow next to him: "Another strongman homer!"

When Danny Worth was announced as a pinch-hitter for Verlander in the top of the 5th, Giants fans cheered the cheer of the victor. Verlander was out. The team had slain the beast—and in only four innings, too. Their minds flashed back to Game 1 of the 2010 World Series, when the Giants knocked out Texas ace Cliff Lee in 4⅔ innings en route to a Game 1 win.

And the Panda wasn't finished.

In the bottom of the 5th, Tigers manager Jim Leyland went with reliever Al Albuquerque. With one out, Sandoval came to bat. The count was 1–1 when Albuquerque threw a curve ball, dipping below Sandoval's knees, reminiscent of the All-Star Game curve ball thrown by Verlander. As if possessed by destiny, Sandoval again kept his head down, focused, and lashed his wood across the plate.

The baseball took off, yet again.

It traveled to straightaway center field this time, bounding off the green facing behind the center field fence. Austin Jackson, Detroit's center fielder, could only look up at home run number three for Sandoval—and baseball history.

As the Panda rounded the bases, he'd joined the most exclusive of clubs—players who'd hit three home runs in one World Series game. Albert Pujols did it in 2011. Reggie Jackson did it in 1977. Babe Ruth did it, twice, in 1926 and 1928.

In the Giants broadcast booth, Jon Miller cried out: "And Pablo Sandoval looks like the Babe himself has come back to life!"

In the Tigers' broadcast booth, play-by-play man Dan Dickerson said: "Are you kidding me?" Added his color man, Jim Price: "The ball looks like it has rockets on it!"

That the game also featured Barry Zito's 5⅔ innings of one-run baseball to notch a World Series win for the team that left him off the 2010 postseason roster; that the game also included a remarkable RBI single for the light-hitting Zito off of Verlander; that the game involved more etching of Tim Lincecum's bullpen legend (five strikeouts in 2⅓ scoreless relief innings) paled next to Sandoval's night.

A career nagged by second-guessing over his eating habits and his commitment to excellence, blended with consistent and hopeful admiration

for his pure hitting abilities, crystallized into history. The Kung Fu Panda became everything the Giants had hoped he'd be, and then some, in three swings of the bat. (He singled sharply in his fourth at-bat, too, to complete a 4-for-4 night.)

"The guy had one of those unbelievable World Series nights they'll be talking about for years," said Leyland.

"I still can't believe it," Sandoval said. "When you're a little kid, you dream about being in the World Series."

To think he and Zito were both afterthoughts two years ago.

"It's definitely kind of a cool thing," Zito said in the postgame media room, next to the Panda, "that we're both sitting up here after 2010."

Giants fans filed out into the streets, barely able to process the thought that six nights ago, down 3 games to 1 in St. Louis, the season was essentially over. Now, dreams of another World Series victory were very, very much alive.

World Series Game 2, Thursday, October 25, 2012, San Francisco
Giants 2, Tigers 0

Increasingly, Giants fans turned to Bochy's next move with eager anticipation. The low-key manager with the burnished *basso profundo* voice earned lifetime appreciation status with his 2010 World Series win, forged on a lineup card that more resembled an Etch-a-Sketch for its daily changes and alterations. Outside of the pitching staff, there was only one starter (Posey) who had been on the 2010 World Series team. When Bochy took the San Diego Padres to the 1998 World Series, the former big league catcher had earned his reputation as a deft handler of bullpen arms, and his 2010 use of Sergio Romo, Santiago Casilla and, particularly, his lefthanders Jeremy Affeldt and Javier Lopez to set up Brian Wilson saves, landed him a coveted spot in a vintage convertible in the 2010 World Series parade, hoisting the Commissioner's Trophy on high down Market Street.

With the Giants on a four-game October win streak, and owning a 1–0 Series lead, Bochy's word gained heft with each passing game.

Here came another Bochy decision: to start Madison Bumgarner in Game 2.

On paper, starting Bumgarner fell into the "no-brainer" category. After all, the 23-year-old lefthander already had a World Series win on his résumé, and what a win that was, eight innings of shutout ball at Rangers Ballpark in Arlington to win Game 4 of the 2010 World Series, mesmerizing and silencing AL MVP Josh Hamilton and company in eight innings of three-hit ball. He was 21 years old. Only three pitchers in the history of baseball had ever won a World Series game at a younger age.

But Bumgarner's October of 2012 was not playing out on paper. Despite an excellent regular season in which the lefthander from North Carolina logged career highs in wins (16) and innings pitched, he slammed into an October wall of fatigue and defaulting mechanics. The Reds had knocked him out of NLDS Game 2 in the 5th, en route to a 9–0 Cincinnati win. Then, St. Louis had shooed Bumgarner away in the 4th in NLCS Game 1, scoring six runs in just 3⅔ innings. Combined with a lousy end to his regular season—a 5.94 ERA in his last six starts—the conventional wisdom said Bumgarner was plumb tuckered out.

Bochy's loyalty to players who performed was a trademark. But with Bumgarner, Bochy could not avoid action. Citing Bumgarner's need for physical and mental rest, he had removed him from the NLCS rotation. That had allowed Zito to start that pivotal Game 5 in St. Louis. Another Bochy winner, fans marveled.

And yet, Bochy tabbed Bumgarner to return to the rotation for Game 2 of the Series. He said three intense bullpen sessions with pitching coach Dave Righetti cured Bumgarner of a mechanical ill, confident that the player who wore jersey No. 40 would be back to his old self against the Tigers. Risky? Bochy's track record made for a hard contrary argument.

Besides, by the time Pence led another "Slow Clap" dance in the dugout before the first pitch, and by the time sunflower seeds littered the roof of the third-base dugout, Bumgarner had to know he was in a good place, that something larger than the sum of its parts was playing out for the Giants. He turned the pregame energy into a called strike-three on Tigers leadoff hitter Austin Jackson, unleashing both a rested slider with more bite and the cheers of 42,982 fans.

A 1-2-3 first inning lent the sense that Bumgarner was back, but the second inning proved that the Giants were onto something bigger.

Bumgarner hit Prince Fielder with a pitch to start the second inning, and then came Detroit's first sign of life in the series—outfielder Delmon Young

lined a Bumgarner pitch down the left field line. It looked like extra bases, and trouble, especially when it took a funky bounce off the grandstands, making a tricky play for Gregor Blanco. Tigers third base coach Gene Lamont sensed an opening when the ball kicked off the wall, eyed 275-pound Prince Fielder headed toward third base, considered the Tigers' deficit in the Series, and waved Fielder home.

And here is where the Giants, who'd enjoyed two diving catches from Blanco in Game 1, who'd enjoyed Crawford's stylish shortstop play in the first two playoff series, who'd enjoyed Pagan's nick-of-time dive in Cincinnati, proved their defense could continue to win games.

Blanco's relay to Crawford sailed over his head, but Scutaro, alertly and properly, had backed Crawford up near third base. Scutaro fielded the ball, turned, and cocked his arm.

Posey specifically set up off of home plate, as had been the Giants' game plan since February in Scottsdale. The memory of the May 2011 collision that had threatened Posey's career was too stark. The Giants knew they might surrender runs by instructing Posey not to block the plate, but it was a tradeoff they happily made.

Fielder recognized Posey giving him the plate, and began his slide. Scutaro threw a strike to the catcher, who nabbed it and in one sweep of his left hand tagged Fielder's backside a moment before his foot touched home plate. Umpire Dan Iassogna stood on top of the call, and waited to see Posey hold his glove aloft, ball still secure. Iassogna made the call:

Out!

The Giants had done it again. They'd played superlative baseball at a crucial time.

Later, Blanco would wonder why Scutaro even backed up Crawford on that play. Scutaro laughed and teased Blanco, saying he is an outfielder who doesn't know the intricate thought patterns of infielders on relays.

Either way, Bumgarner received the surge of energy he needed. He struck out five of his first ten outs, and began to emote on the field in ways that indicated the import of the moment. Intense fist pumps punctuated key outs, and with each inning that passed, the cheers for his walk from the mound to the dugout grew louder and louder.

Yet Doug Fister was also pitching beautifully for Detroit, and when the game rolled into the bottom of the 7th still scoreless, it was time for the Giants to appeal to those baseball gods for whom they'd showered sunflower seeds. A Hunter Pence single caused Leyland to replace Fister with reliever Drew Smyly, and he walked Brandon Belt. With two on and no outs, every soul at AT&T Park knew Blanco, the team's best bunter, would bunt. And so he did, rolling one up the third base line that rolled and rolled and rolled . . . and as the third baseman Cabrera and the catcher Gerald Laird and Smyly waited for it to roll foul, it . . . stayed . . . fair. When it stopped rolling, Iassogna, following the baseball up the third base path, pointed with clarity and purpose to his right, looking like a school traffic guard directing cars.

The bases were loaded, and Leyland's decision to play his infield at double-play depth either indicated overconfidence in his American League bats or an underrating of the Giants' bullpen, because when Crawford, the next hitter, grounded into a 4-6-3 double play, Pence scored with the only run the Giants needed to win Game 2. They added one in the 8th on a Pence sacrifice fly that scored Pagan, but the 2–0 final meant that once again, Bochy's decision to use Bumgarner for seven innings, Santiago Casilla for one, and Sergio Romo to close was golden.

Two wins now separated the Giants from another World Series victory.

Bumgarner, with seven shutout innings, eight strikeouts, and only two hits allowed, had done it again in the Fall Classic. Added to his 2010 start, Bumgarner's shutout pitching had made him the first Giant to throw 15 scoreless innings in his first two Series appearances since Christy Mathewson in 1905.

Watching from the opposing dugout, Leyland marveled at Bumgarner's commitment to the moment. "He had a pretty determined look on his face," the Tigers' manager said. Known for his dry wit, Bumgarner was asked what changed between his two poor playoff starts and Game 2 of the World Series.

"I went into the 7th inning, instead of getting took out in the third," he said in that North Carolina drawl, causing the media room to break into laughter.

After the game, much discussion centered on Blanco's bunt. "The baseball gods, I guess," said Crawford. The deities saw to it that the Giants' postseason win streak reached a franchise-record five.

Leyland didn't want the Giants' mastery of their craft to be diminished by talk of the supernatural. "They've earned everything they've got," he said. "They're playing like the Giants play."

Fans left AT&T Park gob-smacked by two thoughts. One, had the past week of baseball, dating back to the Friday night start in St. Louis by Zito, the Vogelsong Sunday Game 6 win at home, the rain-drenched epiphany of Game 7, Sandoval's three-home-run night in Game 1, and on to Bumgarner's fist-pumping mastery, been the greatest one-week stretch of baseball in franchise history? Quite possibly.

And, with only two wins needed to clinch, had the Giants just played their final home game of 2012? Quite possibly.

Heading out into the warm San Francisco evening, one fan said, maybe only half-jokingly, "I want Bruce Bochy to make all my major life decisions for me." His friends laughed. The good times rolled.

World Series Game 3, Saturday, October 27, 2012, Detroit
Giants 2, Tigers 0

The Tigers arrived at Game 3 hoping several things tilted in their favor. Their starting pitcher, righthander Anibal Sanchez, owned great career numbers against the Giants. A day of travel might halt Giants' momentum. And a late October chill in the Midwest—47 degrees at first pitch, but windy enough to feel colder—might disrupt a team from California.

The Giants' clubhouse had a one-word answer to all that: Vogey.

And by the close of the evening, they'd add one more word: Timmy.

A late-season fade that featured a 5.85 ERA in August and September marred Vogelsong's fourteen-win campaign. His October, however, was a different story. Two wins in the NLCS meant he would have won MVP, if not for Scutaro's dominant play. And now Bochy set up his rotation to have Vogelsong start Game 3. That meant the former Japanese League pitcher was in line to start Game 7, also, if necessary. Bochy's response: "If he starts Game 7, I'm OK with that."

Buster Posey said he couldn't figure out why Vogelsong's August and September had steered off course. His velocity was fine, the catcher said.

He just missed on a few pitches, and the outings went south. Vogelsong's steel-eyed intensity—and fastball command, evidenced by his barrage of heaters at the Cardinals in Game 6—may be what turned it around in October.

Famous in the clubhouse for his don't-approach-me attitude on game-day starts, he had earned the nickname "Vogeltron" from teammates, joking that on game day his robotic superpowers transcended the human experience. During games, he simmered with barely concealed fire, scowling on the mound and in the dugout. On the Giants' flagship station, KNBR, hosts played the sound of a revving chainsaw when they discussed Vogelsong, to symbolize his almost scary mound rage.

Temperatures in the 40s weren't going to bother a guy raised in Pennsylvania, either. His inner heat took care of that. So did great pitching. In the first inning, Vogelsong escaped a two-on, one-out jam by inducing a 4-6-3 double play from Detroit's cleanup hitter, Prince Fielder. In the third inning, he slithered out of a two-on, one-out situation by coaxing another Scutaro-to-Crawford-to-Belt double play.

And in the 5th, he pitched like a man intent on winning a World Series. Two singles and a walk loaded the bases for Detroit with only one out. The Tigers' No. 2 hitter, 28-year-old rookie left fielder Quintin Berry, was up. Behind him loomed Cabrera, who'd be declared that year's AL MVP, and Fielder. Comerica Park came to life, anticipating the moment the Tigers would gain control of Game 3—and maybe turn the Series around. They waved white rally towels and cheered from underneath ski caps that featured the team's trademark Old English "D."

Vogelsong was carrying a 2–0 lead from the second inning with which to work, thanks to the bottom of the Giants' order. Gregor Blanco, as if to prove to Tigers fans that he could do more than lay down line-hugging bunts, had stroked an RBI triple to deep right-center field, plating Hunter Pence, who'd walked. Blanco scored when Crawford, having a dynamite Series, singled him home.

But the advantage hung on a precipice with Berry up and Cabrera looming. Berry worked a 2–2 count, when Vogelsong and Posey agreed to a fastball, up. Berry chased the 91-mph pitch, and whiffed. Strike three.

Now with two out, up came Cabrera, with a résumé as thick as any in the game. Vogelsong chewed gum on the mound, working out nervous energy. His 0–1 pitch was a fastball that bore in on the plate. Its late movement

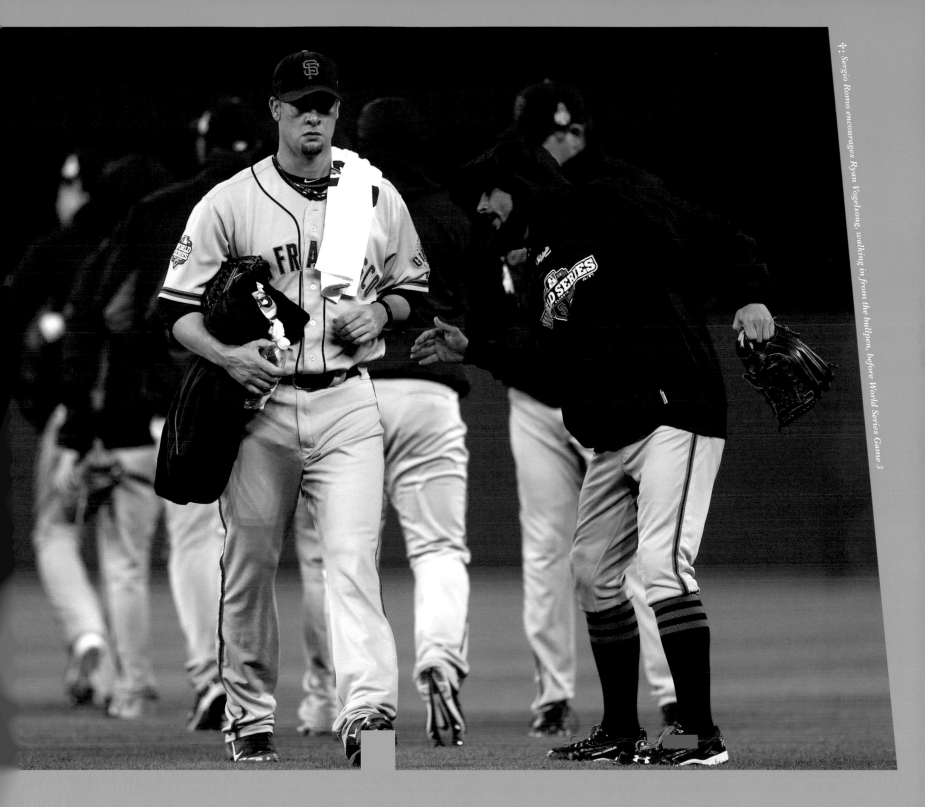

was enough to miss Cabrera's barrel when he swung. He popped it up. Crawford camped under it at short. Out number three.

After 104 pitches and 5⅔ innings of shutout ball, Bochy thanked Vogelsong for his work, then made his other key move of the evening: He signaled for Tim Lincecum to emerge from the bullpen.

Timmy the Kid, even bounced from the rotation, retained his rock-star status. In the NLDS Game 2 loss to the Reds at home, the only moment of life at AT&T Park had come when Lincecum emerged from the dugout, as if sprung, to jog to the bullpen down the left-field line. The park roared at the sight of No. 55, a sensation Scutaro later called "electric." And Lincecum's five strikeouts in 2⅔ innings of Game 1 World Series relief caused Jeremy Affeldt to say, "That was 2010 Timmy."

Now here he came, to preserve Vogelsong's gem. The two-time Cy Young Award winner, now morphed into the Giants' multigame bullpen ninja, again proved up to the task.

He retired Jhonny Peralta on a fly ball to right field to end the 6th, fanned Berry on a trademark split-finger changeup to end a scoreless 7th, then stared down Cabrera to start the 8th. Cabrera broke his bat on a Lincecum fastball and sent it up the middle, but Crawford's dynamic play continued—he dove to his left to spear the smash, leaped to his feet, and fired a strike to Belt to retire Cabrera. Energized by the play, Lincecum fanned the slumping Fielder on three pitches—the killer another changeup that cruelly dove at the plate—then finished off the 8th by doing the same to Andy Dirks. A changeup fooled him. Swing and a miss. Strike three.

It was classically freakish stuff from Lincecum, who penned a new chapter in his superstar career. The Giants won Game 3, and were one game away from another World Series.

The two pitching stars of the game sat in the media room afterward, each sporting characteristic looks. Vogelsong was still partially in uniform, sporting a black long-sleeve Giants undershirt. Next to him sat Lincecum in a red plaid flannel shirt and gray beanie, like a skateboarder from his hometown of Seattle who had taken a wrong turn into the press conference.

Their October résumés dueled for top billing. Vogelsong, in four starts, had pitched 24⅔ innings and allowed three earned runs for an ERA of 1.09. He became the first major league pitcher to start his postseason career with four starts of at least five innings pitched, allowing one earned run or fewer, since Christy Mathewson.

Lincecum, meanwhile, in five relief appearances threw thirteen innings, allowed one earned run and just three hits. He struck out seventeen.

"What sticks out the most is that when the lights come on the biggest stage, he's shown everybody what he's truly about," Vogelsong gushed of Lincecum. "He could have been upset about going to the bullpen, but not for one second did you see that from him. He just went down there and came out firing BBs."

Bochy had orchestrated the move, and the idea of having Lincecum available for multiple roles, this "Timmy On Demand," as one fan called it, was a masterstroke.

"Some things are hard to explain," Bochy said. "Timmy's an incredible talent. It just so happened to work out we thought he could help us in the bullpen."

It could have backfired, but it didn't. For that, the Giants credited the guy in the skater flannel. Said Lincecum: "Winning a World Series leaves you wanting more. If that means being a good teammate or being in the bullpen, I don't care. I just want to win."

World Series Game 4, Sunday, October 28, 2012, Detroit
Giants 4, Tigers 3 (10 innings)

For the last lineup card he'd pen in the 2012 season, Bruce Bochy leaned on the concept of "team" one final time. He wrote in the name "Theriot" in his eighth-place spot at designated hitter.

Ryan Theriot had played second base on Opening Day for the Giants, a utility player signed until, theoretically, 2010 World Series champion Freddy Sanchez returned to play the two-bag. But Sanchez, chronically nagged by injuries, never returned. Theriot wound up being a key man for Bochy. The LSU product and clubhouse comic made 78 starts until mid-August, when a healthy Sandoval returned to third base and Scutaro was installed at second. Theriot, though he'd only make three starts in the Giants' final 44 games, made sure his presence was still felt. His colorful wardrobe kept teammates laughing, and his intense, hang-on-

the-dugout-rail game presence reminded teammates that he was always watching, always cheering.

Bochy needed a designated hitter for Game 4 and hadn't loved Hector Sanchez's Game 3 at-bats. Despite Sanchez having played a vital role as Posey's backup and as the regular catcher for Zito and Lincecum throughout the year, Bochy went with a hunch and tabbed Theriot—who'd never played a game at DH before.

"He's an experienced veteran," said Bochy before the game, "who finds a way to get the bat on the ball."

Something about Theriot's relentless team-first attitude made the move seem right. Asked to assess his diminished role down the stretch, Theriot's answer spoke to the reason Sabean valued signing the player who had won a World Series with the Cardinals in 2011. "You realize it's not about you, personally," he said. "It's about the ball club."

Matt Cain faced Detroit's Max Scherzer in a Game 4 pitching matchup that oozed history in favor of the Giants. Of 23 teams to take 3–0 leads in the World Series, 20 of those teams finished the sweep. The other three won in five games. The Giants, though, didn't want to hear it. Some veterans spoke before the game of the looming presence of a vengeance-seeking Verlander in Game 5, and they could not let the Series get that far.

The Giants listened. Pence stroked a ground-rule double in the second inning off Scherzer, then up stepped 24-year-old first baseman Brandon Belt.

Few Giants players divided the fan base like Belt. His supporters saw a young, improving, homegrown talent whose minor league numbers portended major league success. They pointed to his excellent work at first base and his .360 on-base percentage—bested only by Posey's .408 and Melky's .390—as a valuable lineup addition. His detractors howled, citing his team-high 106 strikeouts and a too few total of 7 home runs in 411 at-bats for a power position like first base.

By late July, when Belt was struggling with his mechanics and with his confidence, his batting average dipped to .229. It appeared he might be headed to Triple-A Fresno. The Giants needed him to succeed, since first base had a vacancy ever since veteran Aubrey Huff's 2012 season nosedived. Huff had left the team in April because of an anxiety disorder, and never returned to form. The team invested their hopes in Belt, but his summer woes prompted much waffling.

And then, the six-foot-five player, whose awkward body language and gait inspired the nickname "Baby Giraffe," clicked. Through intense work in the cage, and through conversations with coaches about his approach in the box, Belt took off. He hit .349 in August, .310 in September and grew into an important mainstay for Bochy. Baby Giraffe had found his legs.

October, however, was a big stage for the wide-eyed Belt. He was hitless in the World Series when he dug in against Scherzer. But Belt turned aggressive, looking first-pitch fastball in, and got it. He dropped the bat head on the ball and smoked it, sending it off the right field wall, just two feet shy of a home run. Belt slid into third with a triple, and Pence scored the game's first run, shouting as he crossed home plate. The Giants were on their way.

At long last, though, the Tigers challenged the Giants.

In the bottom of the third, Miguel Cabrera struck. He lofted a Cain pitch up into the jet stream blowing out to right field. What looked like a routine fly ball kept going and going, and when Pence bumped his shoulder against the outfield fence and looked up, Cabrera had his two-run homer. The Tigers led, 2–1, and the Giants trailed for the first time in 57 innings, dating back to Game 4 of the NLCS. As a spitting rain made the 44-degree night tougher, the Giants needed an answer.

In the top of the 6th, they got one. Though Scherzer was pitching well, Scutaro forced him into the stretch with a single. With one out, up stepped Posey.

For all he'd done in 2012, Posey's World Series at the plate had flagged. Perhaps it was the strain of catching every game that caused him to tote a .190 Series batting average to the box for that at-bat. During the regular season, the Giants had given Posey starts at first base, to rest his surgically repaired ankle. But Bochy needed him at the most important position for the most important games. Posey's Game 4 start was his seventh consecutive start at catcher, and his fourteenth in sixteen post-season games.

The NL MVP would not be held down for much longer. He came to the plate knowing Scherzer liked to throw a changeup, and looked for one. Scherzer threw a 1–0 change, and Posey waited, then swung. He skied it down the left field line, and the only question was whether it would it stay fair. It did.

A home run in the freezing drizzle to give the Giants a 3–2 lead in Game 4

of the World Series meant Posey had produced another legendary moment. As thousands of Giants fans back home in San Francisco, watching on an outdoor big screen TV in front of City Hall, erupted in pulsating cheers, Posey watched the ball's flight. He jogged down the first base line, holding his index finger aloft. That's how important the usually reserved Posey knew the moment was.

It was his first extra-base hit since the grand slam in Cincinnati. As Sabean would later say, "He's the rare offensive catcher, who has a flair for the dramatic."

Though Cain threw seven innings of competitive ball, he got no decision. A Delmon Young homer tied the game in the bottom of the 6th, and it came down to the bullpens. The Giants love those kinds of games— particularly when Jeremy Affeldt gets involved.

Affeldt had made his October bones with Giants fans when he pitched the team out of a sticky jam in Game 6 of the 2010 NLCS in Philadelphia. Now, in Detroit, the lefthander only exalted his status.

After issuing a leadoff walk to Avisail Garcia, Affeldt faced the unappetizing prospect of Detroit's 3-4-5 hitters coming up in a tie game in the bottom of the 8th. One of the rocks of the Giants' clubhouse, who often mixes long-term perspective with timely witticisms, Affeldt showed another side as he faced Cabrera and Fielder and Young, a ferocious concentration punctuated by shouts of intensity.

Here is what he did: He struck out Cabrera on a wicked back-foot slider. He first buckled Fielder with a curve ball, then finished him off with a fastball on the hands. And then he struck out Young on a dipping breaking ball Young could only wave at. Inning over.

Now, in the tenth inning, it was time for the Giants to win the World Series. Though Tigers reliever Phil Coke fanned the first seven Giants he had faced, Theriot led off the tenth by somehow forcing an opposite-field single through the hole. The player Bochy said would find a way to get the bat on the ball found a way to get the bat on the ball. The Giants snapped into action. Crawford laid down a textbook sacrifice bunt on the very next pitch Coke threw, the same kind of bunt Tim Flannery had coached out of him since the Scottsdale days in February. Pagan struck out, and up came Marco Scutaro.

Though he'd only been a Giant for three months and a day, there was a

sense that no matter what, Scutaro was about to produce yet again. In the dugout, Cain said he thought it, only wondering if magic was finite, and that maybe Scutaro's seemingly endless supply of it had some limit. He and everyone else also knew that Scutaro's compact stroke, patient approach, and ability to make contact were more pertinent. So when Scutaro swung at Coke's 3–1 fastball, a high pitch up and over the outside part of the plate, the contact he made was the 105th time he'd made contact in 107 post-season swings.

This was a good one, too.

The baseball traveled over the head of second baseman Danny Worth and plunged in front of center fielder Austin Jackson. Flannery waved home Theriot. Jackson's throw was feckless, late. Theriot didn't need to slide, but he did, touching the plate with his left arm to score the go-ahead run. The force of his slide across home plate knocked his helmet askew. He moved with so much speed his slide carried him well past the lefthanded-batter's box. He popped out of the slide and placed his right knee on the ground. He pumped his right fist, and screamed a barbaric yawp.

It was perhaps the ultimate team moment for the 2012 Giants—the team that raptly listened to Pence's wide-eyed speeches about playing for each other, about playing one more day—that Theriot, who'd lost his everyday job to Scutaro, scored the Series-clinching run on a Scutaro hit. As Bochy said later of Theriot, "He never complained and always kept himself ready."

The only thing standing between the Giants and a championship were three outs in the bottom of the tenth. Bochy turned to Sergio Romo to get them.

Because the game was in Detroit, Romo did not get his hometown entrance music, a blast of Mexican horns and beats called "El Mechón" (The Lock). In its own way, the rollicking rhythms of "El Mechón" had taken on the 2012 equivalency to Brian Wilson's entrance music, the sound of October 2010: House of Pain's "Jump Around." Appropriate, since Romo, after a season of evolution, had taken Wilson's spot as Bochy's October closer.

Wilson had earned a save in Colorado on April 12; doctors then found a torn ulnar collateral ligament in his pitching arm. He'd need Tommy John surgery for the second time in his career, and was gone for the rest of the season. Though a devastating blow for Wilson and the team, the eccentric closer with the comically dark, long beard tried to treat the situation with humor, at least publicly. After his surgery, he tweeted out a link to a YouTube video. The video was a still shot of him in a sling, Photoshopped next to

Bigfoot, also in a sling. The accompanying music was Dionne Warwick and Elton John's "That's What Friends Are For." It made no sense, but for fans who'd come to embrace B-Weezy, that made it all the funnier.

The Giants never truly settled on a replacement for Wilson. Santiago Casilla took the early lead, and saved nineteen of his first twenty tries before developing a blister and becoming less effective. Bochy and Sabean called a meeting in August, and told the bullpen closing would be done "by committee." Affeldt, Javier Lopez, and Romo combined for thirteen saves from August to mid-September before, slowly, Bochy continued to call on Romo to close.

The team often stated Romo couldn't be an everyday closer because of his reliance on a wicked slider that tested his elbow's durability, and because of his slight, five-foot-ten, 185-pound frame. Those were Romo's listed measureables, by the way. In reality, he was probably shorter and lighter.

But that slider proved too tantalizing for Bochy to ignore. Hitters couldn't touch it. Romo posted another statistically brilliant season, holding hitters to a .185 batting average. Bochy went to Romo for the clincher on September 22, went to Romo for the blood-and-guts NLDS Game 5 in Cincinnati, went to Romo for saves in Games 2 and 3 of the World Series, and went to Romo once more.

At AT&T Park, when "El Mechón" played for Romo, the enormous scoreboard in center field showed a video of Romo jogging through San Francisco in slow-motion, shadow boxing. He couldn't look menacing, though. Romo's California-bred sunniness defined him, and he won over fans with a weekly radio show in which he consistently praised his teammates, expressed his love of the game, and was never afraid to wear his heart on his Giants-patched sleeve.

His outlook was born of his long road to the big leagues. From the dusty town of Brawley, California, through four different colleges, and drafted in the unglamorous 28th round of the 2005 draft, Romo appreciated every chance the game gave him.

Now, on a cold Sunday night in late October in Michigan, the game gave him the ultimate chance. He would not let it pass. He struck out Austin Jackson, and struck out Don Kelly. Up came Miguel Cabrera, who could tie the game with one Triple Crown–caliber swing. Romo worked the count to two balls, two strikes with a steady diet of sliders. Posey called for another one. Romo shook him off.

Though Romo's fastball only hits 88 mph, it can stun hitters who are looking for his slider. Romo, at the most critical moment of his career, knew this. He would outfox Cabrera. Posey read Romo's head shake and changed to a fastball. Romo nodded and threw a fastball that bore in on the plate.

Cabrera was stunned. He never swung. Plate umpire Brian O'Nora signaled called strike three, and at 11:50 p.m. Eastern time, the San Francisco Giants were World Series champions.

In the radio booth, Dave Flemming called it:

> *2 and 2 the count . . . Romo shakes off Posey . . . now, has the one he likes . . . Romo's 2–2 pitch on the way, Cabrera TAKES STRIKE THREE CALLED, AND THE GIANTS HAVE WON THE WORLD SERIES IN DETROIT! . . . And the celebration begins as the Giants mob the mound . . . Cabrera strikes out looking to end it . . . and not only have the Giants won the World Series, they have swept the Tigers in four games, in dominant fashion . . .*

After the bounding and hugging and shouting on the field, Posey, a World Series champion for the second time at age 25, handed the game ball to Bochy, the first Giants manager to win two World Series since John McGraw. In the clubhouse, Sandoval went on national TV to accept the Series MVP award after hitting .500. Bochy held the Commissioner's Trophy above his head as he walked into a partying, champagne-splashed clubhouse. He shouted, "This is yours!" His players roared.

Back in San Francisco, fans hugged and screamed at City Hall. They poured out of The Public House at AT&T Park into intersections choked by cars honking horns. Fans gathered in the streets of the Haight-Ashbury to high-five and hug. A fan base so gratified by the 2010 World Series after a half-century of waiting now had two championships in three years. The fans also held proud the rightful claim that Giants baseball—Sabean and Bochy's emphasis on homegrown arms, speedy outfield defense, a grinding competitiveness, and a team-first mentality—was now the gold standard in the game.

Who could tell when the Giants had turned into the team of destiny? Was it when the clubhouse, led by a defiant Posey, refused to accept Melky's suspension as a death knell? Was it when Hunter Pence gave his "One More Day" speech in Cincinnati? Was it Scott Rolen bobbling Joaquin Arias's ground ball in Game 3 of the NLDS? Was it Buster Posey's grand slam in NLDS Game 5? Was it the #RallyZito movement that banded a

fan base? Was it Zito's historic performance in St. Louis in NLCS Game 5? Was it Sandoval turning on a Verlander fastball in the first inning of World Series Game 1?

Was it all of those things, gradually and then suddenly? Sometimes, in baseball, answers are undefined. They just are.

"We bought into something you don't see very often," Pence said, offering one possibility. "We bought into playing for each other, and loving each other."

THE PARADE. October 31, 2012. San Francisco

Civic officials estimate 1.3 million fans showed up at the Giants victory parade down Market Street. As they had done in 2010, fans stood on rooftops and atop Muni buses, climbed lampposts, and waved from fire escapes. Romo stole the show in a T-shirt that read "I JUST LOOK ILLEGAL." He left his convertible on Market Street and ran up and down the street, much like Wilson did in 2010.

At City Hall, the players expressed their love for the fans who had sold out every home game this year. Sandoval and Scutaro spoke in Spanish, until Scutaro ended his speech in English: "Love you guyyyyys!" Vogelsong appealed to the masses, saying the crowds in Cincinnati and St. Louis couldn't match Giants fans, and "quite frankly, Detroit's fans weren't even as close to as loud as you, and that's why we won."

Zito stood next to Vogelsong and spoke in heartfelt fashion: "Me and Vogey have a special bond. . . . We've both been through a couple different states of hell in this game. The lows have been very low. But we're enjoying the highs right now. It's such a blessing."

Posey was greeted with chants of "MVP!" He'd later win the award, and in characteristic style, too—telling the TV cameras if they wanted to interview him, they'd have to come to his mother's school fundraiser in Leesburg, Georgia, because that's where he'd be with his wife and two children. At the City Hall parade, he spoke with an elder's wisdom.

"I think for me, looking around and seeing all the excitement and happiness on everybody's face, you realize an accomplishment like this means more

than just winning a game," he said. "This is about making memories with your friends and family that will last a lifetime. We all know and believe that if you think something's achievable, as long as you're willing to work hard enough for it and believe it can happen, you can get it done."

Romo cited the City's and team's diversity, and common goal. "For dang sure," he said, "we are ALL world champions here in San Francisco, and that's what's up."

Pence told the crowd that the Giants embodied the concept of "sacrifice." He led one last "Slow Clap" in front of City Hall, and his teammates joined him with props, tossing seeds and Cracker Jacks in the air. The team then posed in front of the 2010 and 2012 World Series trophies as Queen's "We Are the Champions" blasted. They kneeled and crouched in front of the trophies for photos, as if at a high school awards ceremony. And then out came Tony Bennett, live and in person, right there at City Hall, to nail a piano-accompanied rendition of "I Left My Heart in San Francisco." The sight of the 86-year-old Bennett standing directly in front of Scutaro, in his "WORLD SERIES CHAMPIONS" black hooded sweatshirt, and Romo, in his bold T-shirt, while being filmed by Vogelsong and Cain on their smart phones, was almost too rich to be true.

Some three weeks later came the ultimate coda. The Giants debuted their World Series DVD at the Castro Theatre. Bochy brought the World Series trophy and heard thunderous cheers. The fans ate up the highlights, and then saw the best of them all. As the credits rolled, MLB's production crew asked several Giants players to imitate a Hunter Pence speech. The players provided outtakes for a lifetime, bulging their eyes as best they could, channeling Pence's heart-and-soul emotion, laughing all the while.

Posey went first: "Today, boys, is a chance for us to make history!"

Next, Vogelsong: "I don't care what they say about us! I don't care about them! It's about the guys in this room!"

Posey again: "Nobody's been through what we've been through. Nobody will stand in our way!"

Scutaro, cap backward, stared in: "I love you guys. I will go out there and die for you!"

Pagan, who himself owned an intense pair of eyeballs: "Pagan! I want to play with you tomorrow!

Zito joined the party: "Every time you get a filet mignon . . ."

Vogelsong: "Every out! Every inning!"

Back to Zito, pointing his finger: "Every time you get a piece of chicken, a piece of fish, you want to throw it on the grill, you gotta think 'win'!"

Affeldt, perhaps bulging his eyes the best of them all: "You guys want something? I've got something! I've got one more day!"

Cain, animated as ever: "I want to see you. I want to play with every one of you. One more day! I don't care! I want to play with Theriot!"

Scutaro: "I want to see what Theriot is gonna wear tomorrow!"

Vogelsong: "I want to see what Ryan Theriot is going to wear to the field tomorrow!"

Pagan: "I want to play with you, baby. I want to win this together, baby!"

Affeldt: "And I don't want to go home!"

Sandoval: "I don't want to go home!"

Scutaro: "I frickin' love you guys!"

Cain, still screaming: "I want to see you guys one more day! This is gonna happen!"

Sandoval: "I love you guys! Let's do this together. Let's do this for us. Let's do this for the fans!"

Affeldt: "I love this team, and I want to be with every single one of you for one more day!"

Affeldt widened his eyes as much as he could, and smiled.

MLB's production crew showed Pence the impressions on a laptop. He stared at the screen and took it in, and then laughed and shouted and clapped his hands and raised them in the air, and he did one other thing. He got a little choked up.

"This," he said, "is what it's all about."

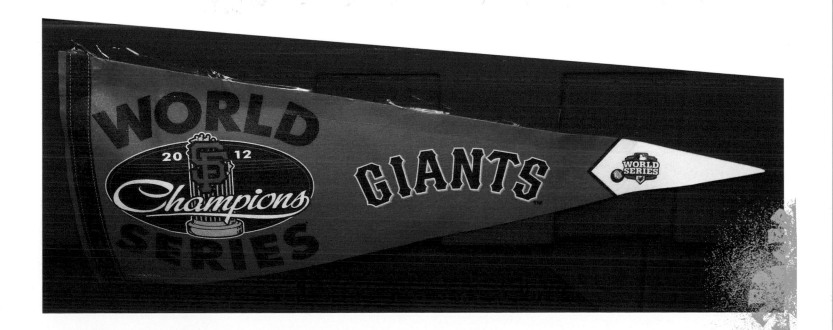

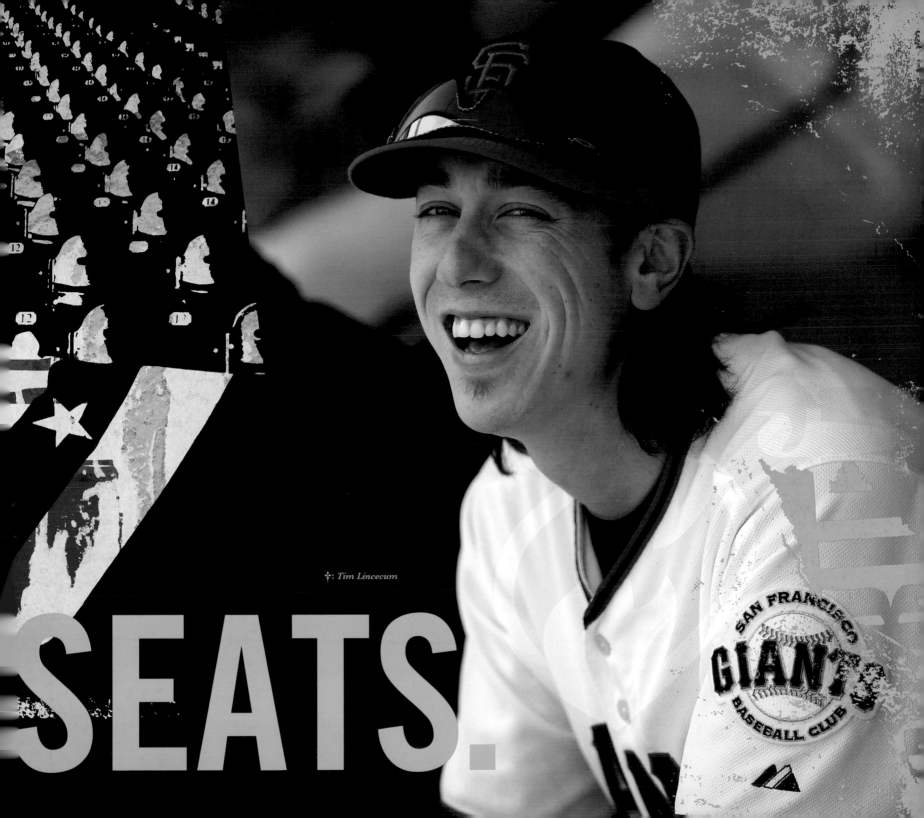

✝: Tim Lincecum

SEATS.

SAFE.

HOME.

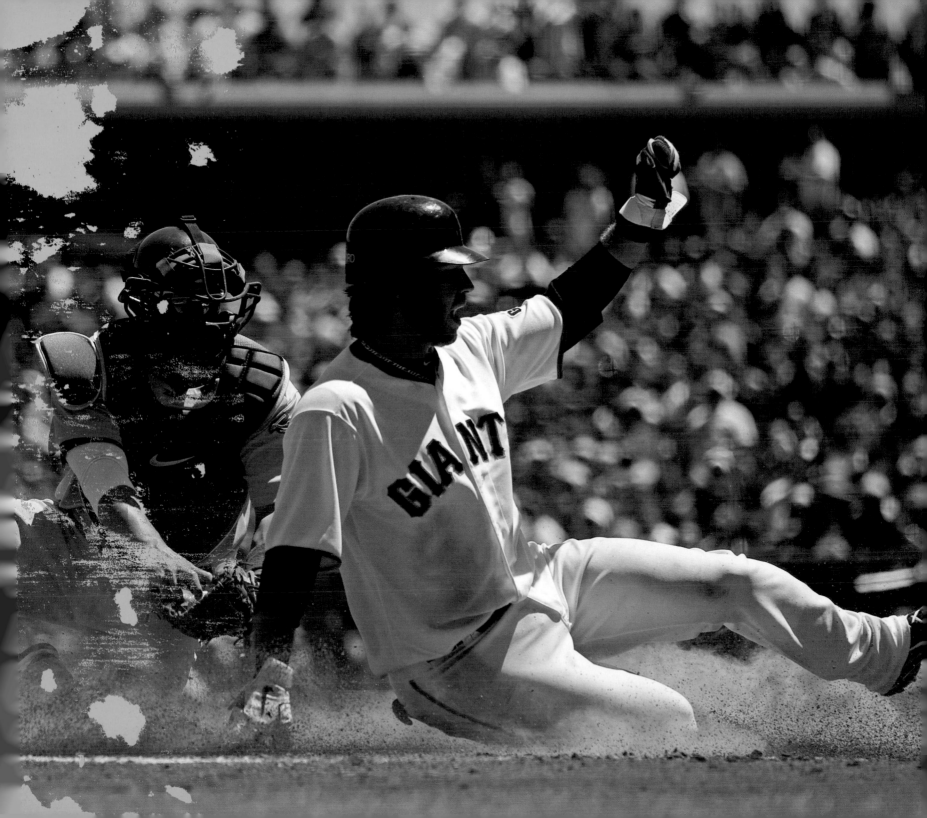

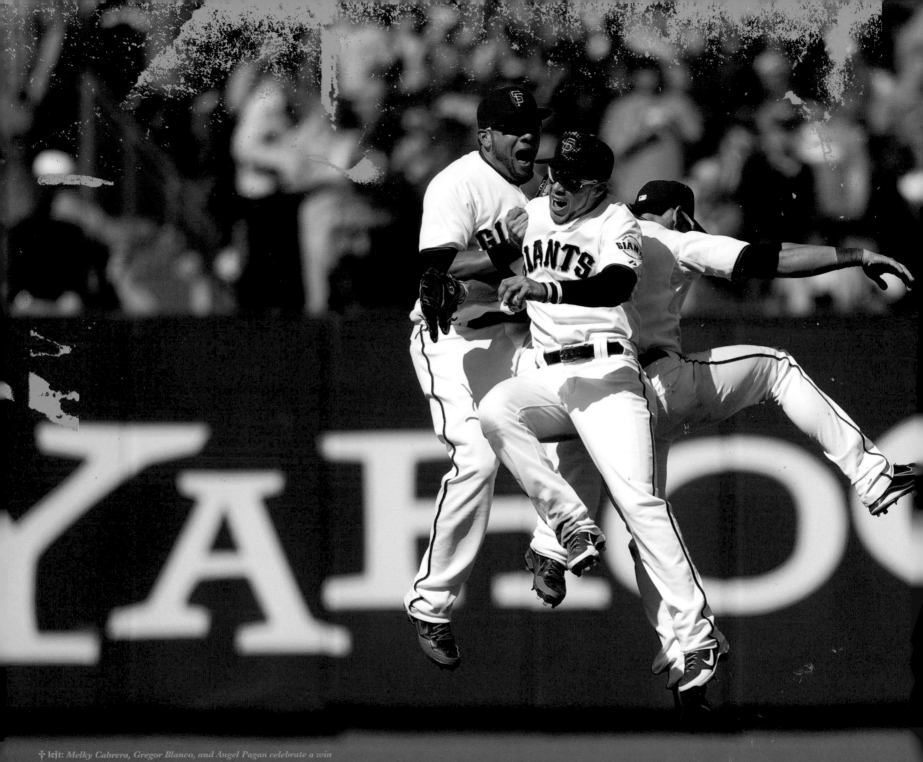

✝ left: *Melky Cabrera, Gregor Blanco, and Angel Pagan celebrate a win*
✝ right: *Buster Posey on Turn Back the Clock Day*

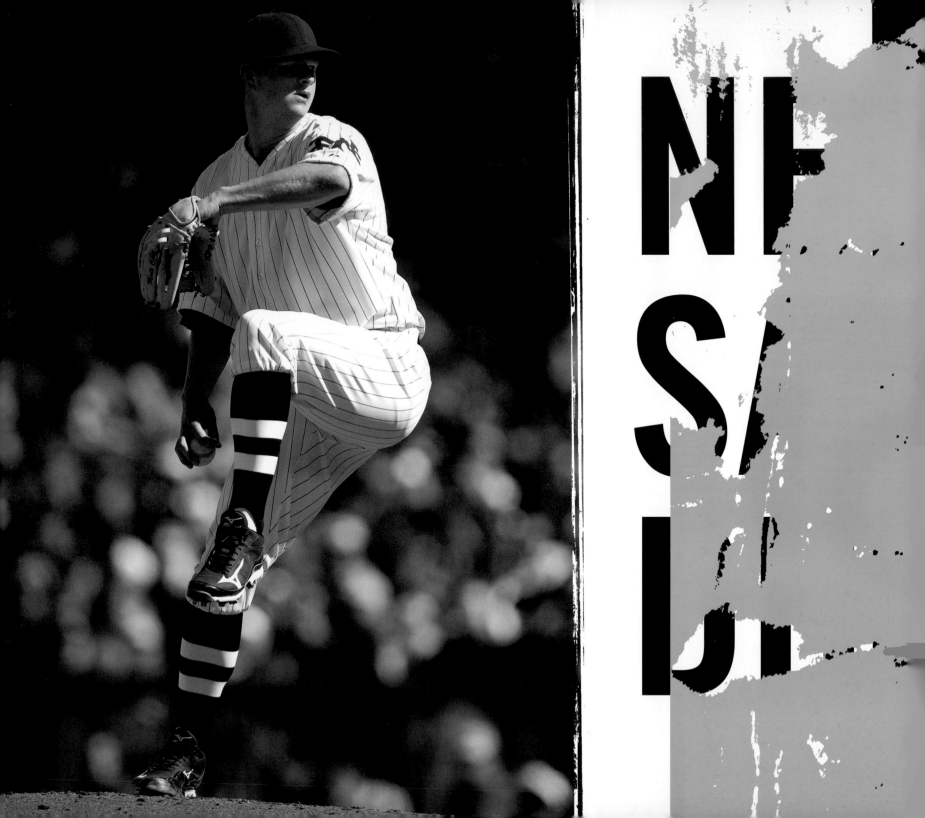

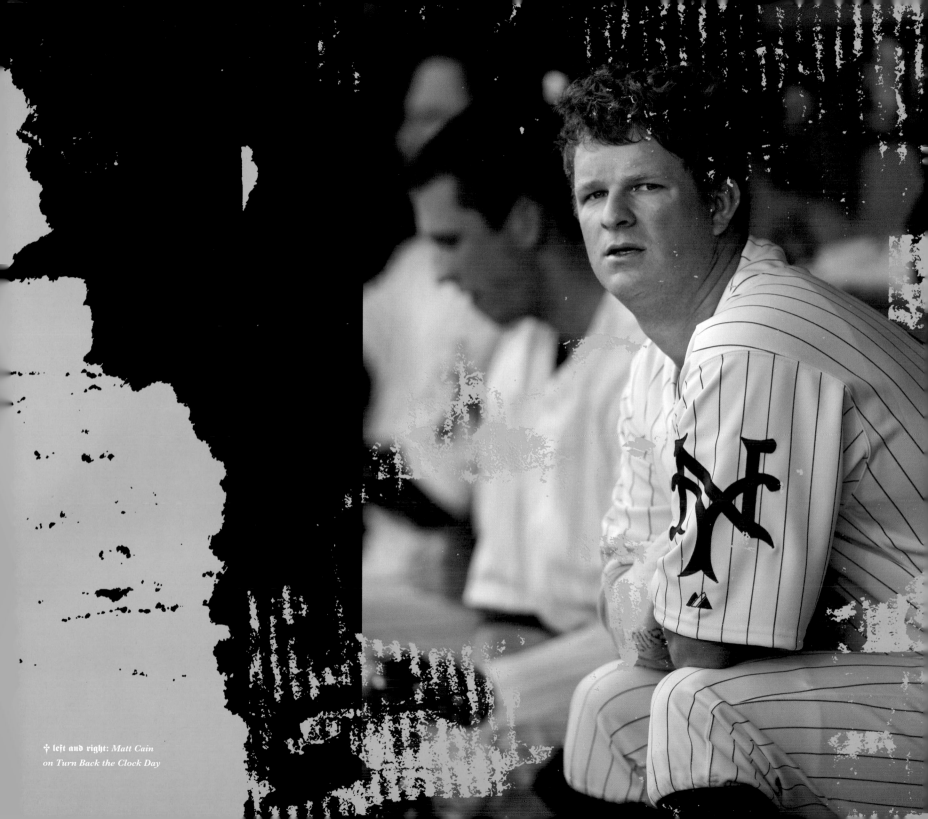

✝ left and right: Matt Cain
on Turn Back the Clock Day

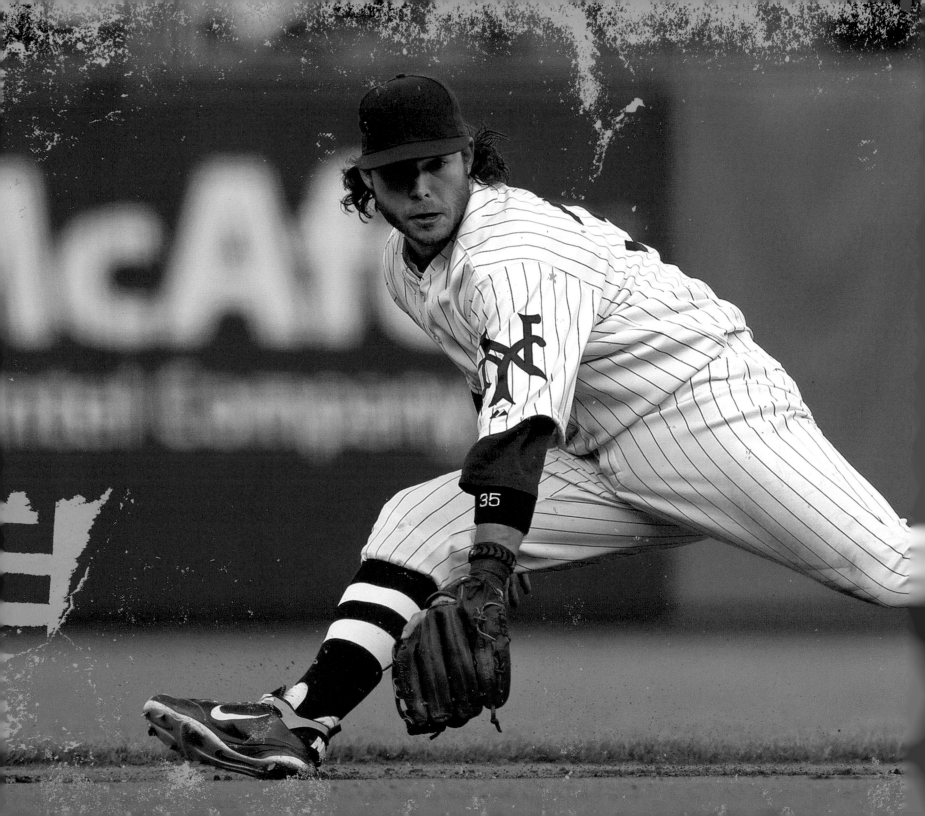

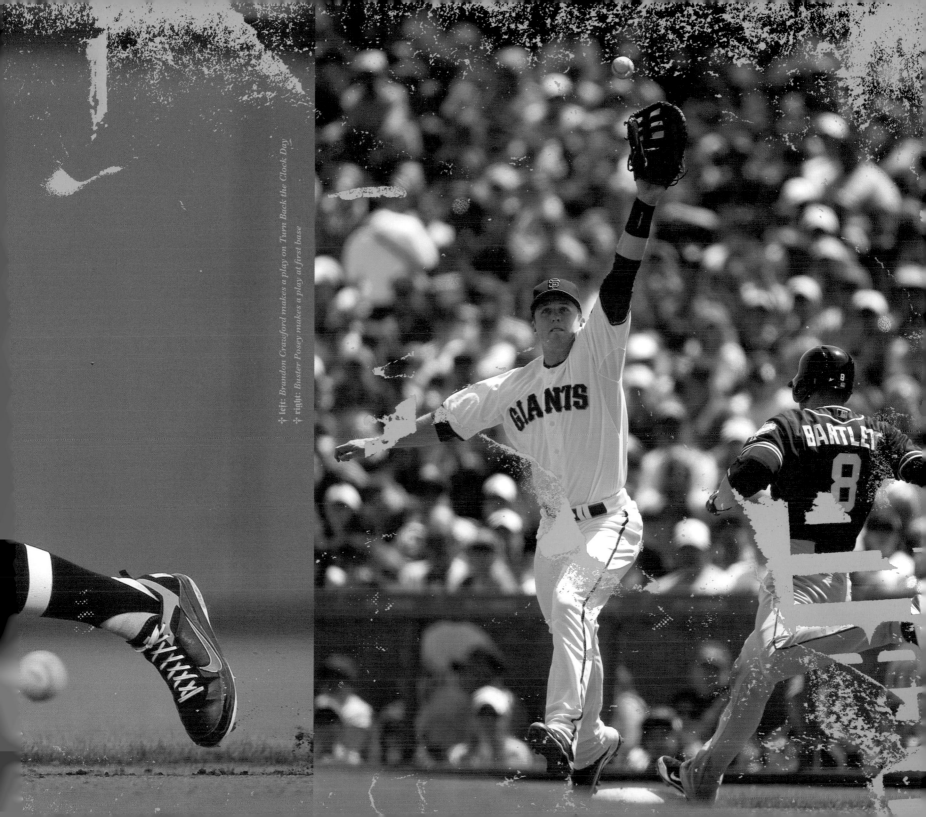

✦ **left:** *Brandon Crawford makes a play on Turn Back the Clock Day*
✦ **right:** *Buster Posey makes a play at first base*

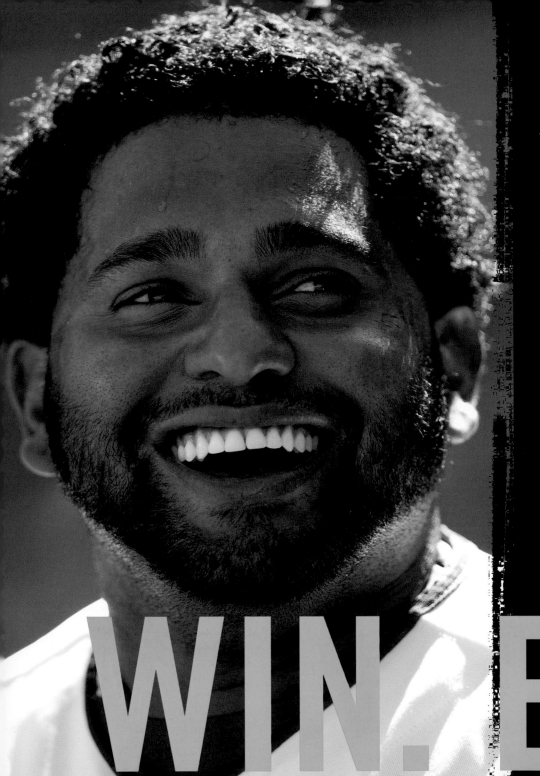

WIN. EACH.

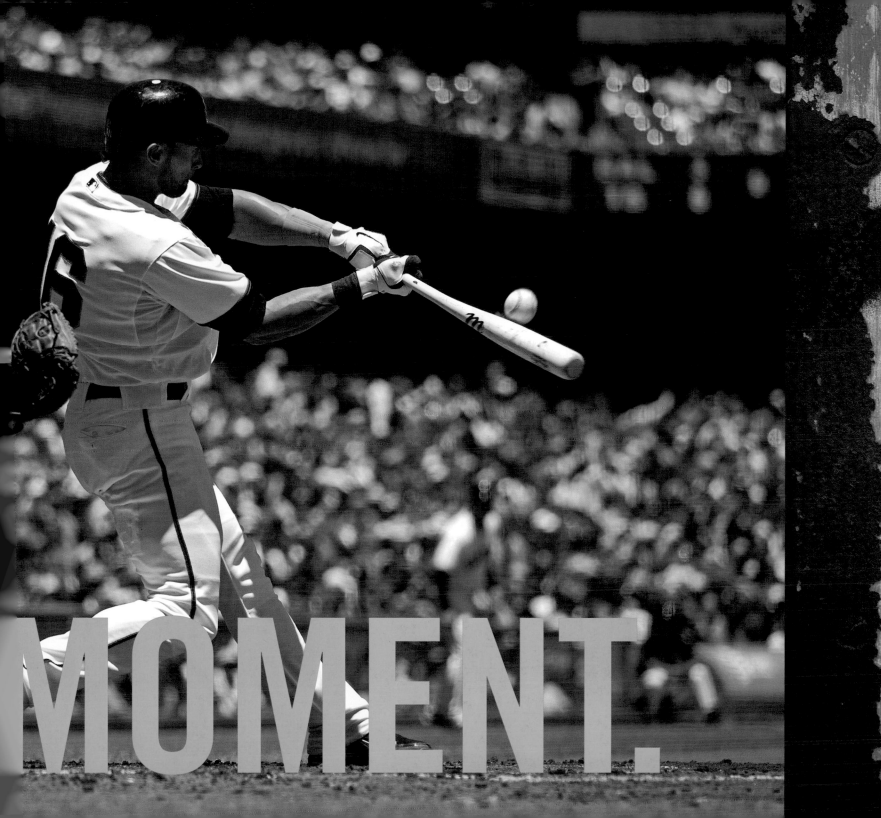

MOMENT.

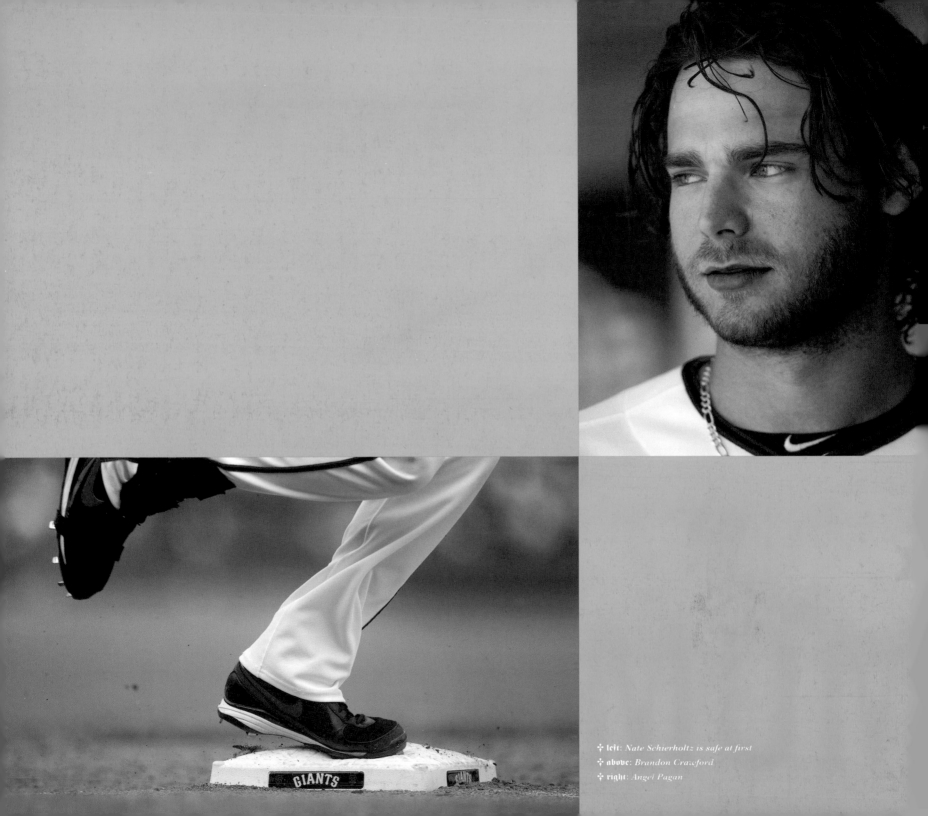

✢ left: *Nate Schierholtz is safe at first*
✢ above: *Brandon Crawford*
✢ right: *Angel Pagan*

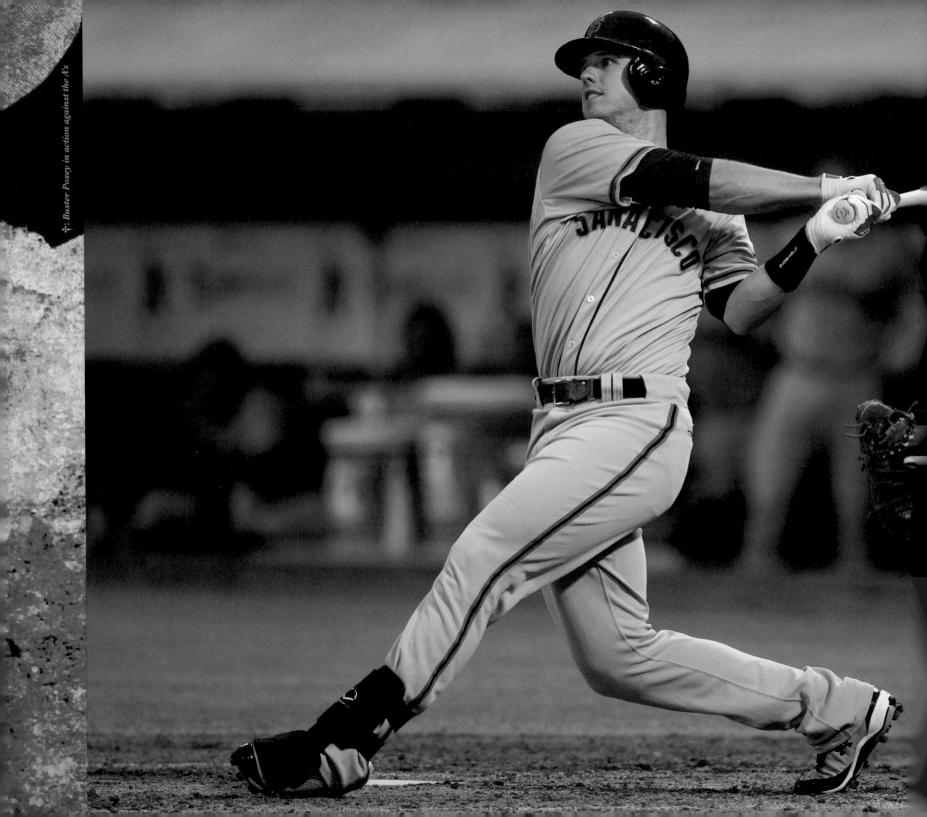

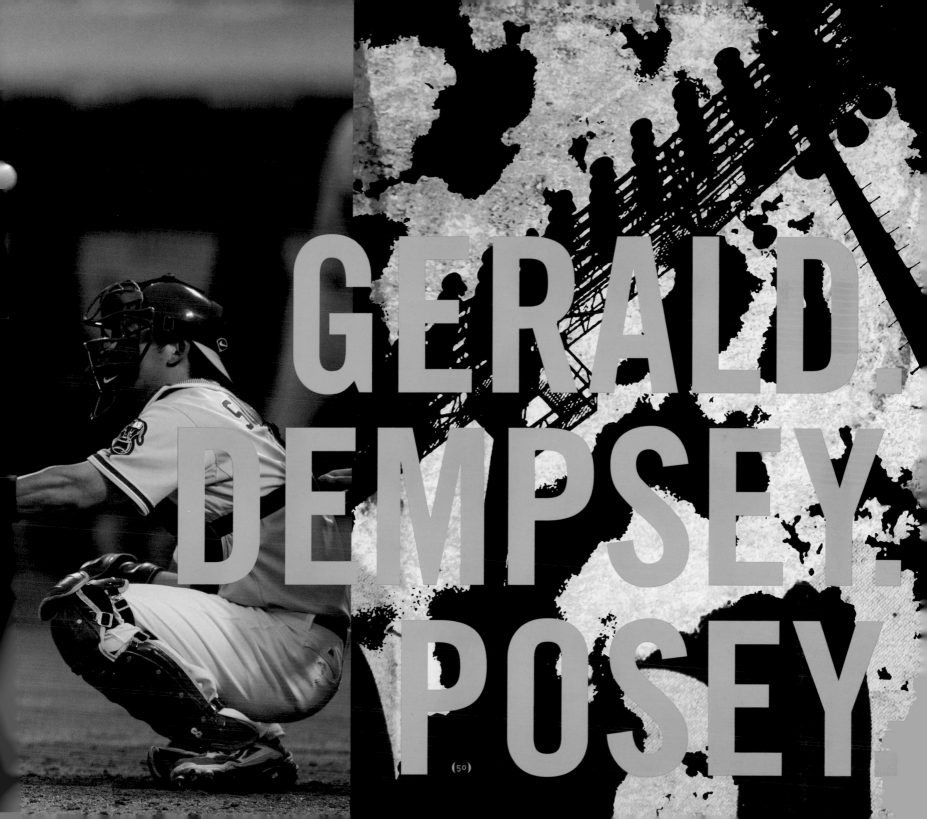

GERALD. DEMPSEY. POSEY.

(50)

✝ left: *Melky Cabrera, Tim Lincecum, and Gregor Blanco get ready*
✝ right: *Angel Pagan and Bruce Bochy talk before a game*

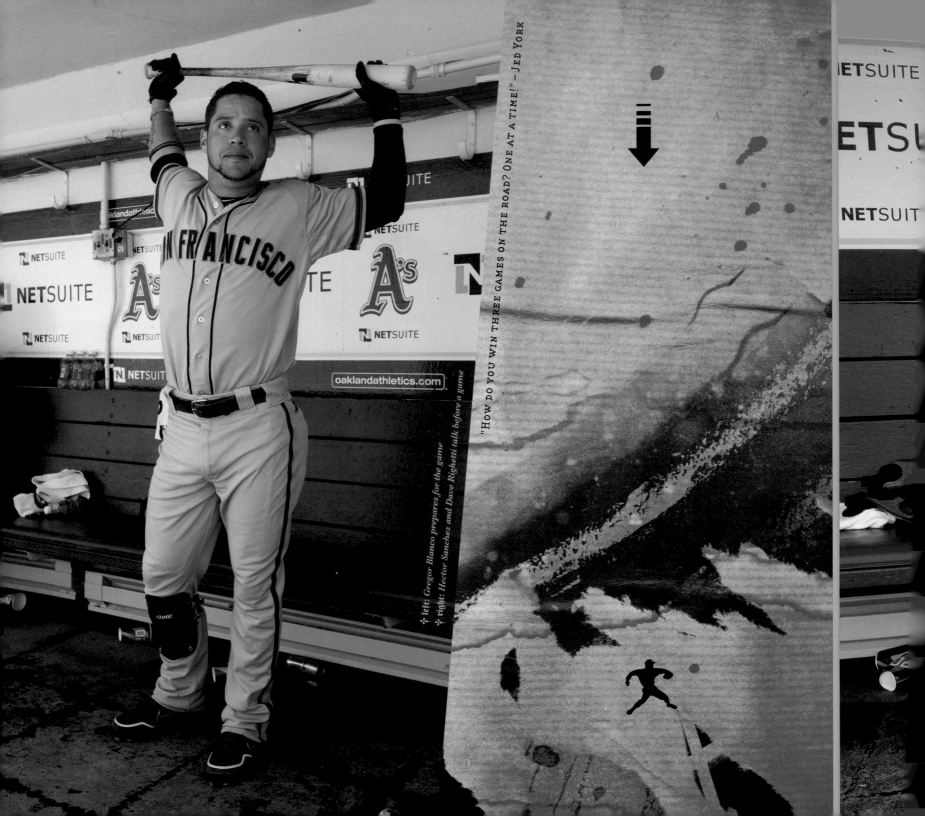

left: Gregor Blanco prepares for the game
right: Hector Sanchez and Dave Righetti talk before a game

"HOW DO YOU WIN THREE GAMES ON THE ROAD? ONE AT A TIME!" – JED YORK

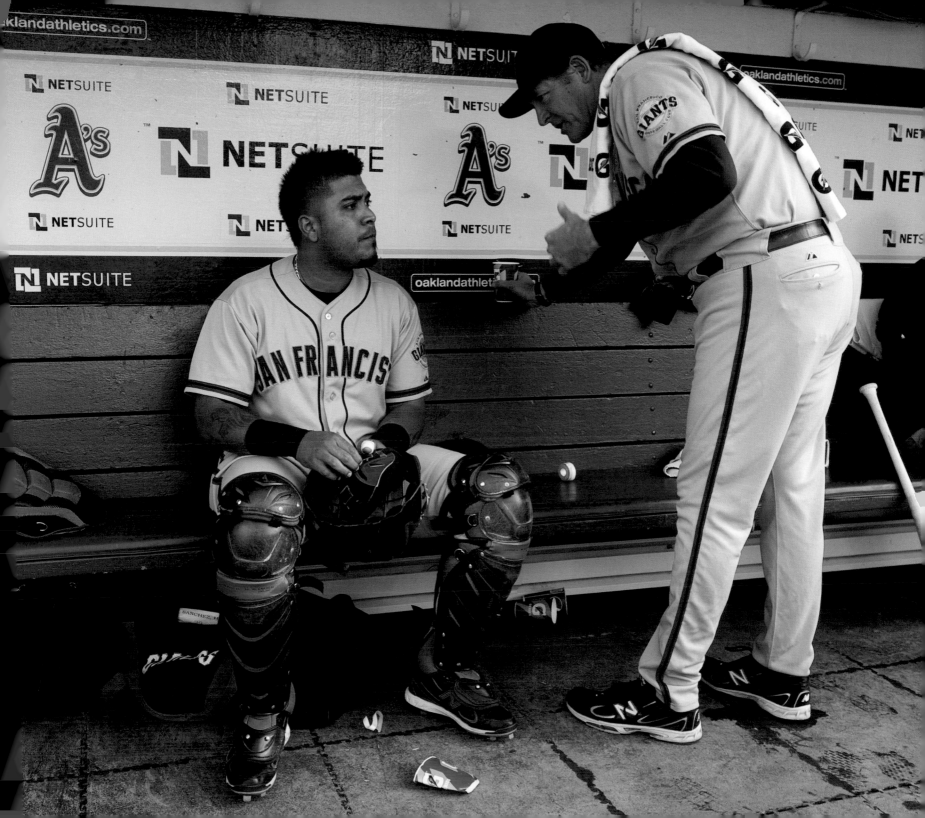

SEND. HIM. HOME.

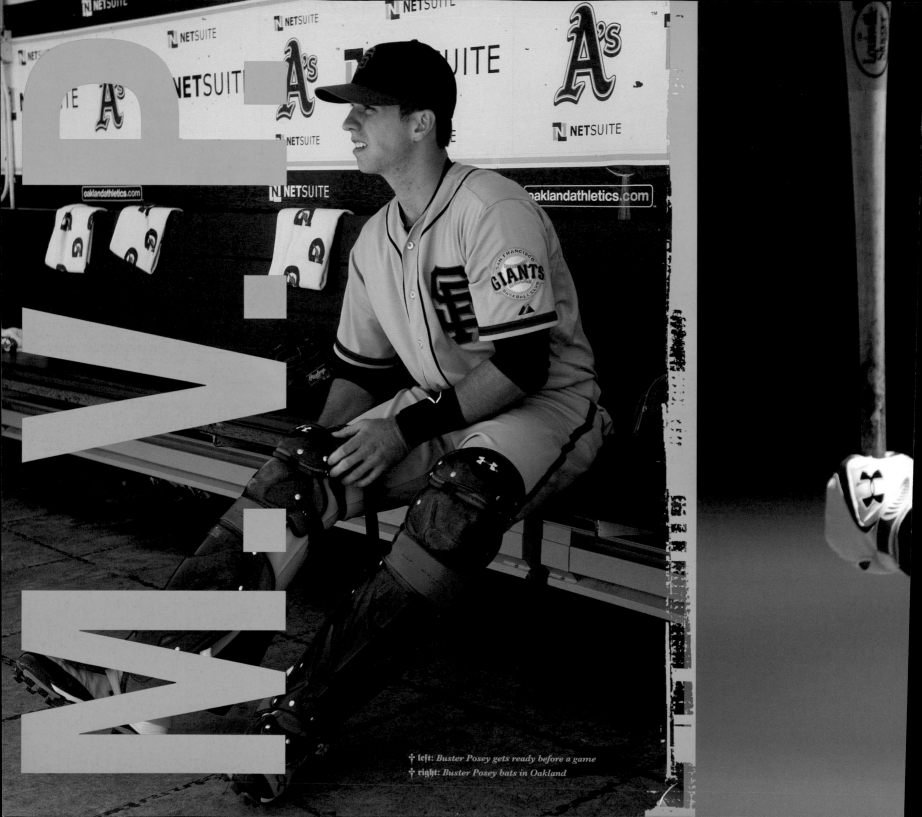

† left: *Buster Posey gets ready before a game*
† right: *Buster Posey bats in Oakland*

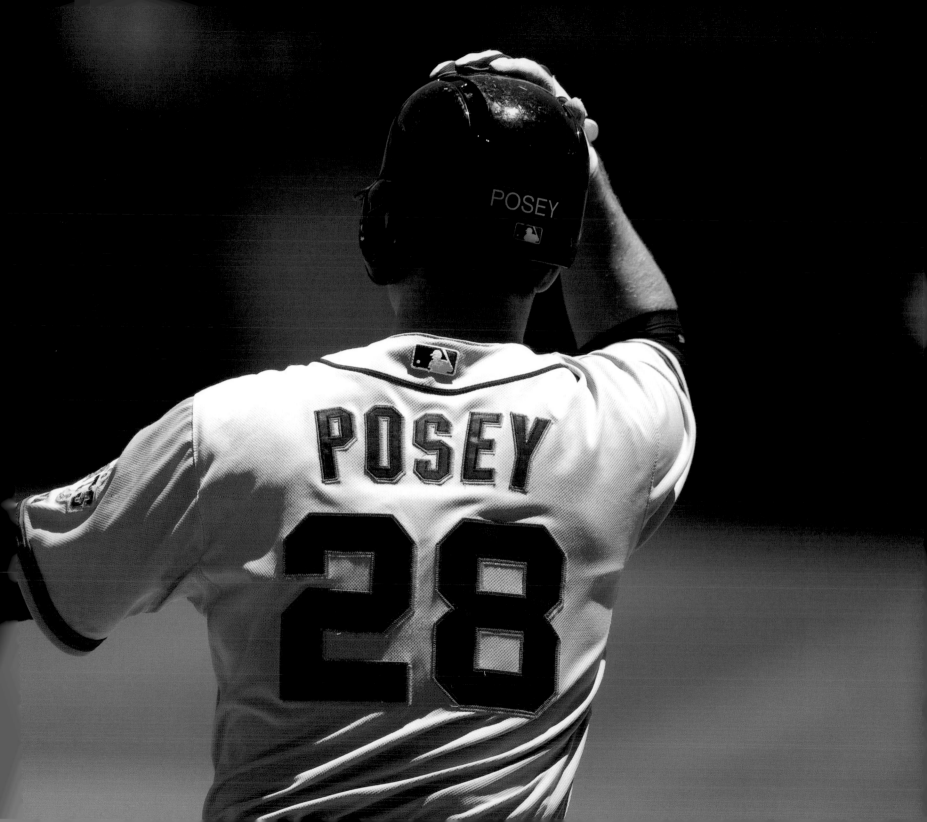

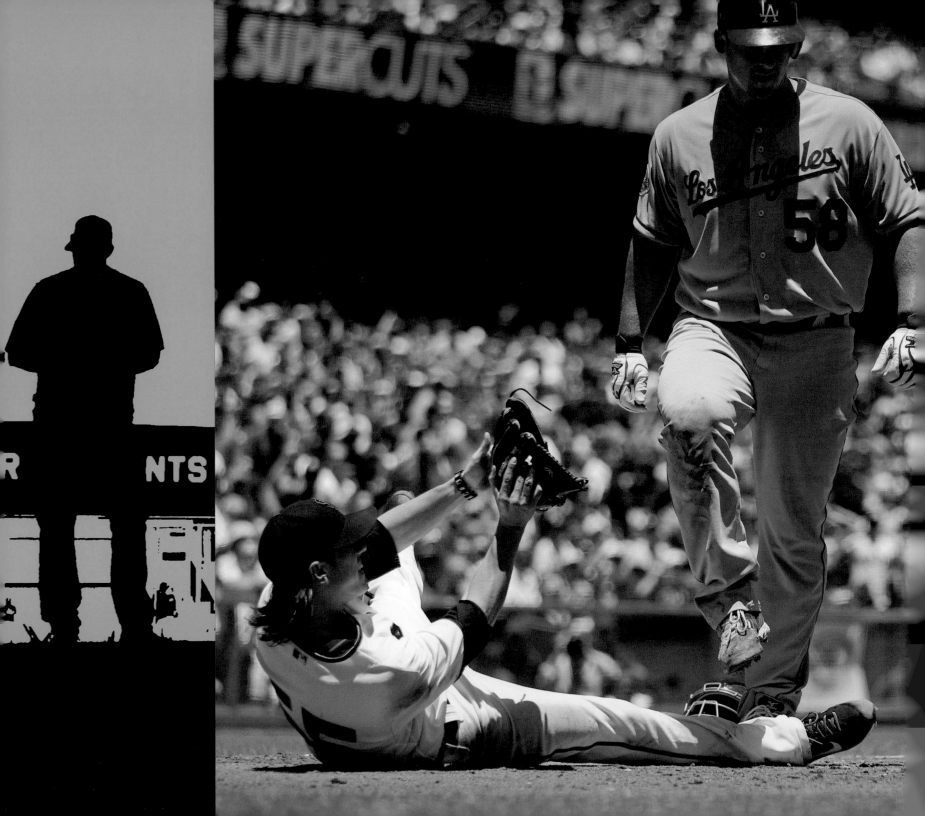

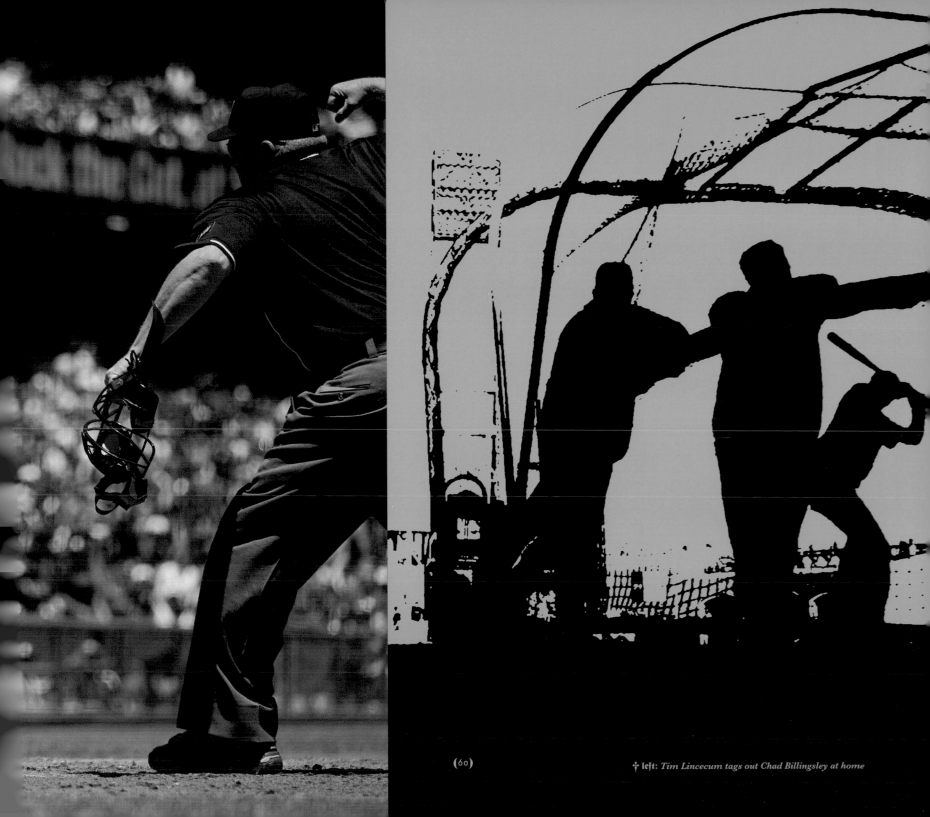

† left: *Tim Lincecum tags out Chad Billingsley at home*

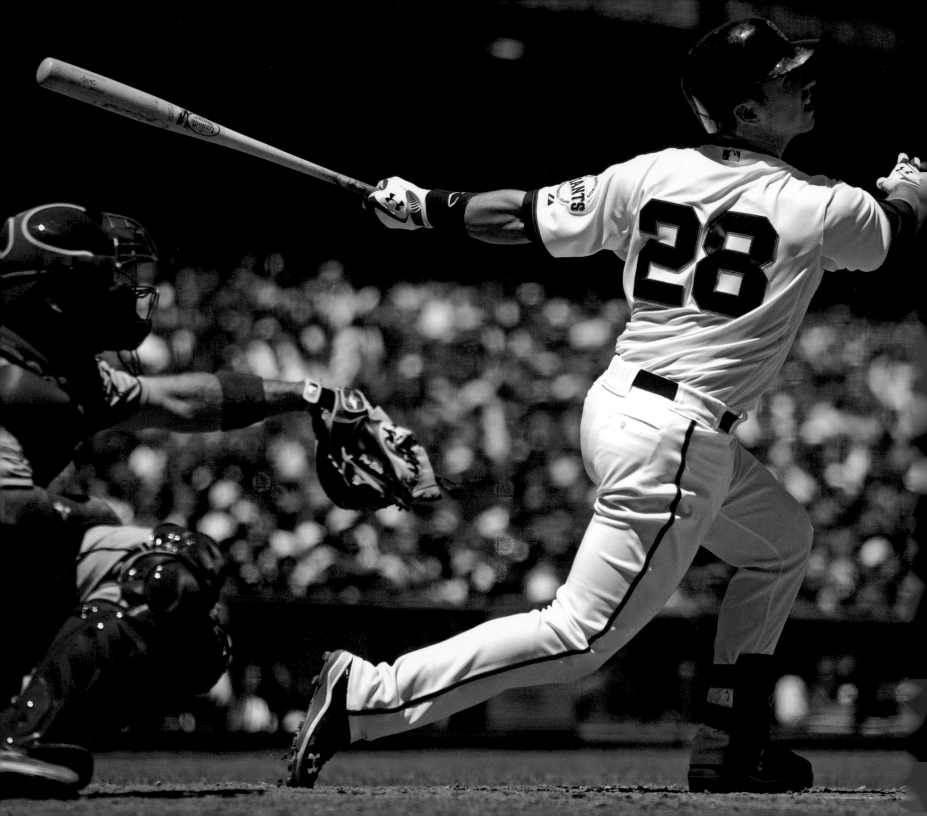

BRING. 'EM. ON.

✝ left: Buster Posey goes to right field
✝ right: Buster Posey scores the winning run

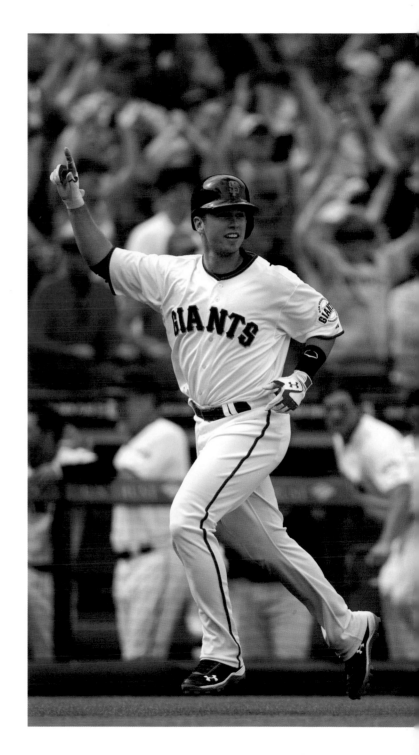

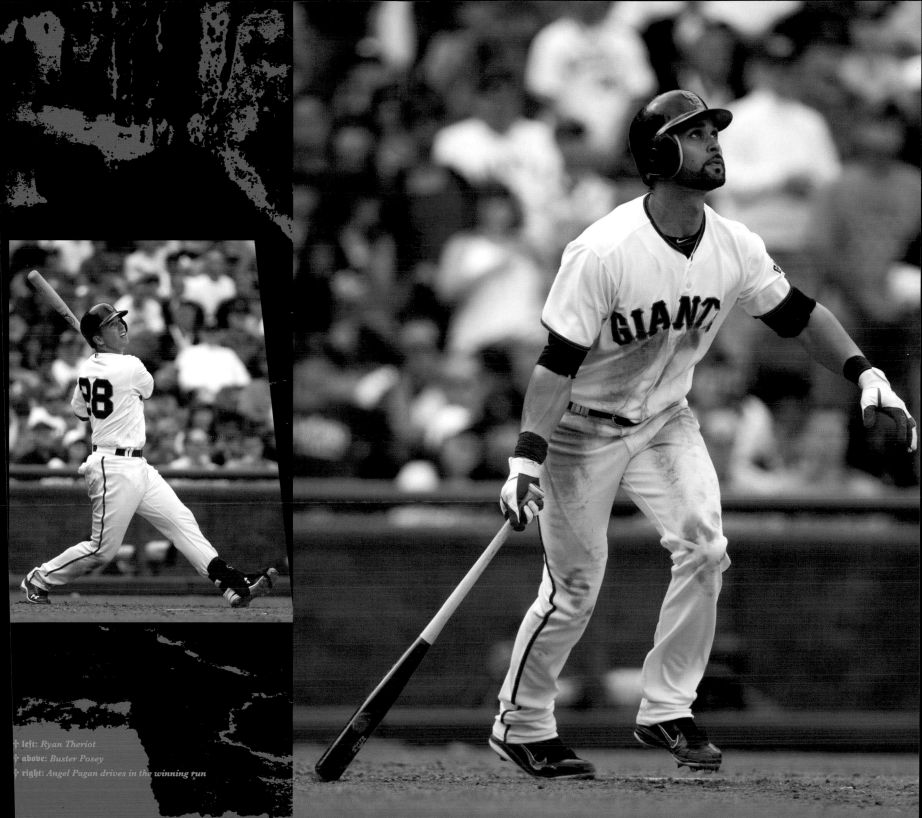

† left: *Ryan Theriot*
† above: *Buster Posey*
† right: *Angel Pagan drives in the winning run*

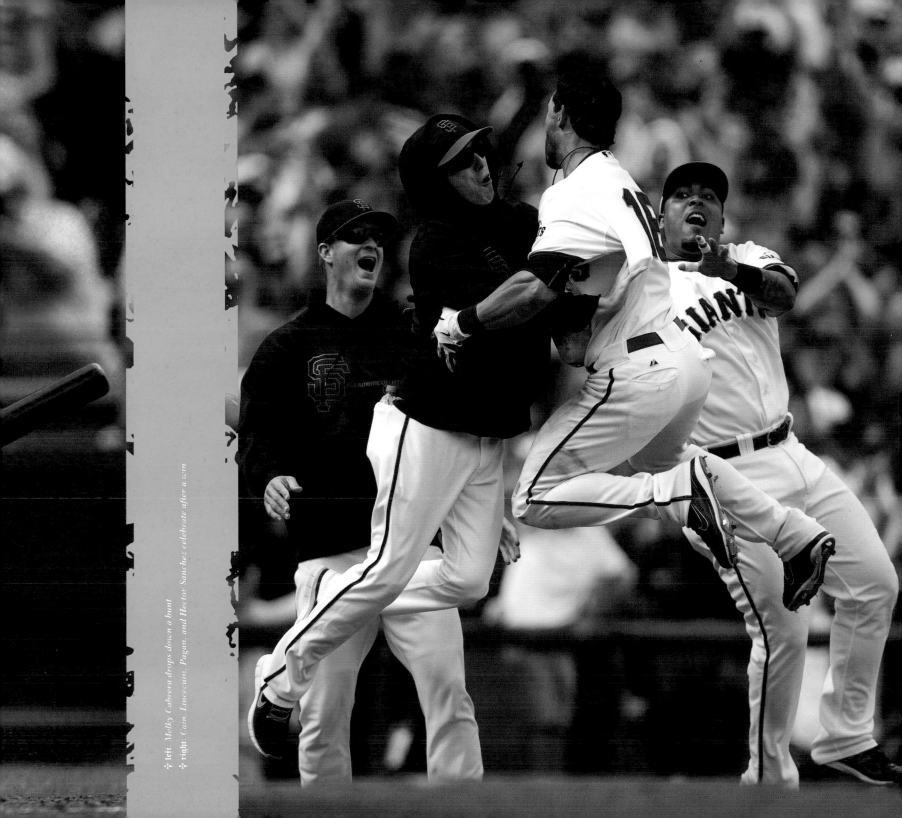

HEY BATTER BATTER!

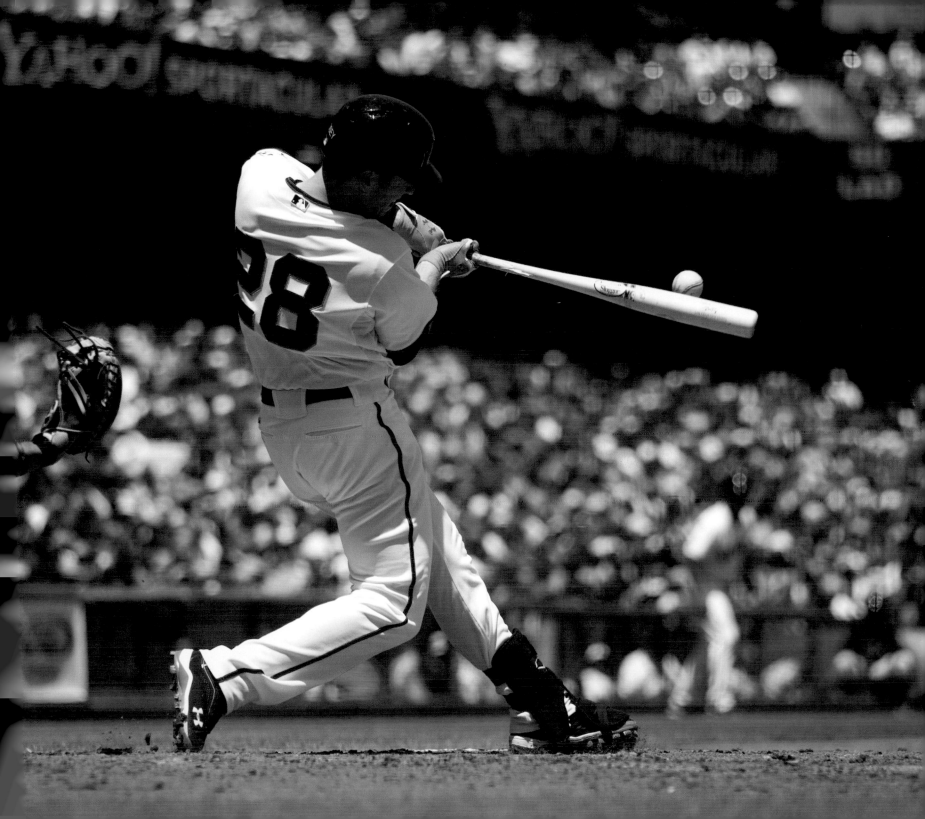

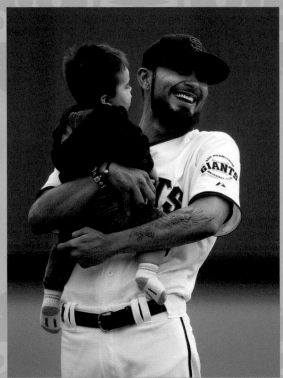

❖ left: *Family Day: Javier Lopez; Sergio Romo and his son; coach Ron Wotus*
❖ right: *Buster Posey takes batting practice*

(69)

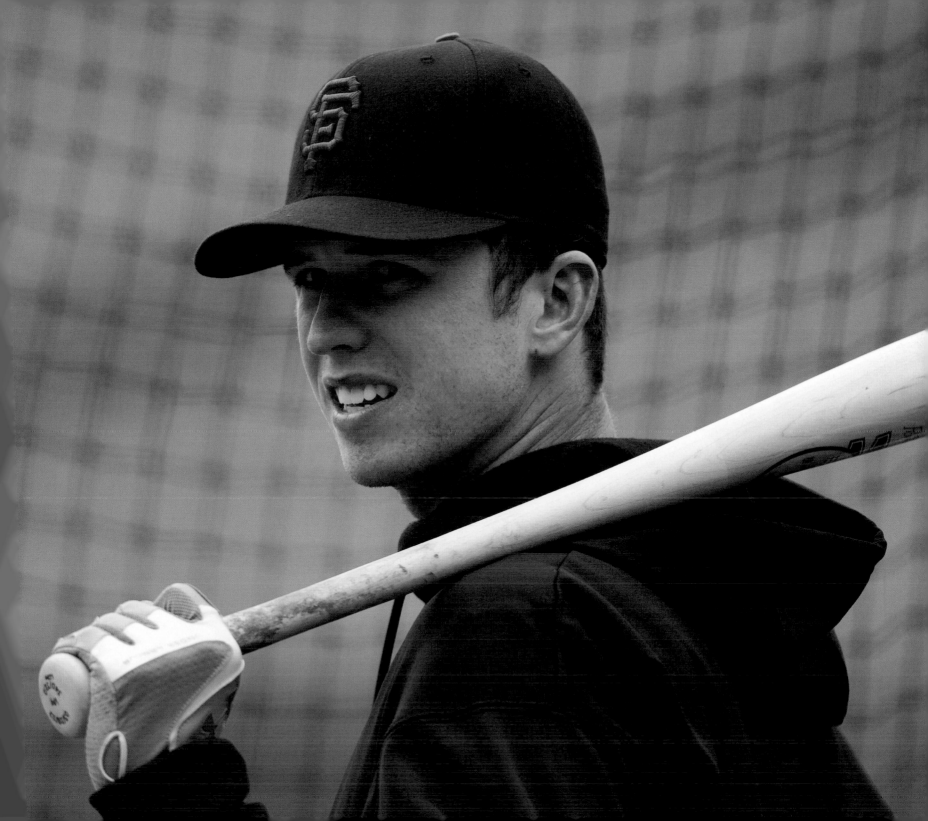

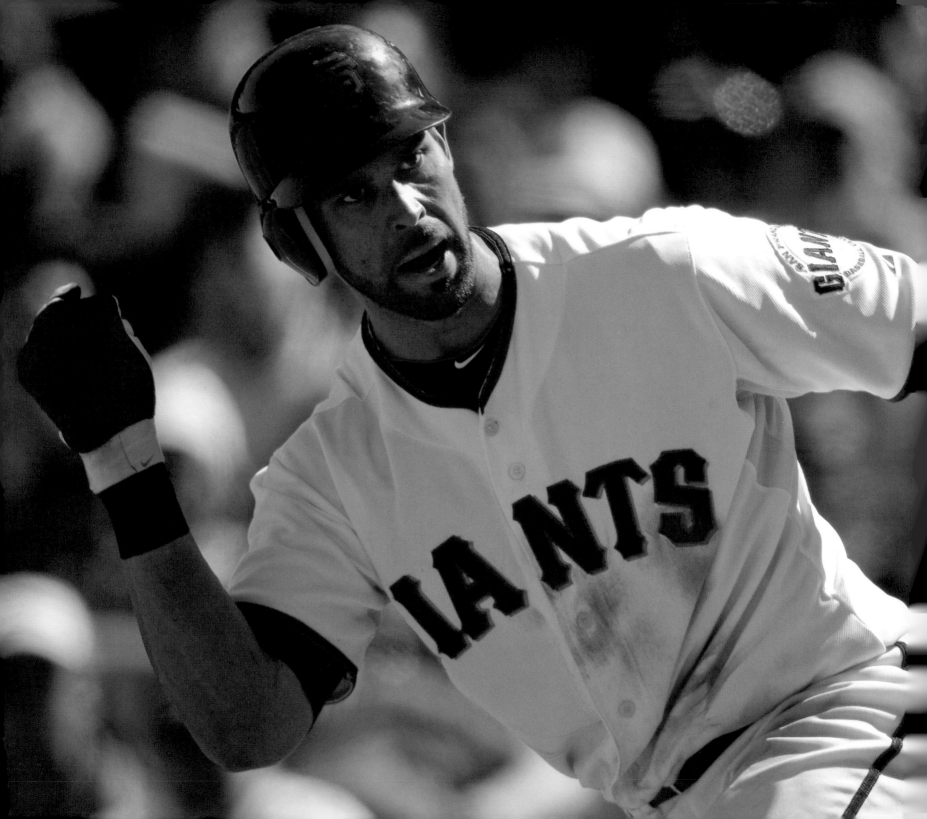

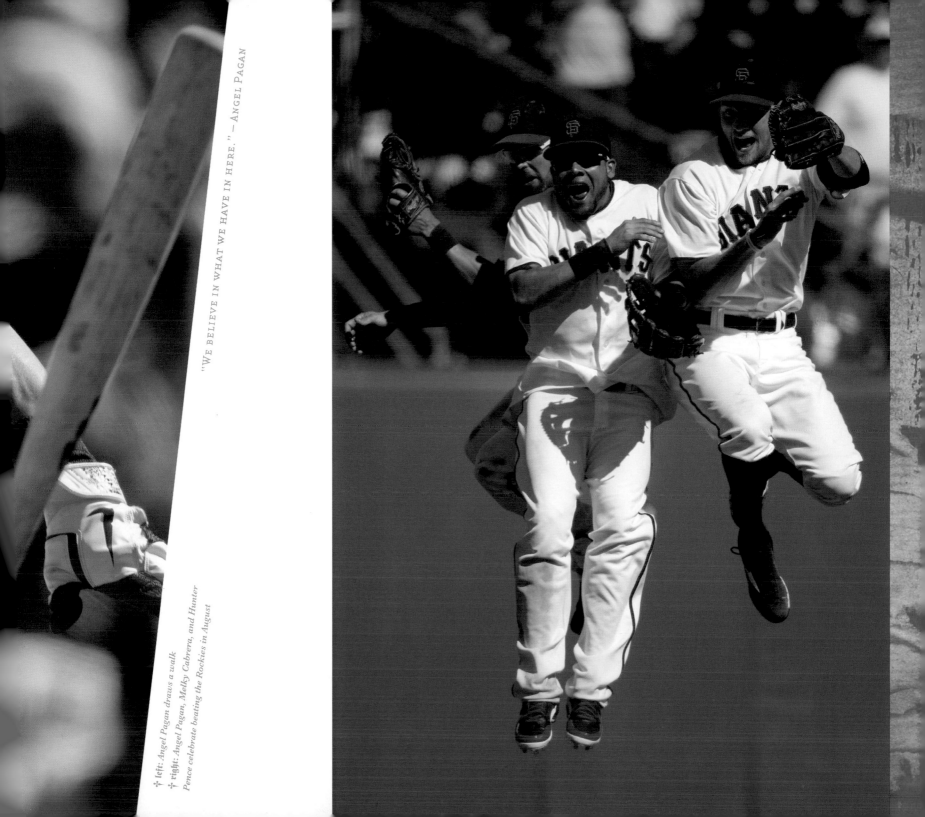

"WE BELIEVE IN WHAT WE HAVE IN HERE." — ANGEL PAGAN

✝ **left:** *Angel Pagan draws a walk.*
✝ **right:** *Angel Pagan, Melky Cabrera, and Hunter Pence celebrate beating the Rockies in August*

BRING.

THE. HEAT.

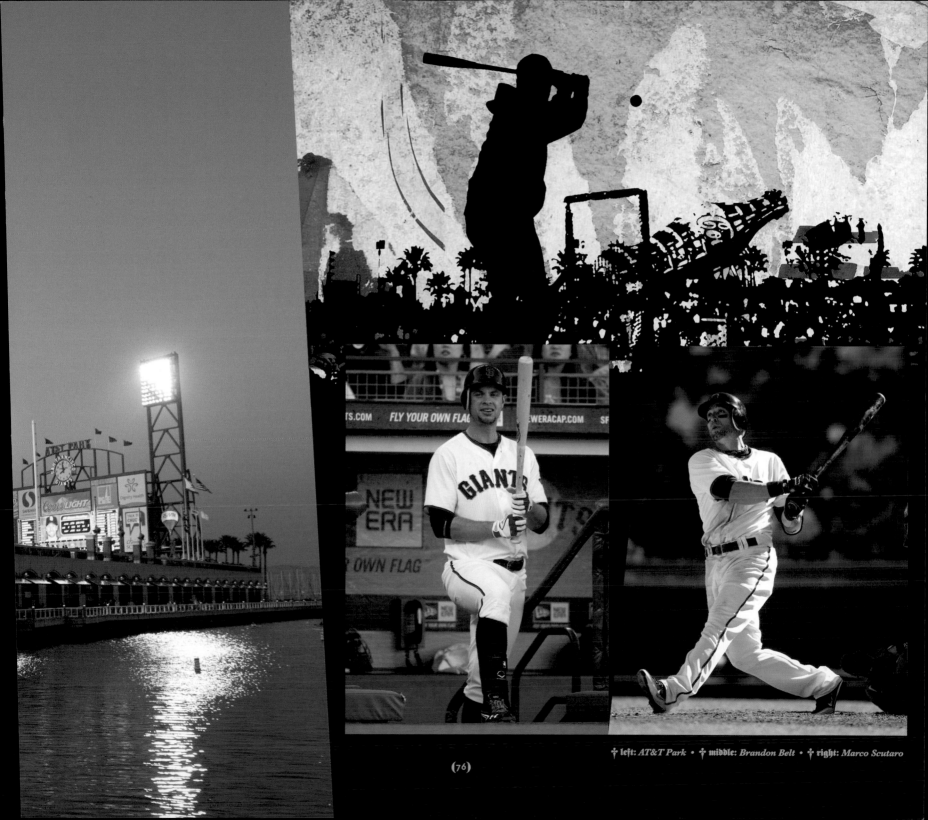

† left: *AT&T Park* • † middle: *Brandon Belt* • † right: *Marco Scutaro*

† left: *Madison Bumg*
† right: *Barry Zito pit*

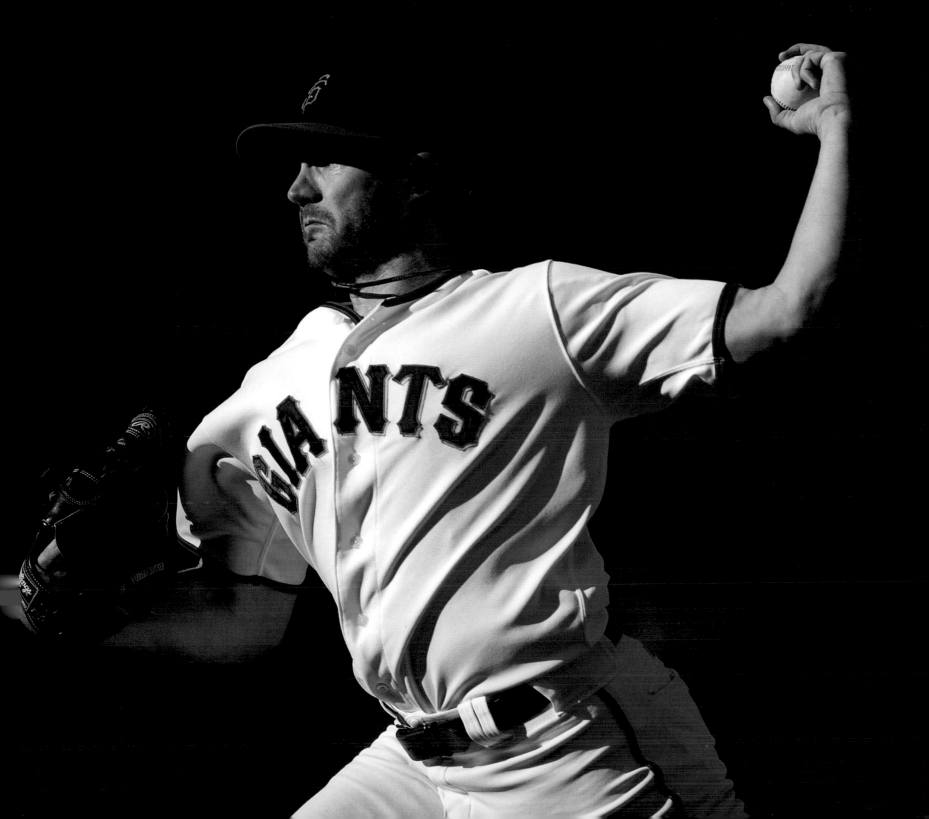

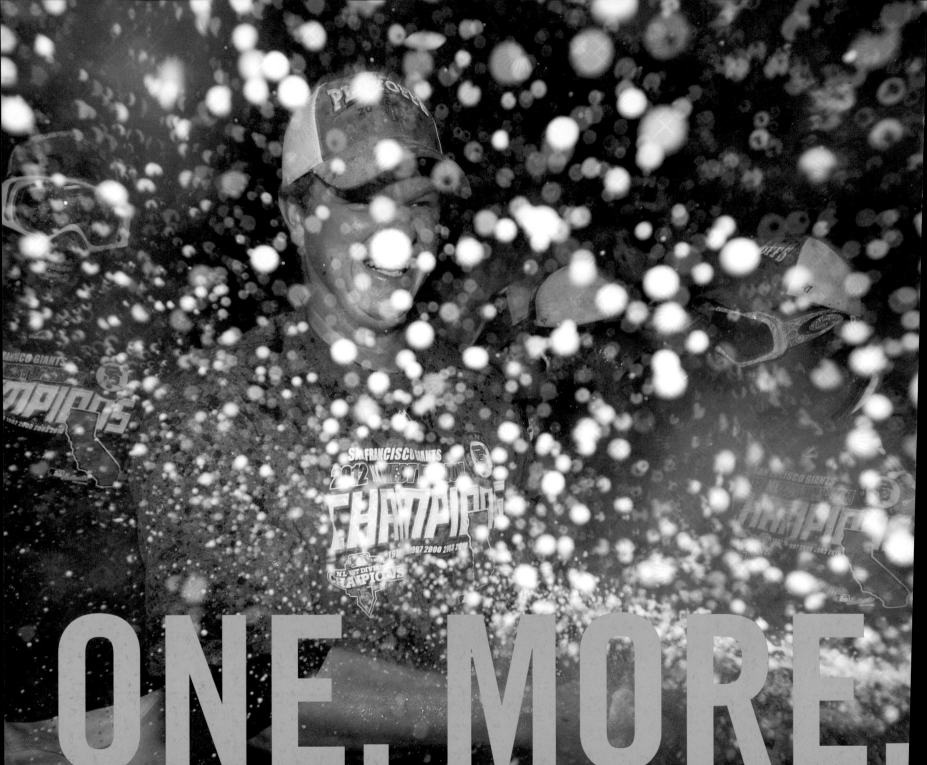

ONE. MORE.

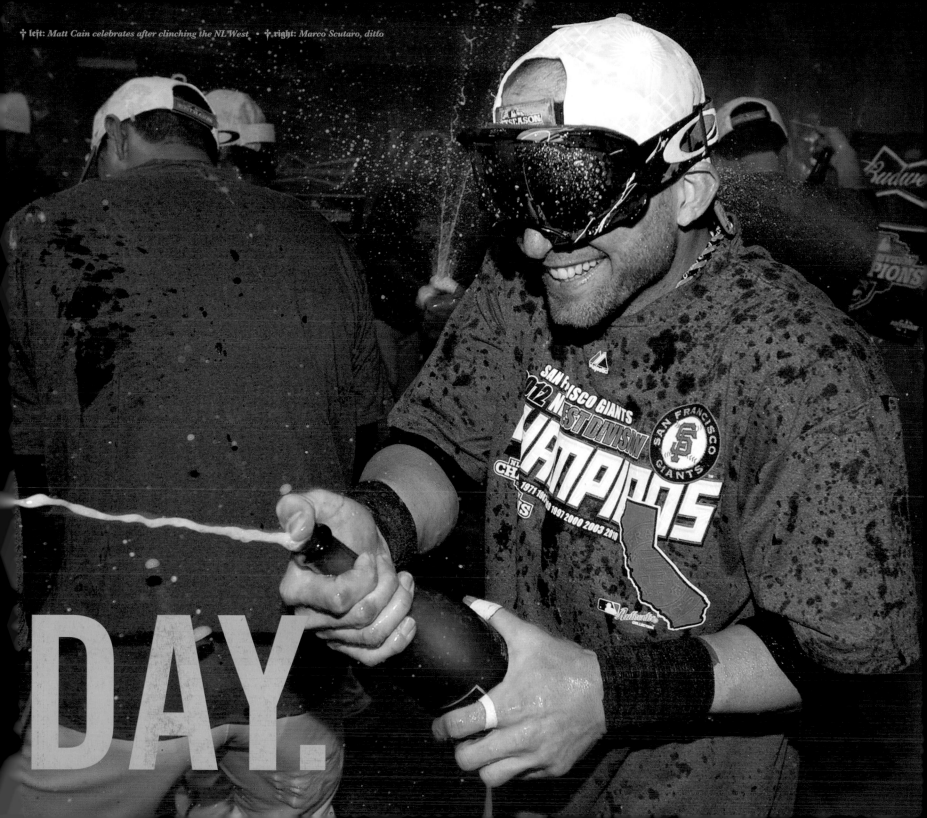

DAY.

✝: Hunter Pence

(81)

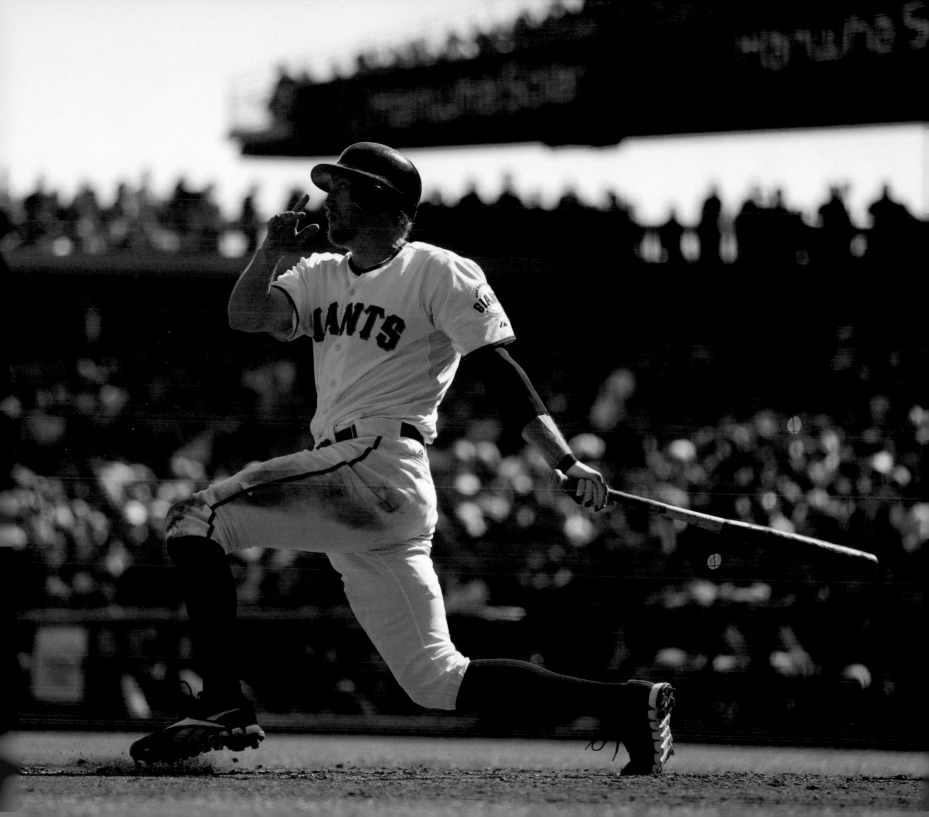

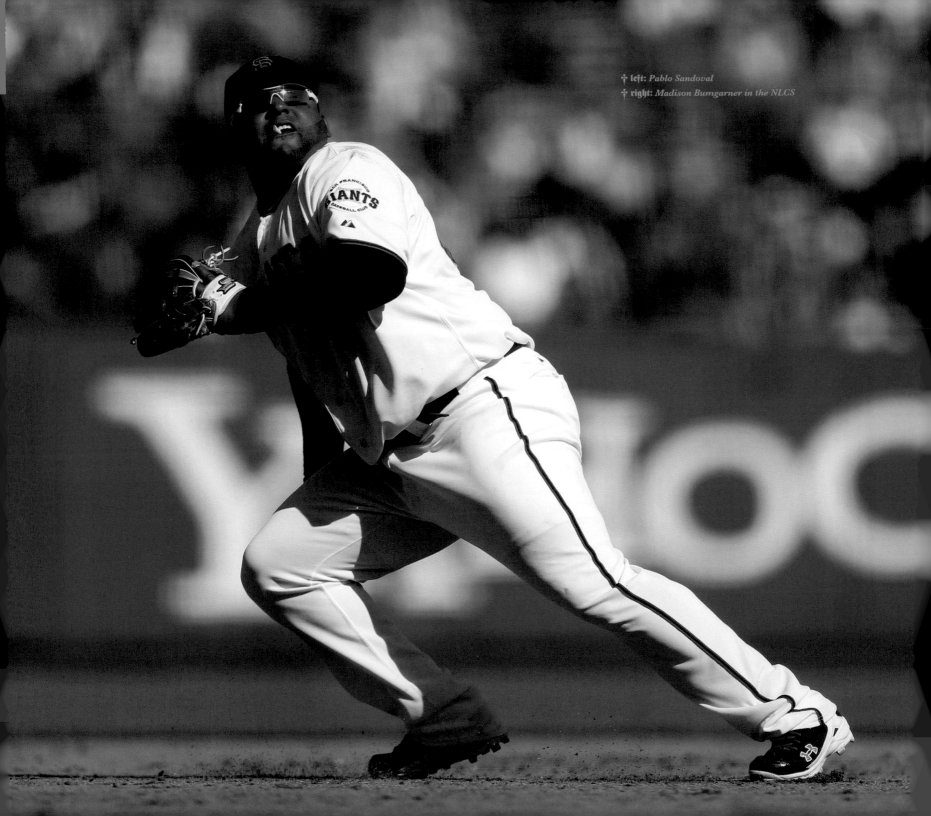

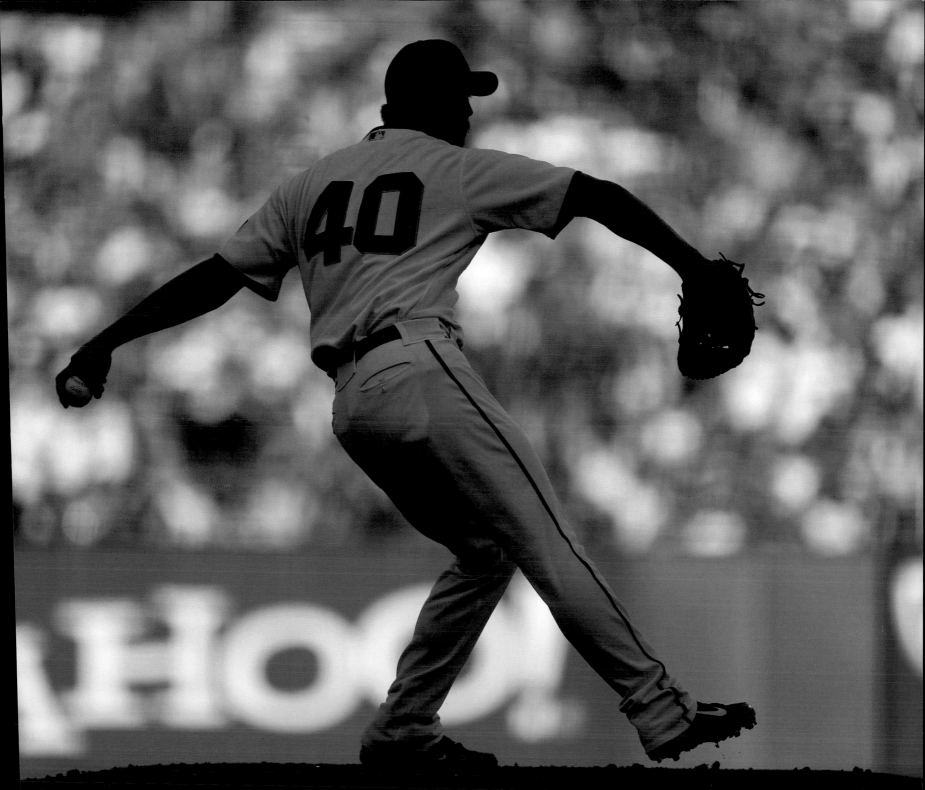

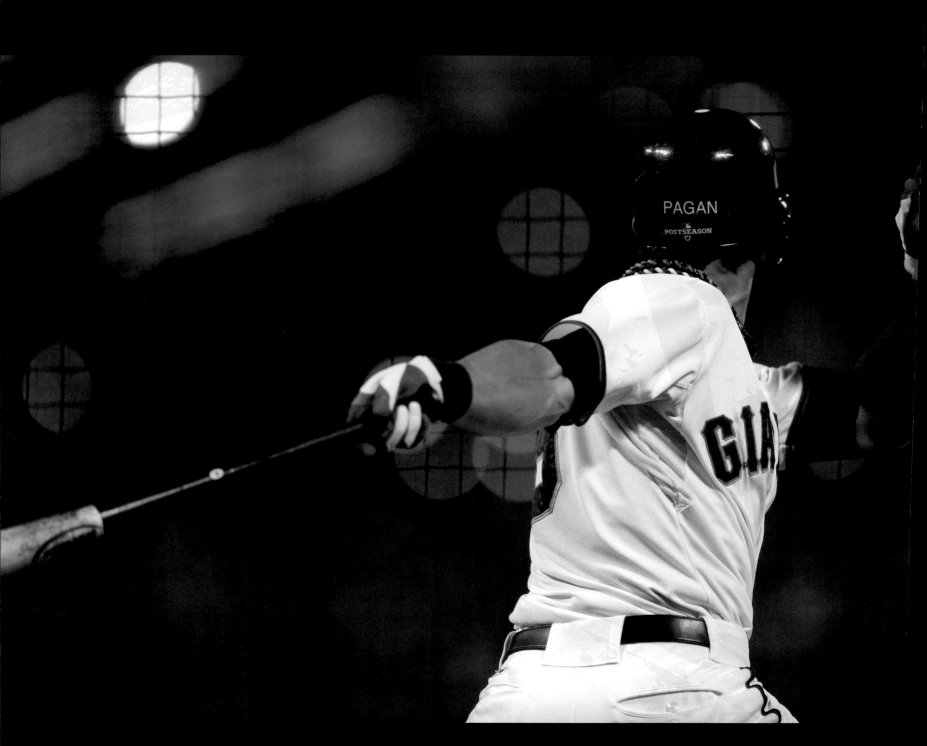

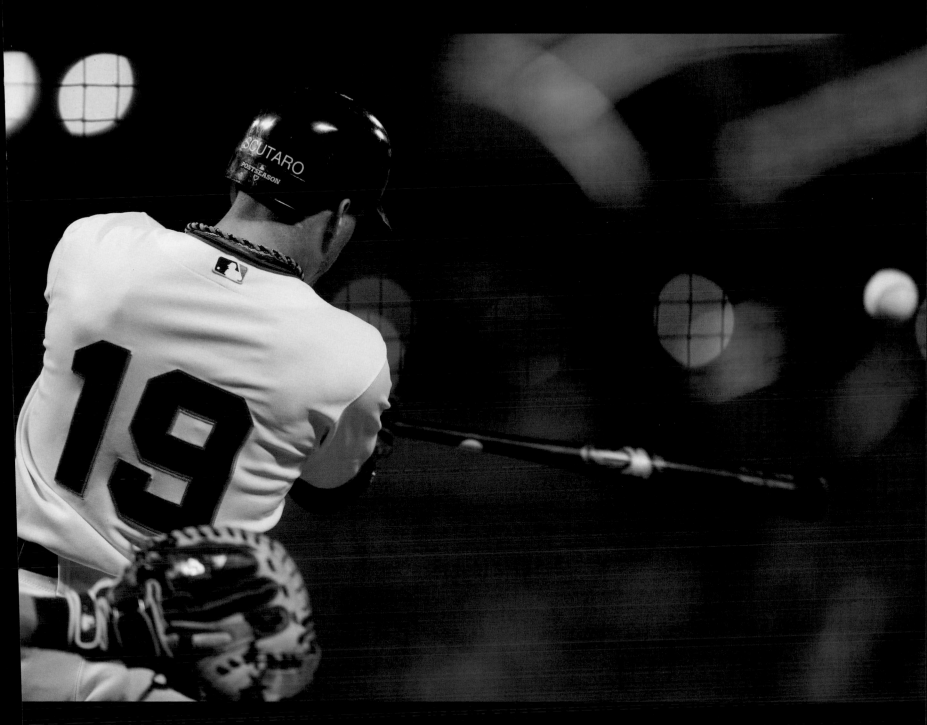

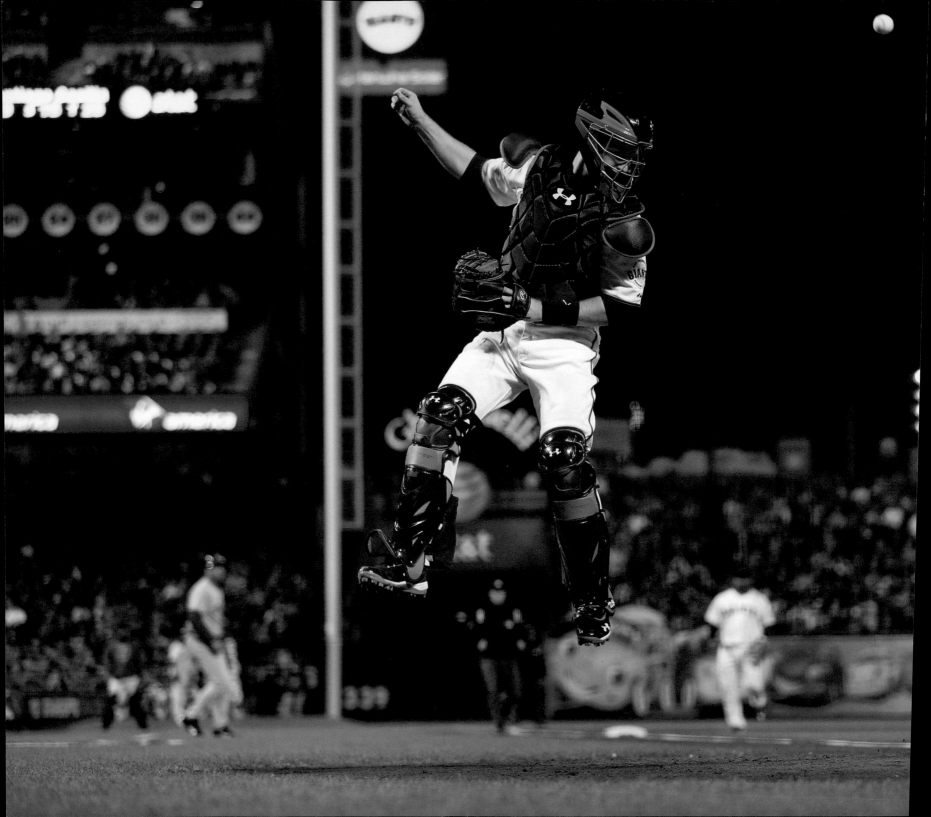

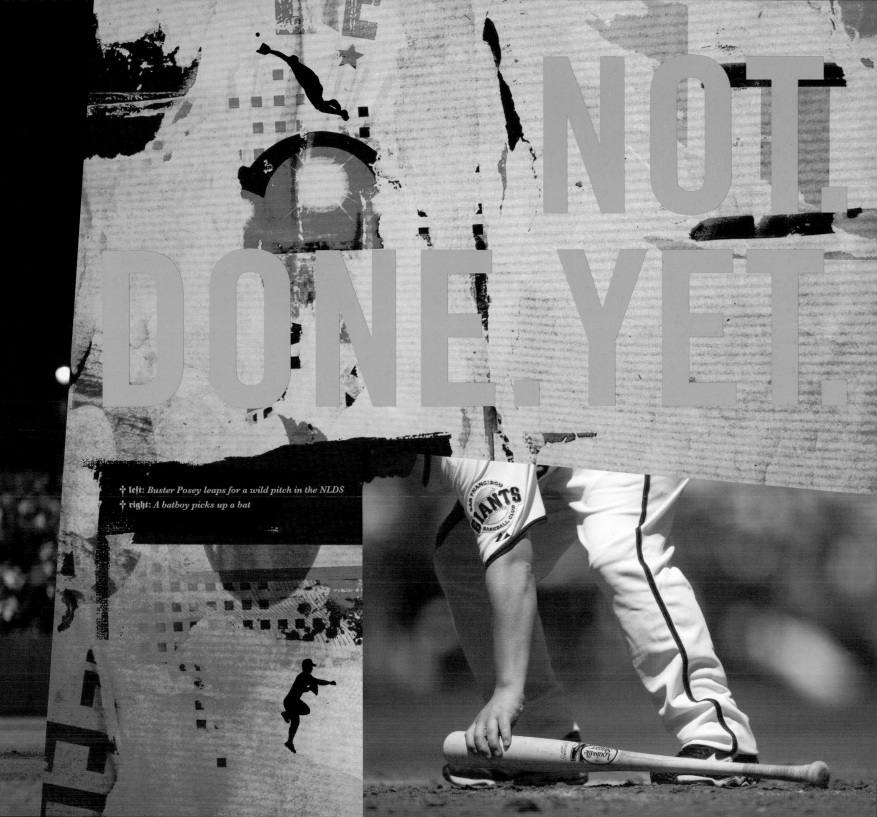

NOT.
DONE. YET.

✝ **left:** *Buster Posey leaps for a wild pitch in the NLDS*
✝ **right:** *A batboy picks up a bat*

salesforce

SOFTWARE

501

WALK·OFF
A HERO

382

2013
WORLD
BASEBALL
CLASSIC

YAHOO!

GIANTS

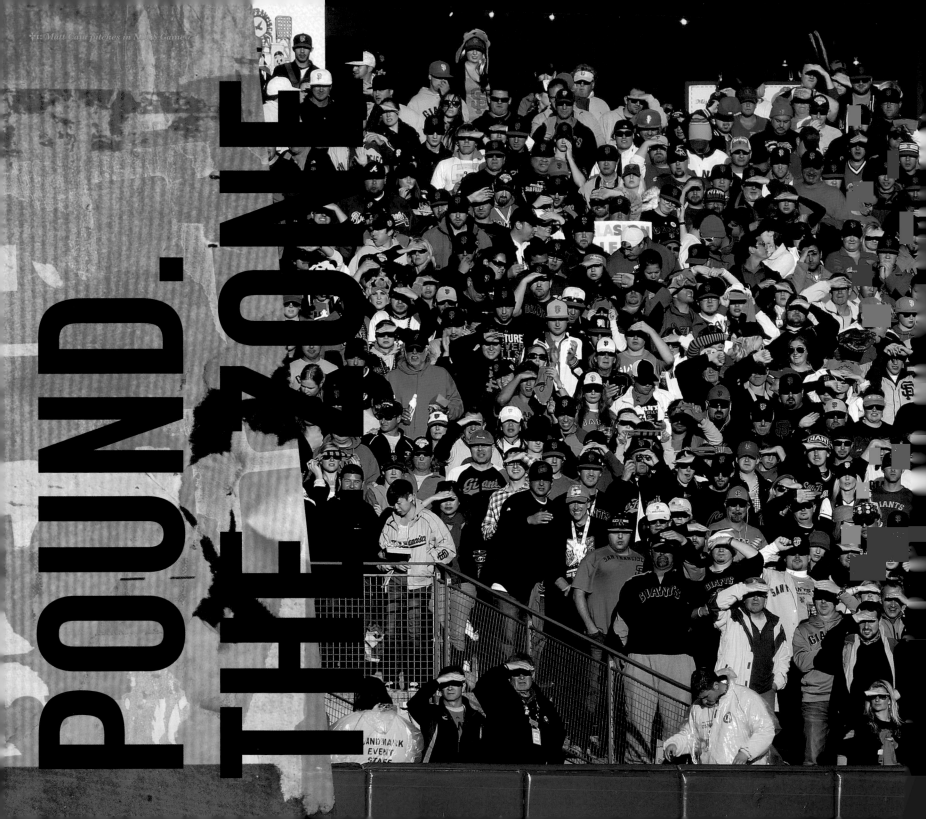

↟↟ *Matt Cain pitches in NLDS Game 7*

POUND.

THE ZONE.

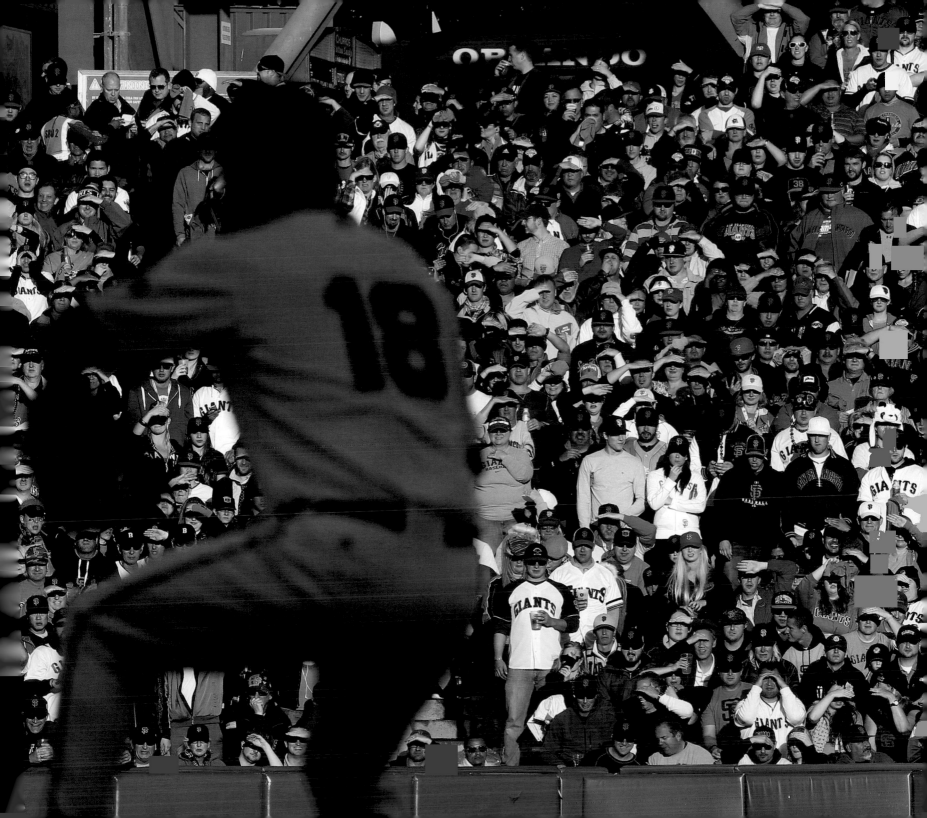

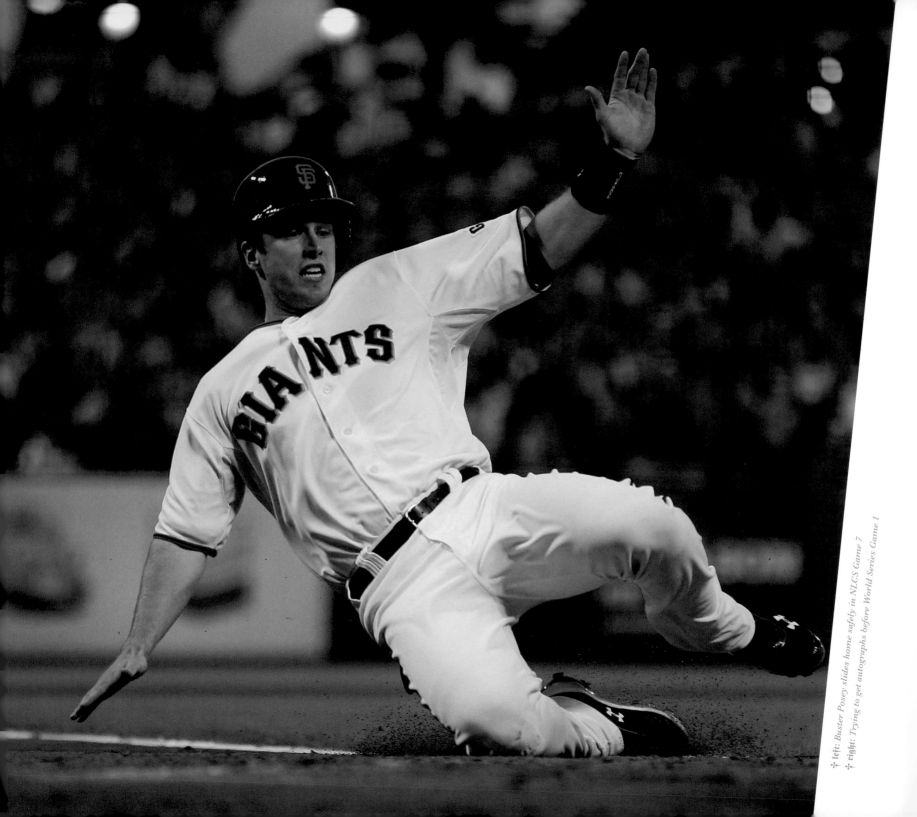

✝ left: *Buster Posey slides home safely in NLCS Game 7*

✝ right: *Trying to get autographs before World Series Game 1*

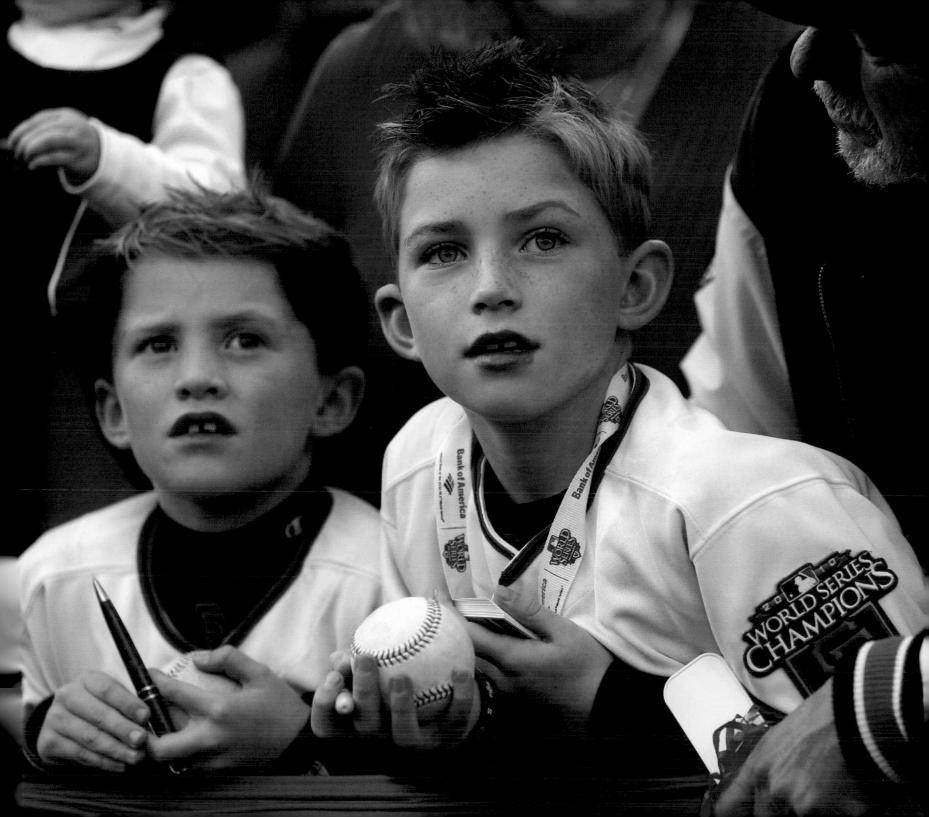

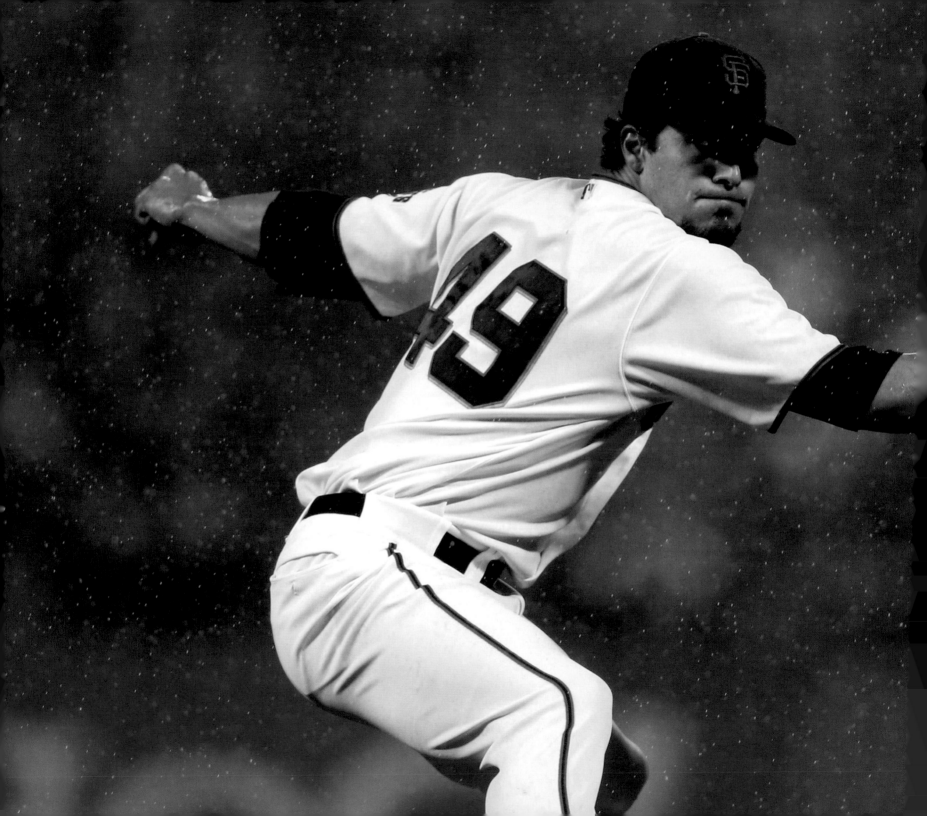

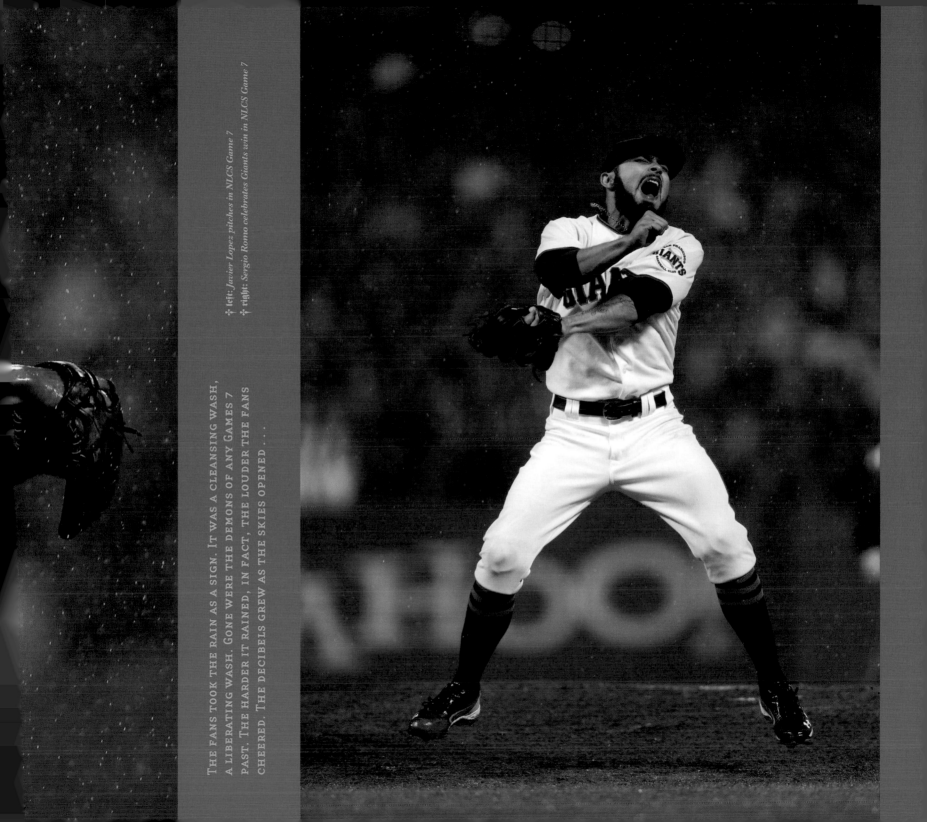

THE FANS TOOK THE RAIN AS A SIGN. IT WAS A CLEANSING WASH, A LIBERATING WASH. GONE WERE THE DEMONS OF ANY GAMES 7 PAST. THE HARDER IT RAINED, IN FACT, THE LOUDER THE FANS CHEERED. THE DECIBELS GREW AS THE SKIES OPENED . . .

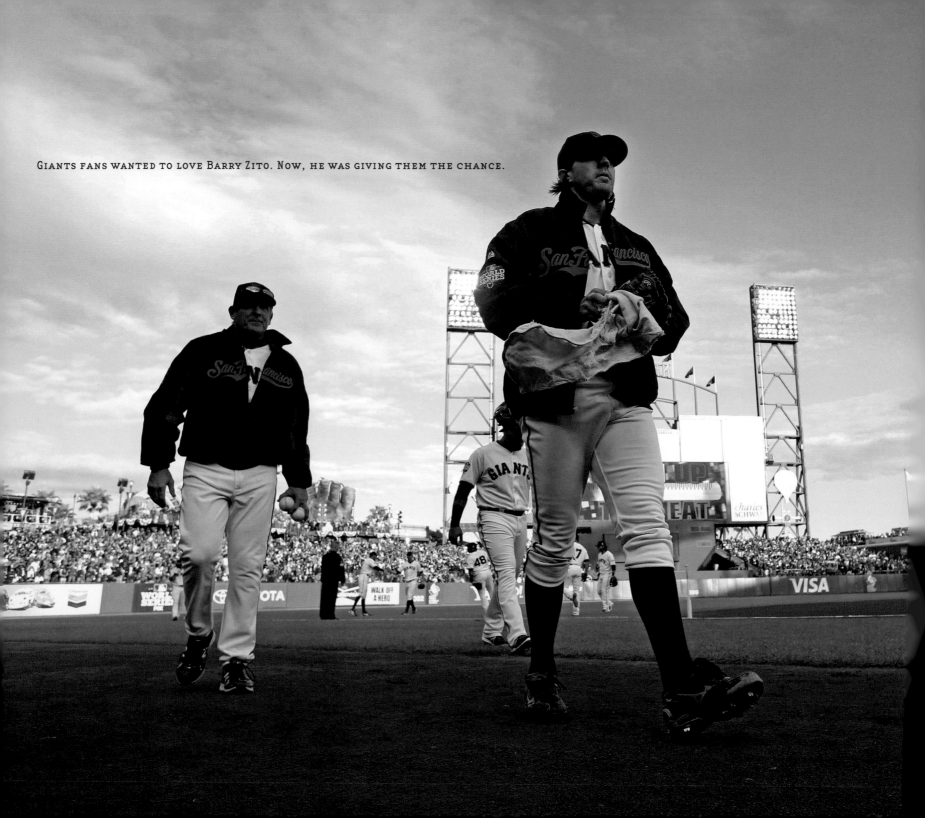

Giants fans wanted to love Barry Zito. Now, he was giving them the chance.

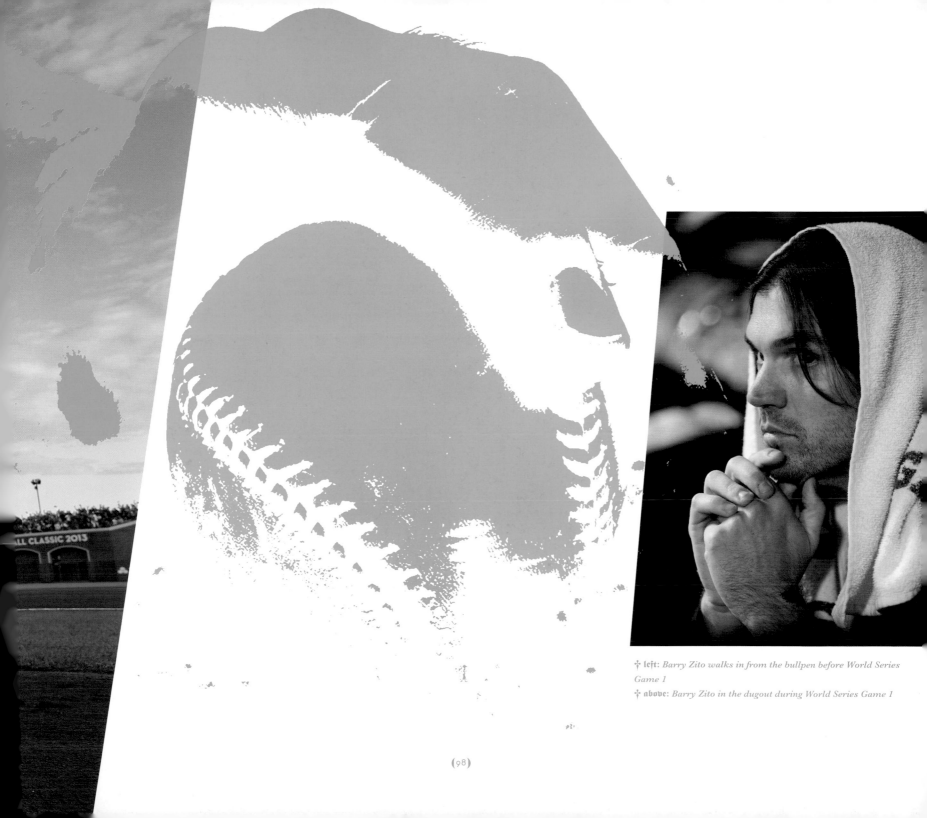

✝ left: *Barry Zito walks in from the bullpen before World Series Game 1*

✝ above: *Barry Zito in the dugout during World Series Game 1*

(98)

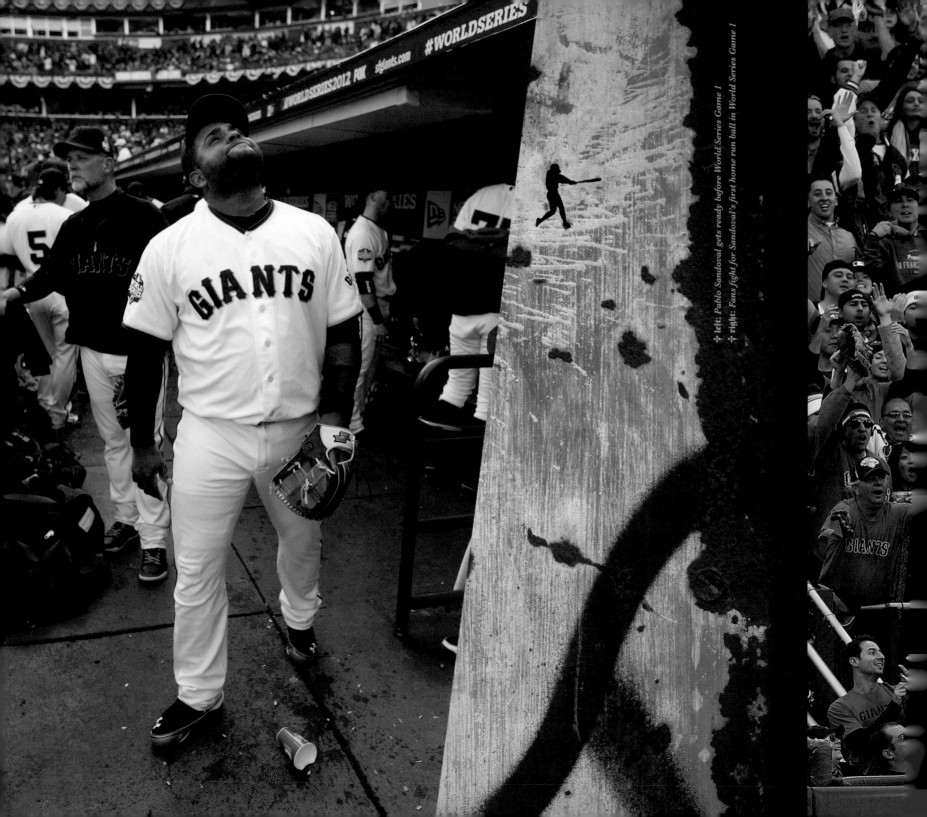

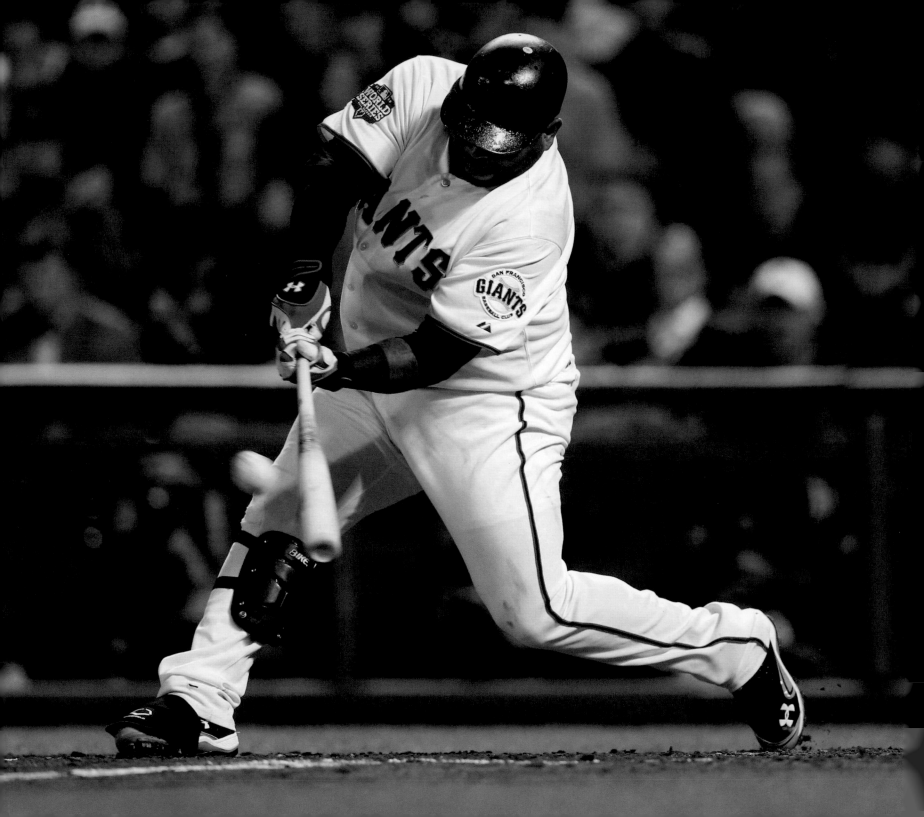

THE TRAJECTORY AND FORCE OF THE HOME RUN CALLED TO MIND THE HOME RUNS HIT BY BARRY BONDS IN HIS PRIME, AND THE BEST PART WAS THAT SANDOVAL WAS ONLY STARTING HIS HISTORIC DAY.

† **left:** *Pablo Sandoval connects for his third home run in World Series Game 1*

† **right:** *Sandoval rounds the bases after hitting his third home run*

† left: *Pablo Sandoval stands on third base in World Series Game 1*

† right: *Justin Verlander pitches to Hunter Pence, ditto*

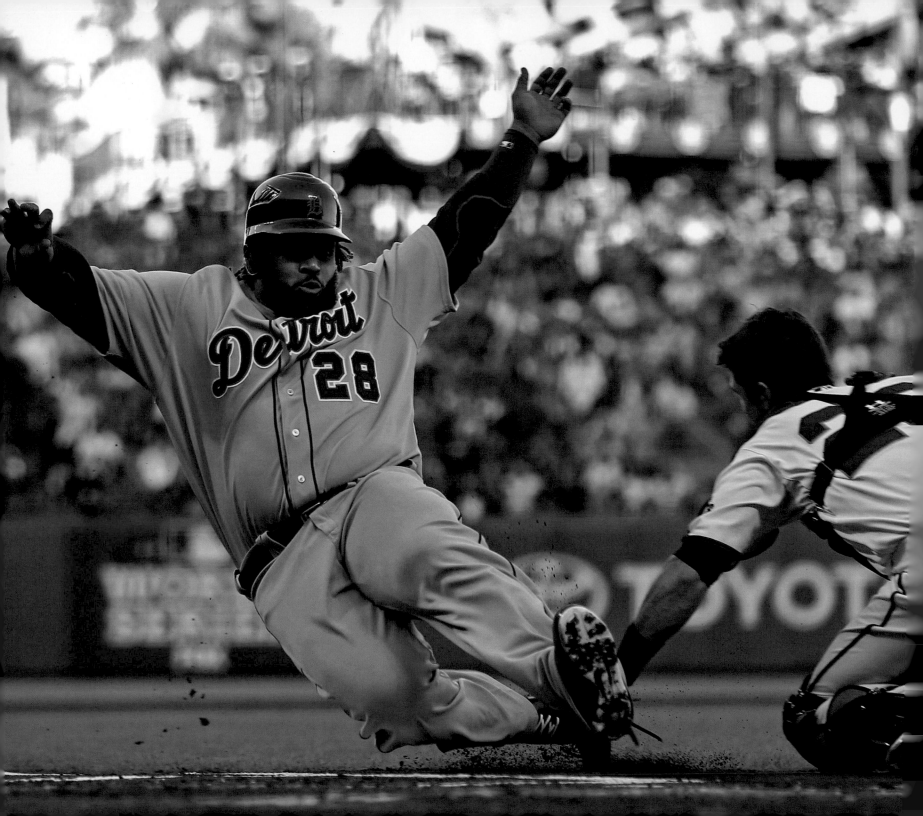

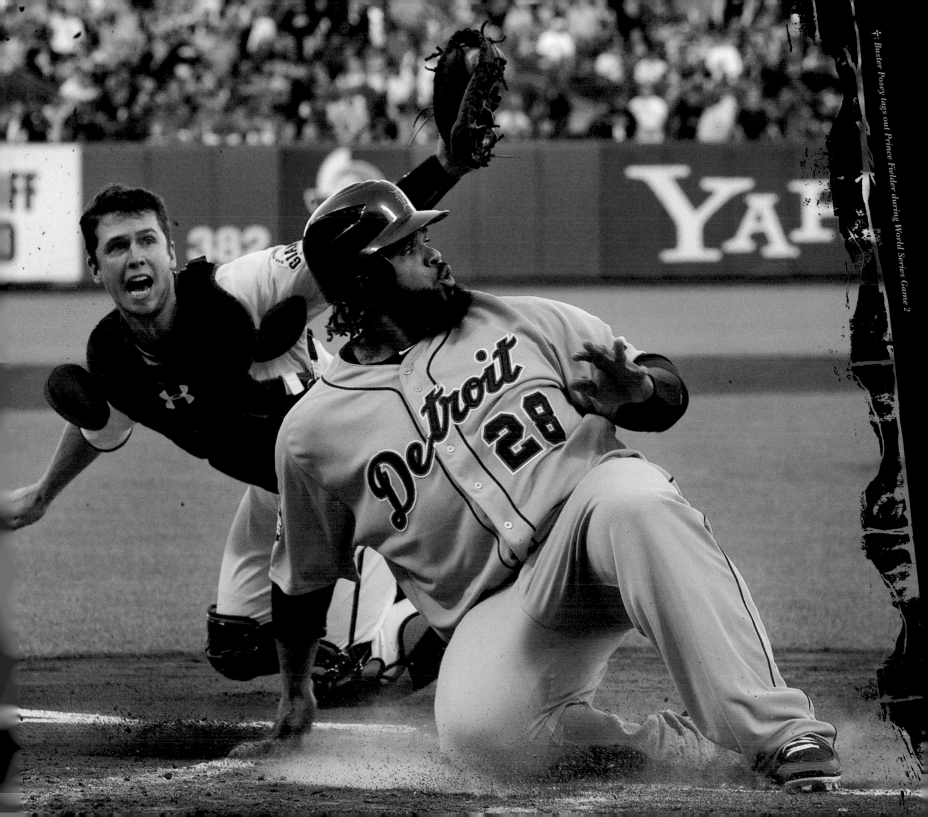

THE. FALL. CLASSIC.

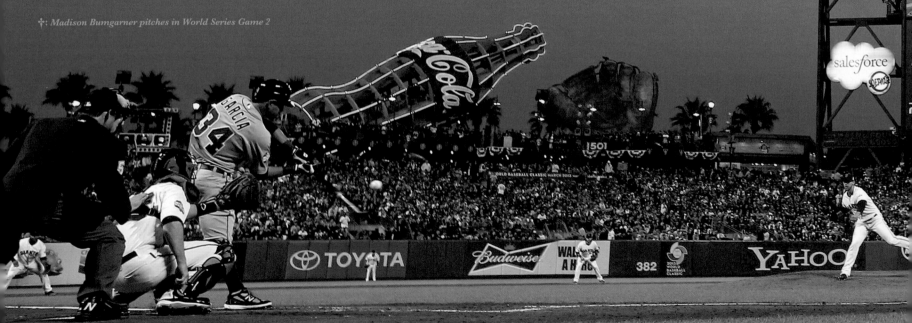

✤: *Madison Bumgarner pitches in World Series Game 2*

✛ above: *Marco Scutaro's batting helmet in Detroit*
✛ left: *Tim Lincecum pitches in World Series Game 3*
✛ right: *Giants fans cheer for their team and Vogelsong*

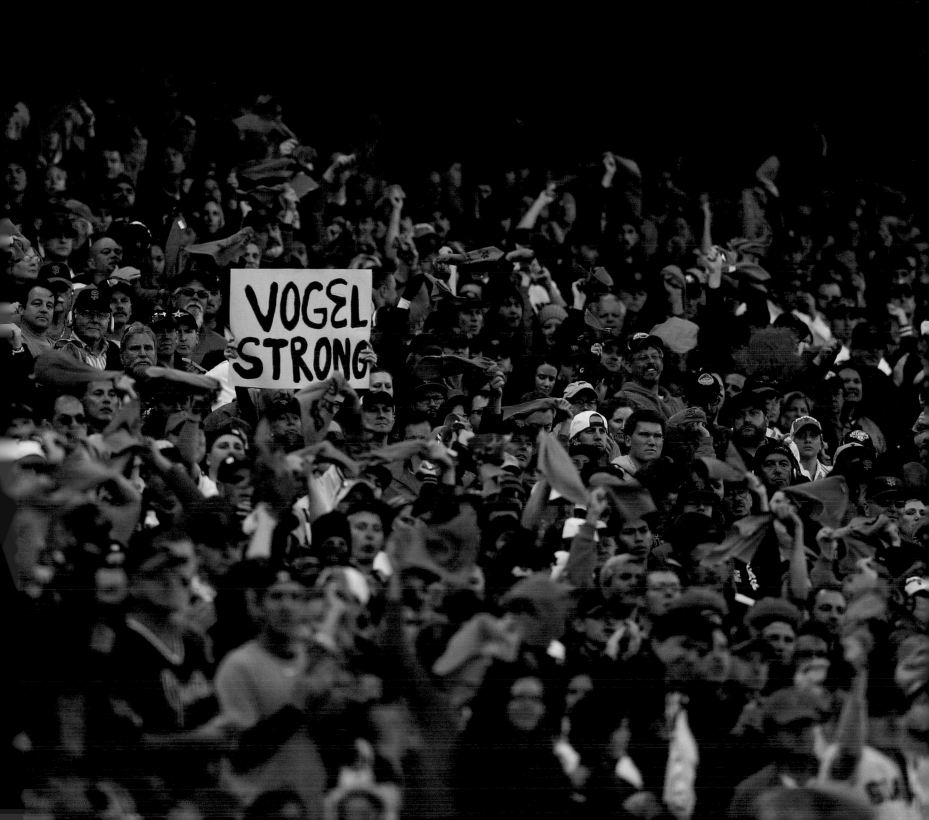

✝ **left:** *Bruce Bochy meets with writers before World Series Game 3*
✝ **below:** *Buster Posey, Bud Selig, and Hank Aaron after Posey's winning the Hank Aaron Award*
✝ **right:** *Giants autographed World Series baseballs in Detroit*

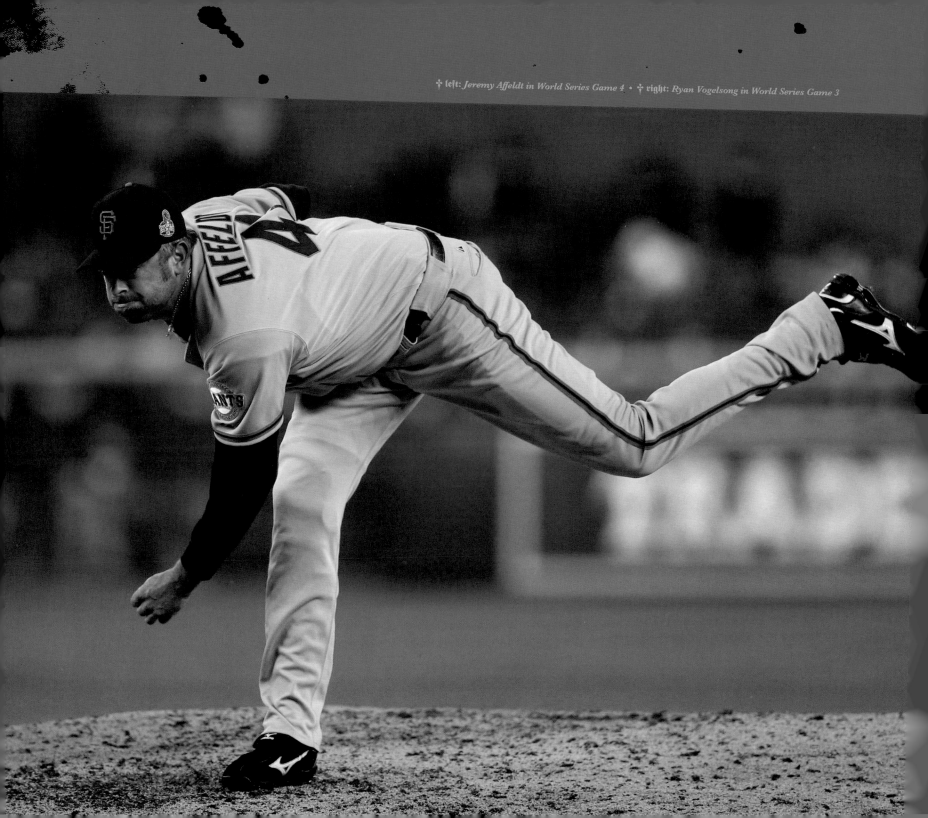

SIX CONSECUTIVE ELIMINATION GAME WINS, FOLLOWED BY A WORLD SERIES SWEEP, VAULTED THE 2012 GIANTS FROM PLAYOFF AFTERTHOUGHT TO BASEBALL LEGEND.

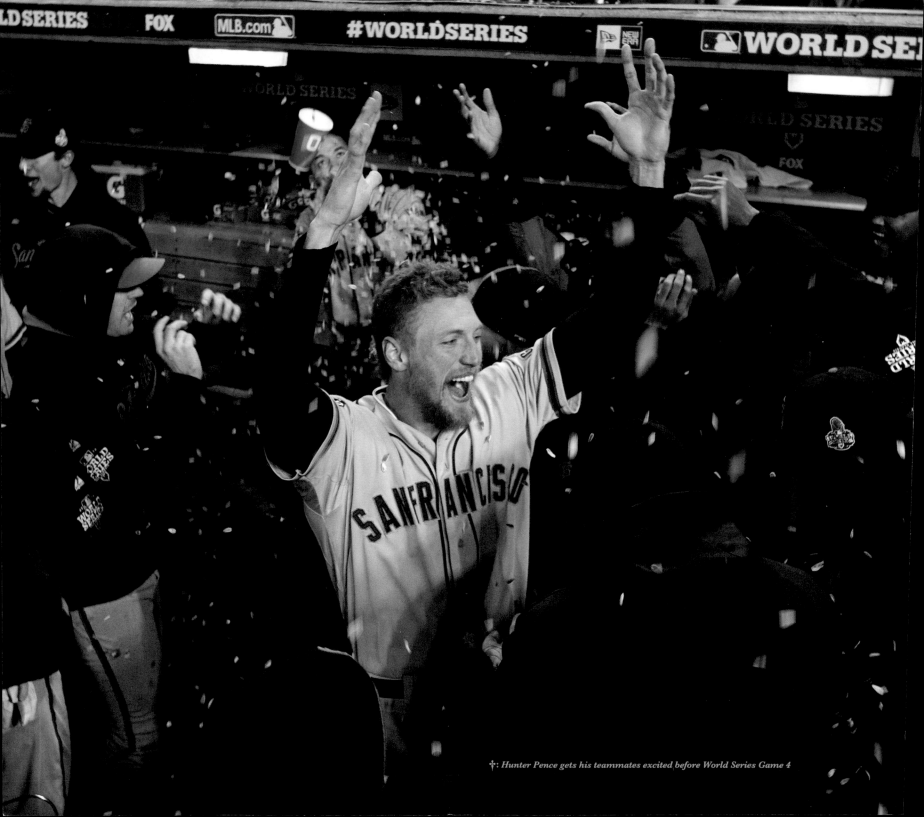

✝: *Hunter Pence gets his teammates excited before World Series Game 4*

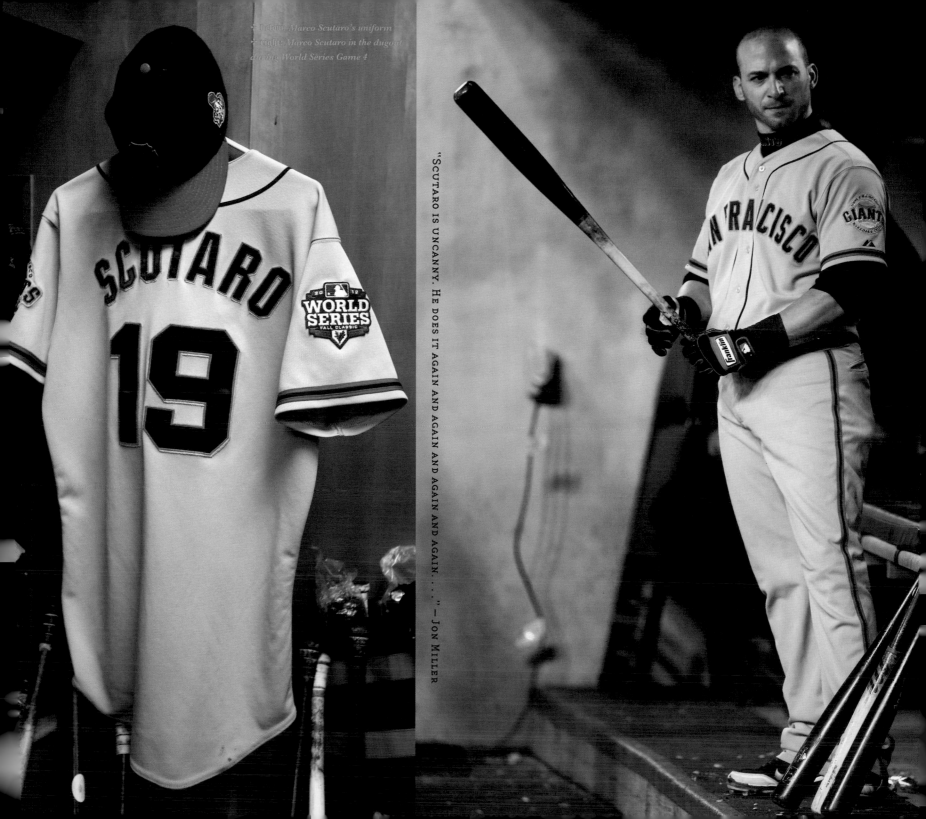

"SCUTARO IS UNCANNY. HE DOES IT AGAIN AND AGAIN AND AGAIN AND AGAIN. . . ." —JON MILLER

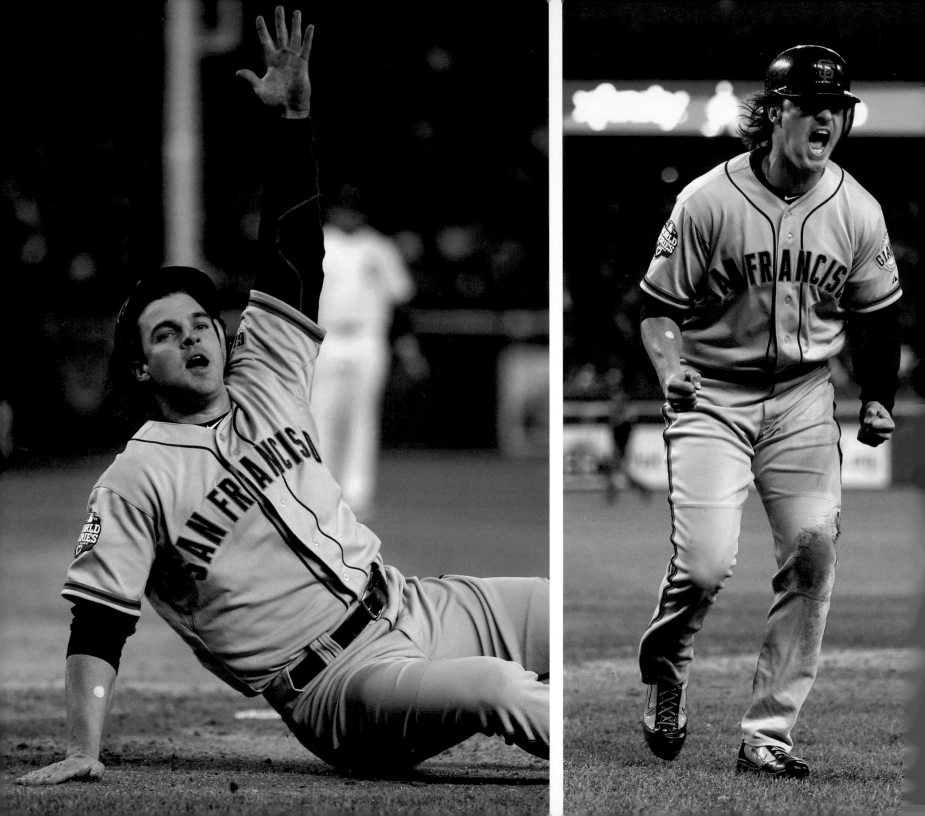

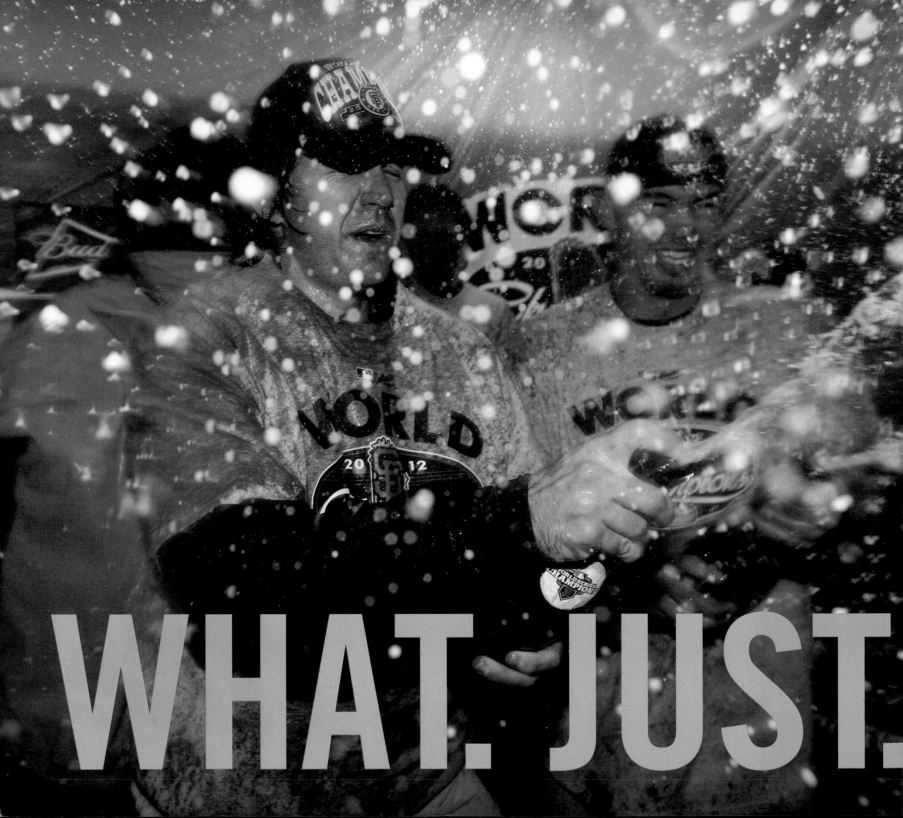

WHAT. JUST.

WORLD
20 12
SF
Champions
SERIES
WORLD SERIES

HAPPENED?

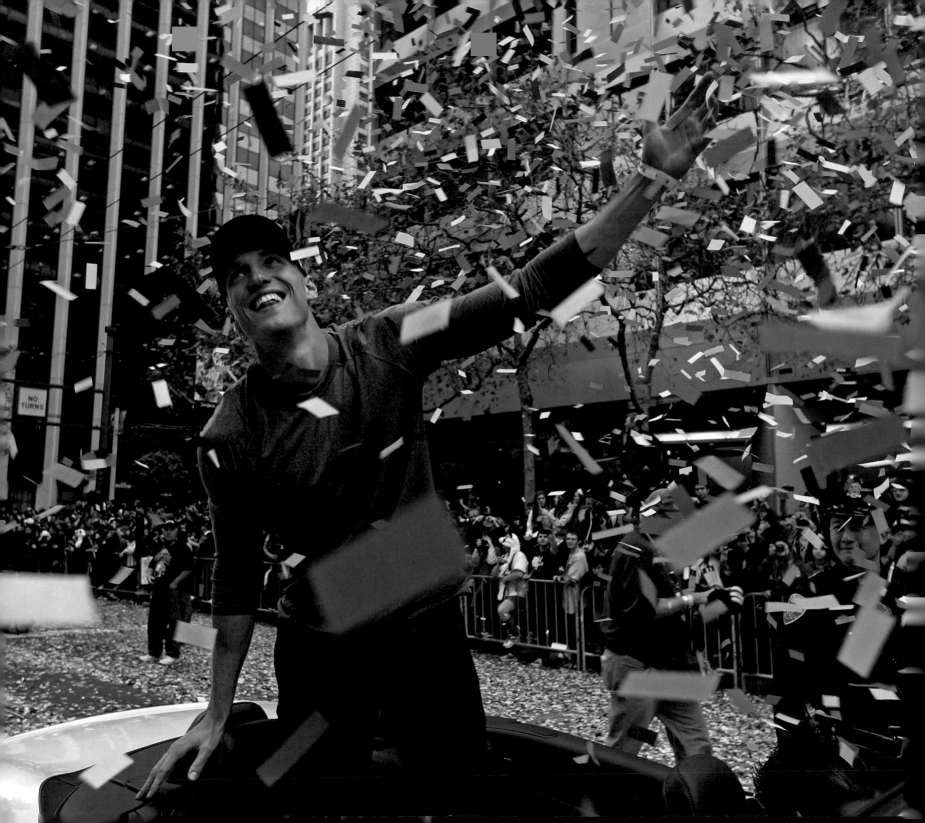

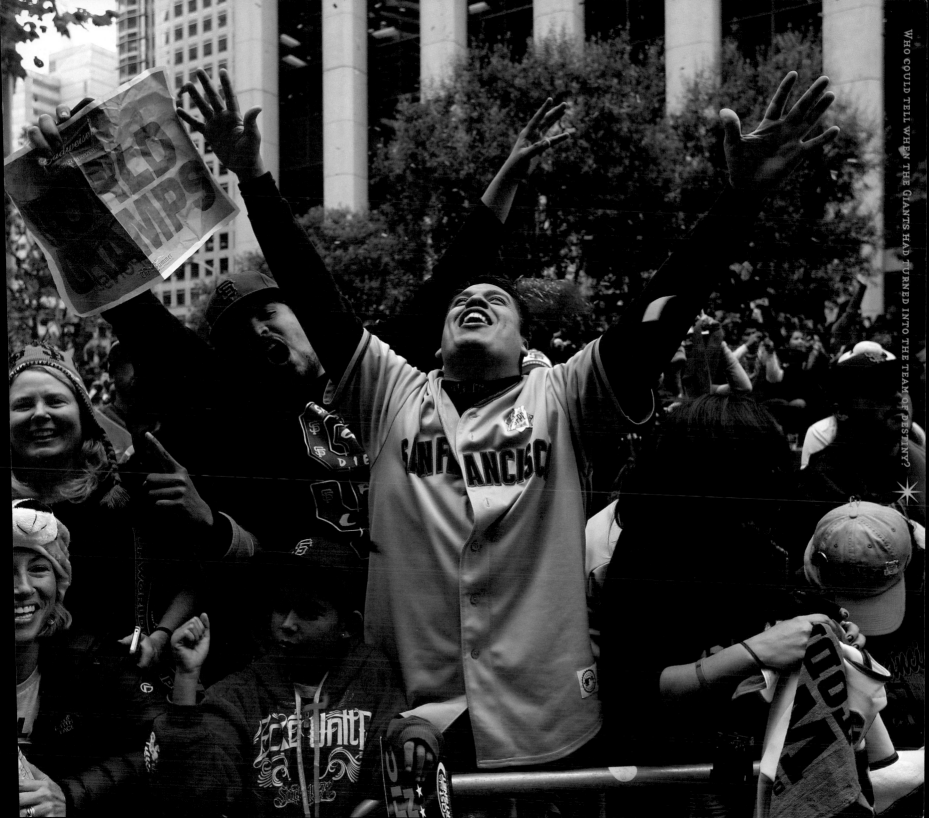

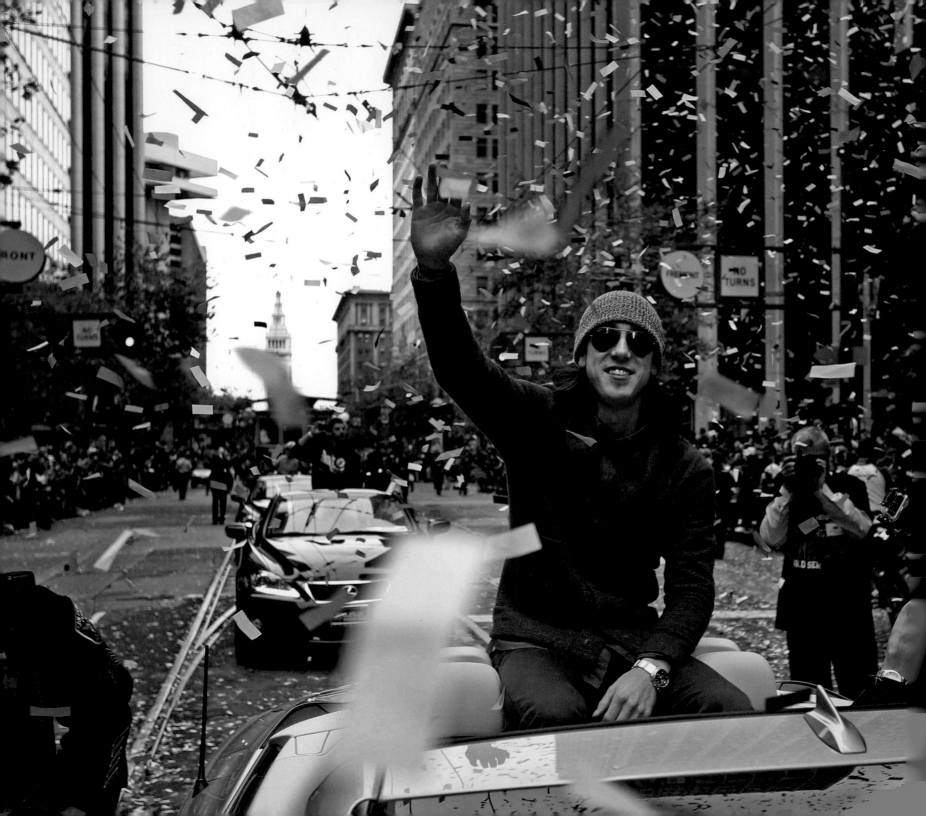

2012.
WORLD
CHAMPS.

I would like to dedicate this book to my dad for teaching me to love baseball and the San Francisco Giants, and to my mom for teaching me how to see, and keeping score at all my Little League games.

Thanks to my good friend and co-author, Brian Murphy, for working with me again on a book to celebrate a World Series champion San Francisco Giants team. Being able to put together a book like this with a fellow Giants fan like Murph has been a real joy. There are few people out there to whom I can truly relate about the 1978 Giants like Murph.

Candace Murphy has always been so helpful on all of

ACKNOWLEDGMENTS.

my book projects. Once again she was there to support us and deliver some clutch hits along the way.

Thanks to publisher Chris Gruener, editor Mark Burstein, and designer Iain Morris from Cameron + Co. for making this book a reality. Chris was the brains that put this project together, Mark made sure we met all our deadlines, and Iain made my pictures look amazing.

Thanks so much to my brilliant literary agent, Amy Rennert, for believing in me and working so hard to get this book published. Amy has done so much for me over the past few years; I will never be able to thank her enough.

My gratitude is due to Don Hintze, Jessica Foster, and Jim McKenna at Major League Baseball. They punched my ticket to San Francisco and Detroit, allowing me to photograph my thirteenth straight World Series.

Michael Klein of Getty Images was instrumental in helping me gather all of my images from the World Series.

It was my pleasure to shoot the World Series once again with my Major League Baseball Photos teammate Ron Vesely. Without Ron's friendship and all the other things he does that don't show up in the box score, this book would not have been possible.

Thanks to *Sports Illustrated* picture editor Nate Gordon and director of photography Steve Fine for allowing me to shoot baseball for the magazine for the past twenty big league seasons. Their coaching and encouragement along the way helped make this book a reality.

Thanks to V. J. Lovero. The best there ever was.

Staci Slaughter, Jim Moorehead, Russ Stanley, Maria Jacinto, and Andy Kuno of the San Francisco Giants

helped make covering the 2012 World Series Champion team so much fun.

I was blessed to have many wonderful teachers: Paul Ficken, Terry Smith, Gerry Mooney, Joe Swan, and Jim McNay.

Finally, I need to thank my very special supporters for all they have done for me: Nick Harrison, Allen Murabayashi, Grover Sanschagrin, Joe Gosen, Paula Mangin, Jim Merithew, and Justin Sullivan, I cannot thank you enough for all of your support.

Brad Mangin

All through October, the Giants rallied around the concept of *team*. "Play for the man next to you!" they said.

When it came to our book, I took the same philosophy: Write for the man next to you! In this case, it's my book co-author, AT&T Park seatmate, and the only guy I know who appreciates Mike Ivie's 1978 pinch-hit grand slam off of Don Sutton more than I do: Brad Mangin.

Brad's photography is second to none, and inspired me. I thank him for his world-class work, for making this book what it is, and for being so darn good at what he does. We've done two World Series books now, pal, and I'm confident that's two more than we ever thought possible.

The beat writers who cover the team: Comcast Sports Net's Andrew Baggarly, Bay Area News Group's Alex Pavlovic, the *San Francisco Chronicle*'s Henry Schulman, and MLB.com's Chris Haft wrote the "rough draft of history," as they say in the newspaper world. As a guy who spent fifteen years as a newspaperman myself, I appreciated the work they did, and reading them guided me through the season. Mike Krukow and Duane Kuiper provided daily insight on the radio, and Jim Moorehead, Matt Chisholm, and Russ Stanley from the Giants always made the ballpark a welcome place.

My workmates at KNBR were an essential part of my daily Giants fandom, and we experienced the arc of a baseball season together. Thanks to Paul (Paulie Mac) McCaffrey, Patrick (P-Con) Connor, Rob (DJ Raw B) Blach, and Kate (Baby Will Clark) Scott for always making

mornings fun when we talk Giants ball. Or, in the case of the musical Paulie Mac, when he sings Giants ball. Our fearless leader, Lee Hammer, even let us into the KNBR suite on occasion.

As always, it all starts at home. My lovely and talented bride of sixteen years, Candace, has learned to tolerate and even enjoy the sounds of Giants baseball in the spring, summer, and fall, and for that I thank her. Plus, she writes a pretty mean title. I thank her even more for our two little Giants fans at home: Declan, five, who wears a Buster Posey jersey like few others; and Rory, one, who pretty much sealed Rookie of the Year status by the time the parade rolled down Market Street. At the heart of it all, Mom and Dad provided the foundation for everything I have in life with their love and support.

Thanks to Jon Miller and Dave Flemming, whose KNBR radio calls helped bring the season's best memories back to life. And to Sergio Romo, who not only took time to write our foreword, but who gave a window into the character of the 2012 Giants in his weekly visits on the *Murph and Mac* show, where he wore his heart on his Giants-patched sleeve.

Thanks to our agent, Amy Rennert, for always being there for us, and for knowing good Chinese food. Thanks to Chris Gruener at Cameron + Co. for being such a dynamite work partner; to Iain Morris for not once sliding a cricket or rugby photo into his artistic and inspired design; and to Mark Burstein for being an editor who respects writers' voices while doing a thorough job.

The first World Series book, *Worth the Wait*, was for the Candlestick generation who thought a title would never come. This one is for the China Basin generation, who has established a culture of Giants fandom that is the envy of nearly every big-league town in the country. When the lights go down in the City, and the sun shines on the Bay . . . you guys are always there. It's pretty sweet.

Brian Murphy

Although the San Francisco Giants have won two World Series in the past three years, Mike Ivie's grand slam off Don Sutton at Candlestick Park on May 28, 1978 might still be **Brad Mangin**'s favorite Giants moment. Mangin was there with his dad, and he has the ticket stub to prove it.

Mangin is a freelance sports photographer based in the San Francisco Bay Area, where he regularly shoots assignments for *Sports Illustrated* and Major League Baseball Photos. Mangin graduated from San Jose State University in 1988 with a degree in photojournalism. His work experience has ranged from being a staff

BIOGRAPHIES.

photographer at the *Contra Costa Times* to working for the legendary sports photographer Neil Leifer at the *National Sports Daily*. Mangin has nine *Sports Illustrated* covers to his credit, and has photographed the last thirteen World Series for Major League Baseball. He has donated his entire archive of baseball photographs, dating back to 1987, to the National Baseball Hall of Fame and Museum in Cooperstown, New York.

Brad Mangin's photographs have also been featured in *Worth the Wait* (2011), the official commemorative book of the first San Francisco Giants World Series season, and *Instant Baseball: The Baseball Instagrams of Brad Mangin* (2013). Mangin lives in Pleasanton, California, with his cats Mike (Ivie) and Willie (Mays, McCovey, Montañez).

Ever since sitting in the Upper Reserved seats at Willie McCovey's last home game at Candlestick Park in 1980, Mill Valley native **Brian Murphy** was probably destined to write about the Giants when he grew up. This is Murphy's third book on the Giants, joining 2008's *San Francisco Giants: 50 Years* and 2010's *Worth the Wait*.

After graduating from UCLA in 1989, Murphy spent fifteen years as a sportswriter covering topics as varied as the San Francisco 49ers, the Oakland A's, and the PGA Tour at the *San Francisco Chronicle*, *San Francisco Examiner*, *Santa Rosa Press Democrat*, and *Los Angeles Times* before joining KNBR radio in 2004. He's been with on-air partner Paul McCaffrey on the *Murph and Mac* show since February 2006, all of which means he hasn't worked a day in his professional life. Murphy also co-authored *The Last Putt: Two Teams, One Dream, and a Freshman Named Tiger* in 2010 with sportswriter Neil Hayes. Murphy and his wife, Candace, live in the North Bay with their two sons, Declan and Rory, and their dog, Oscar.

✝: *Pablo Sandoval and José Mijares*

✝: *Sergio Romo*

CAMERON + COMPANY
Publisher: *Chris Gruener*
Art Direction & Design: *Iain R. Morris*
Editor: *Mark Burstein*

(707) 769-1617
www.cameronbooks.com

COLOPHON.

Cameron + Company would like to
thank Brad Mangin for his keen, veteran
eye for capturing the 2012 San Francisco
Giants like nobody else could (or did);
Brian Murphy for his beautifully written
narrative that perfectly tells the story
of this memorable "Never. Say. Die."
2012 season; Mark Burstein for his
impeccable editorial work; Michelle
Dotter for her timely and thorough copy
edits; Iain Morris for bringing such an
original design vision to this project and
seeing it through to the end so fervently;
Amy Rennert for entrusting us with her
photographer and author for such a
fun book; Sergio Romo for his spot-on
foreword (not to mention his passion
and talent on the field in 2012); and all
of the San Francisco Giants players,
coaches, and staff who made this season
and book such a once-in-a-lifetime
experience for fans like us.